THE
BOOK
OF
TREES

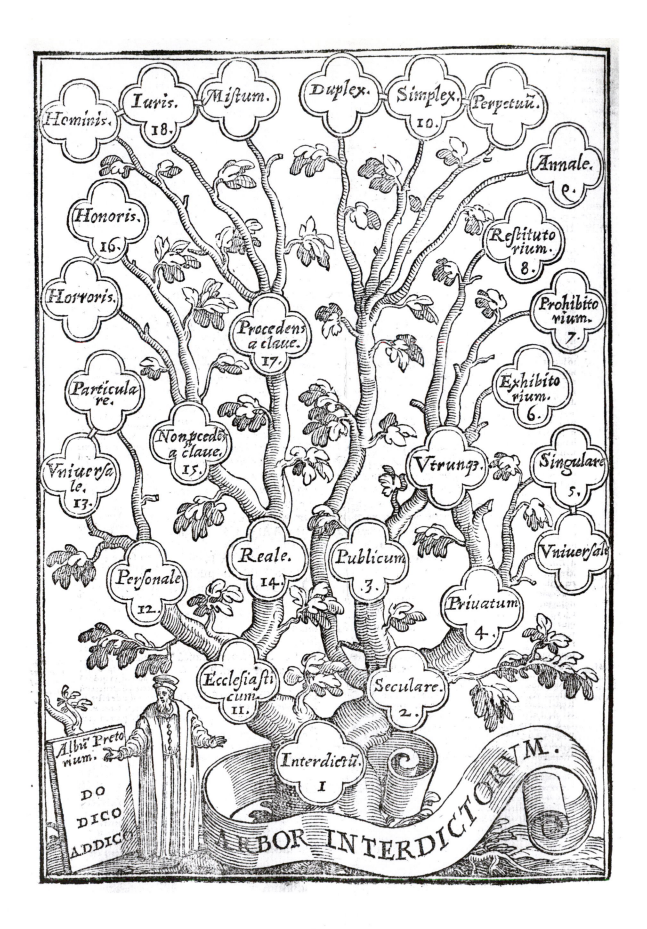

THE BOOK OF TREES

Visualizing Branches of Knowledge

Manuel Lima

Princeton Architectural Press
New York

CONTENTS

Chapter 01

Chapter 02

Chapter 03

Chapter 04

Chapter 05

Chapter 06

Frontispiece:
Anonymous
Tree of interdictions
1592

Illustration from volume nine of a
later edition of *Codex Justinianus* (Code
of Justinian), a large compendium on
Roman law mandated by the Byzantine
Emperor Justinian I (ca. 482–565).
This enticing tree categorizes a series
of legal and ecclesiastical sanctions.
From the main trunk of "Interdictions,"
the tree divides into two primary
branches, "Ecclesiastical" and "Secular,"
which each fork into two subbranches,
"Personal" and "Real" at left and
"Public" and "Private" at right.

FOREWORD

Ben Shneiderman

Soaring oak trees are an attraction for those who sit under them or those who climb up for a better view. The cool shade of leafy maples or broad willows encourages calm reflection, while the eye-catching concentric circles of tree rings remind us of how time passes and seasons change. Trees can also inspire a Newton to notice the proverbial falling apple or a Darwin to see the schema for all life-forms.

The recursive branching structure of trees, which provides a compelling metaphor for organizing knowledge, was at the forefront of my mind as I developed the rectangular treemap as a means to display the nested structure of folders on a computer's hard drive. My innovation went beyond turning a three-dimensional tree into a nested planar diagram; I was eager to show the leafiness of each branch as an area whose relative size showed the magnitude of that leafiness. Furthermore, I wanted to ensure that all the areas would fill the containing rectangle and not spill outside. These constraints, and the variable depth of tree structures, challenged me for months until the sudden "Aha!" moment hit me while in the faculty coffee room at the Department of Computer Science, University of Maryland. It took me several days to work out the details, write the code, and convince myself that the solution would work. It was challenging, intellectual work, but in retrospect the solution seems obvious.

However, what continues to surprise and delight me is how many improvements, variations, and extensions have been made by hundreds of other researchers. They invented "squarified" layouts, causing me to respond with further refinements, as well as circular designs, spiral layouts, diagrams with text-friendly horizontal aspect ratios, organic-looking Voronoi layouts, animated treemaps that could change as values changed, and many more alternatives. Treemaps were implemented in many programming languages and on many platforms, emerging even on small cell phone displays. What would a sonic treemap sound like?

My colleagues and I have studied the twenty-year history of interactive tree representations with the goal of trying to understand why treemaps have flourished.[1] It's hard to prove, but the treemap is a simple visual representation that has been enhanced by repeated refinements and multiple evaluations tied to

specific tasks. In short, treemaps solve problems that people care about—how to visualize computer storage, stock market trading, production and marketing patterns—in a way that is comprehensible and visually appealing. One glance is often enough to understand what has happened and what needs to be done. Treemaps are simple, practical, shareable, actionable, and occasionally attractive. But they are also imperfect, solve only some problems, and have limitations, so much room remains for future innovation.

Manuel Lima's remarkable history of tree diagrams shows how appealing and pliable the metaphor has been for more than eight hundred years. He diligently tracks historical evolutions and cultural crossovers, showing the many domains of human accomplishment that have been supported and explicated by tree structures. Natural and diagrammatic representations of trees come in many varieties, each with its own charm, virtues, and uses. Some trees are broad and shallow, others are narrow and deep; some trees are balanced with fixed depth, others have varying branching factors and erratic depth. Some representations of trees require comparisons across nodes or branches, while other complex uses (such as charting changes to the US budget over many years) require comparisons across two or more trees. Other challenges involve representing created or removed nodes, showing movements of branches, and highlighting large changes in absolute or relative values. I expect more tree-visualization innovation, maybe stimulated by the examples in this book.

Trees have long inspired poetry, such as Joyce Kilmer's memorable couplet: "I think that I shall never see / A poem lovely as a tree." Human interpretations of trees sometimes have been almost as beautiful as their natural inspirations, but they are equally gnarled, cracked, twisted, and sometimes impenetrable. Still, this thorough and enchanting review opens the reader's mind to consider new uses of tree structures, new problems to be solved, and new ways to draw on natural beauty.

PREFACE

This is the book I wish had been available when I was researching my previous book, *Visual Complexity: Mapping Patterns of Information*.[1] During that period, while investigating various tree diagrams, charts, and illustrations—particularly antique ones from medieval Europe or three-thousand-year-old Assyrian stone carvings—I became deeply obsessed with tree iconography. Despite my best efforts, I could never find a wide-ranging book dedicated to the tree as one of the most popular, captivating, and widespread visual archetypes. This was the crucial impetus that propelled me to create such a volume, able to provide a deep look at the history of human culture through the lens of visualization.

Information visualization is a remarkable, ever-changing field of study, with deep roots in cartography, the illumination of manuscripts, and medieval visual exegesis. More recently, it has been a practice fueled by the advent of statistical thinking in the nineteenth century and the dawn of computers and the Internet in the twentieth century. Given the recent surge of interest in the field, it's tempting to contemplate information visualization as an entirely new discipline rising to meet the demands of the twenty-first century. But, as with any domain of knowledge, visualization is built on a prolonged succession of efforts and events, the evidence of which has in many cases been lost or scattered in dark, dusty cabinets. It's critical for us to understand this long evolution and not be overly infatuated by the work created in the last decade alone. As the professor of psychology Michael Friendly wisely stated, "There certainly have been many new things in the world of visualization; but unless you know its history, everything might seem novel."[2]

Most books on this domain go only as far back as the mid-eighteenth century, mentioning the work of Joseph Priestley (1733–1804), William Playfair (1759–1823), and other illustrious contributors seen as the forebears of modern information visualization, such as Charles Joseph Minard (1781–1870), John Snow (1813–58), and Florence Nightingale (1820–1910). The work of these individuals has been pivotal to the modern development of the practice, but it's nonsensical to imagine there was nothing but a blank state before them. We need to ask, what about the remarkable work of Isidore of Seville (ca. 560–636), Lambert of Saint-Omer (ca. 1061–ca. 1125), Joachim of Fiore (ca. 1135–1202),

Ramon Llull (ca. 1232–ca. 1315), Hartmann Schedel (1440–1514), or Athanasius Kircher (1601–80)? After all, each of these pioneering figures actively explored novel ways to visually depict complex topics centuries before Joseph Priestley devised his famous biographical timeline. As many examples in this book demonstrate, the work of these ancient visualization pioneers, in their use of the tree metaphor, epitomizes the same curiosity, drive, and ambition guiding most contemporary projects. The challenges they faced were all similar to the ones we face currently, and the goal was the same then as it is now: to explain and educate; to facilitate cognition and gain insight; and, ultimately, to make the invisible visible. The parallel objective of this book is therefore to convey the long, millennial history of information visualization.

This book also can be seen as an extended introduction to *Visual Complexity*. In the first chapter of *Visual Complexity* I introduced tree metaphors as the seminal predecessors of modern-day network visualizations. In the present book trees take central stage as the main subject matter. By providing a holistic look at the historical portrayal of trees and hierarchical structures, as well as many of their modern manifestations, this book will offer a well-founded context for *Visual Complexity* and the many recent examples of network visualization.

Even though some of the notions normally associated with trees, such as hierarchy, centralization, and immutability, can at times prove problematic when dealing with many of the challenges of our modern-day networked society, these ubiquitous symbols continue to embody a fundamental organizational principle that reflects the way humans like to look at the world. As such, they show no signs of waning in popularity. In Chapter 01 alone we can witness how the use of figurative trees to convey different facets of knowledge has spanned almost an entire millennium. More important, these emblematic, lifelike tree illustrations have given rise to a new, diverse set of models showcased throughout the following pages—many having emerged within the last decades and showing a bright, promising future.

The eleven chapters that compose this book feature a number of visual methods and techniques for the representation of hierarchical structures. The first (and longest) chapter features primeval tree diagrams, which bear a close resemblance to real trees and are, at times, significantly embellished. The remaining ten chapters can be grouped into two sections. The first, comprising Chapters 02 through 06, covers the earliest forms of diagrammatic, abstract tree charts and includes different types of node-link diagrams, where given nodes, entities, or "leaves" are tied across different levels by links, edges, or

"branches." The second group, encompassing Chapters 07 through 11, explores more modern and recently popular approaches, showcasing various types of space-filling techniques and adjacency diagrams that use polygonal areas and nesting to indicate different ranking levels.

Each chapter is organized chronologically, outlining the historical evolution of its category. While all efforts were made to identify and uncover the most significant examples, it's only fair to assume many more exist, some even predating the earliest in each chapter. Other examples, old and new, were simply impossible to track down and bring to light, but certainly not for lack of trying. My hope is that this becomes a growing taxonomy, expanded over the years as many missing links are located, and, perhaps more important, complemented with entirely novel taxa. Mainly, I hope you have as much pleasure browsing this book as I've had witnessing the extraordinary human inventiveness in the visual representation of information and the portrayal of hierarchical structures.

Manuel Lima
New York
June 2013

ACKNOWLEDGMENTS

Such a laborious venture would have been unthinkable without the help of numerous individuals and institutions. First, I would like to thank all the authors and organizations who have kindly shared their images, some having spent many hours updating old code and re-creating new pieces especially for this undertaking. This book couldn't exist without you. Second, I would like to acknowledge a most helpful but rarely recognized resource: the array of new web services and technologies that have dramatically transformed the way curious authors and researchers conduct their investigations into historical materials. Apart from the existing mass of information offered in a plethora of websites and blogs across the World Wide Web, a series of prestigious institutions, such as the British Museum, the National Library of France, the National Library of Spain, the Library of Congress, and the Metropolitan Museum of Art, among many others, have started providing free online access to a copious, ever-growing number of pieces in digital format, which has proved immensely helpful. Moreover, many other online services—particularly social bookmarking systems and content-sharing websites such as Delicious, Pinterest, Instapaper, and Evernote—have made the job of a researcher significantly easier and more exciting. And even though many of these names will become unfamiliar in a few years due to the inherently ephemeral nature of web services, the notion of curated online social experiences will certainly last for many years to come as a critical measure to deal with the growing amount of data at our disposal. I would like to thank Sara Bader and Sara Stemen, from Princeton Architectural Press, for their enthusiastic encouragement of this idea and the patient review of the manuscript; and also Ben Shneiderman, Santiago Ortiz, and Darwin Yamamoto for their relevant feedback. Finally, and most warmly, my caring gratitude goes to my wife, Joana, and to my family and close friends, for their invaluable support and kind belief in this project.

The distributions and partitions of knowledge are not like several lines that meet in one angle, and so touch but in a point; but are like branches of a tree, that meet in a stem, which hath a dimension and quantity of entireness and continuance, before it comes to discontinue and break itself into arms and boughs.

—Francis Bacon

The only thing new in the world is the history you don't know.

—Harry S. Truman

INTRODUCTION

As visitors enter the imposing central hall of the Natural History Museum in London, England, one of the first things they notice—apart from the impressive replica of a *Diplodocus* skeleton—is a trunk section measuring more than 15 feet (4.5 meters) in diameter from a colossal 1,335-year-old sequoia tree, located at the very top of the hall. When it was felled, the tree, which started with a fragile seedling in AD 557, measured a striking 276 feet (84 meters) from top to bottom. When Charlemagne was being crowned Holy Roman Emperor in AD 800, the young sequoia was a mere 243 years old; it celebrated its seven hundredth birthday in 1257, three years after Marco Polo was born, and its first millennium a few years before the 1564 births of both Shakespeare and Galileo. This majestic tree was still standing firm in 1892—on the way to its fourteen hundredth birthday—when it was felled in the Sierra Nevada range of California.

Widespread in the age of dinosaurs, sequoia forests continued to flourish for millions of years thereafter, and fossil remains attest to their presence in Greenland, the Eurasian continent, and North America. Having been close to extermination during the ice ages and the target of extensive worldwide replanting after their discovery in the middle of the nineteenth century, sequoias are now mostly confined to the coastal belt of Northern California in the United States. Able to reach a height of 379 feet (115.5 meters) and a trunk diameter of 26 feet (7.9 meters) and to live more than 3,500 years, sequoia trees are among the largest and longest-living organisms on our planet. These grandiose, mesmerizing lifeforms are a remarkable example of longevity and stability and, ultimately, are the crowning embodiment of the powerful qualities humans have always associated with trees.

In a time when more than half of the world's population live in cities, surrounded on a daily basis by asphalt, cement, iron, and glass, it's hard to conceive of a time when trees were of immense and tangible significance to our existence. But for thousands and thousands of years, trees have provided us with not only shelter, protection, and food, but also seemingly limitless resources for medicine, fire, energy, weaponry, tool building, and construction. It's only normal that human beings, observing their intricate branching schemas and the seasonal withering and revival of their foliage, would see trees as powerful images

of growth, decay, and resurrection. In fact, trees have had such an immense significance to humans that there's hardly any culture that hasn't invested them with lofty symbolism and, in many cases, with celestial and religious power. The veneration of trees, known as dendrolatry, is tied to ideas of fertility, immortality, and rebirth and often is expressed by the *axis mundi* (world axis), world tree, or *arbor vitae* (tree of life). These motifs, common in mythology and folklore from around the globe, have held cultural and religious significance for social groups throughout history—and indeed still do.

We can observe a reference to this universal concept in one of the most sacred texts of the Western world. A few passages in the Bible mention the tree of life, notably in Genesis and in Revelation 22:2, where it is described as growing next to the river of the water of life: "In the midst of the street of it, and on either side of the river, was there the tree of life, which bare twelve manner of fruits, and yielded her fruit every month: and the leaves of the tree were for the healing of the nations." As to the purpose of the tree of life, a better understanding is provided in Genesis 3:22: "And the LORD God said, Behold, the man is become as one of us, to know good and evil: and now, lest he put forth his hand, and take also of the tree of life, and eat, and live for ever."[1]

Such an allusion is not unique to Christianity. In fact, as with many Christian themes and stories, this idea was appropriated from Jewish, Assyrian, and Sumerian traditions. The concept of a tree of life can be traced to many centuries before the birth of Jesus Christ and has been one of the most widespread and long-lasting archetypes of our species.

In the Fertile Crescent, considered to be the cradle of civilization, Sumerians, Akkadians, Babylonians, and Assyrians believed in a concept analogous to the tree of life. This tree, represented by series of nodes and crisscrossing lines, was believed to grow in the center of paradise, sometimes guarded by a snake but more typically attended by eagle-headed gods and priests in an attitude of adoration | *Figs.* 1–3.

Egyptians are known to have worshipped various types of trees, such as the green sycamore, the acacia, the tamarisk, and the lotus, and some evidence seems to attest that Osiris, the great god of the afterlife, the underworld, and the dead, was originally a tree god | *Fig.* 4.[2] Ancient Canaanites revered the Asherah pole, a cult object in the form of a tree that honored the mother goddess Asherah. Esoteric Judaism has its own well-known version of the tree of life, commonly called the Sephirotic tree or Kabbalah tree | *Fig.* 5, and Christian tradition describes both the tree of life and the tree of knowledge of good and

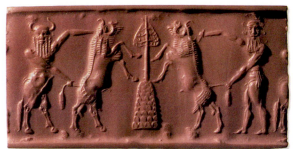

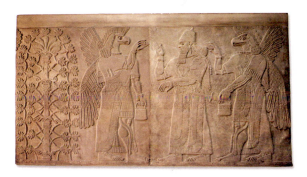

Impression of an Akkadian greenstone cylinder seal depicting an antithetical contest scene, with a sacred tree standing at the center, on a cone-shaped mountain. Cylinder seals were popular communication tools in Bronze Age Mesopotamia—covering the Sumerian, Akkadian, Babylonian, and Assyrian Empires—and presented a wide variety of topics by means of engraved emblematic scenes and written notations. They were normally rolled onto a soft, wet clay tablet, producing a two-dimensional imprint of the scene. In this seal, the sacred tree takes central stage, surrounded on its sides by two men holding and stabbing a bison.

Gypsum wall-panel relief, excavated at the Northwest Palace of Ashurnasirpal II in Nimrud (in present-day northern Iraq), showing an eagle-headed genie fertilizing a sacred tree. A common motif in Assyrian iconography, the winged eagle-headed genie was a protective magical spirit shown recurrently next to a sacred tree, an important symbol of fertility for Assyrians and a popular theme during the reign of Ashurnasirpal II. These mythical figures—also depicted as priests, kings, or supernatural creatures—are thought to represent fertilizing winds or divinities empowered by the artificial fecundation of the tree.[3] The panel includes an engraving written in cuneiform script. It was originally featured in a room completely paneled with depictions of King Ashurnasirpal II surrounded by sacred trees.

Detail of the sacred tree.

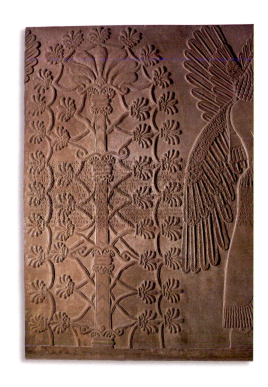

Fig. **4**

Anonymous

Lotus tree

ca. ninth or eighth century BC

Ivory relief panel showing a youth dressed in Egyptian royal costume, holding a lotus tree. The lotus tree and flower were recurrent themes in Egyptian art, iconography, and architecture and are thought to have held a great significance to the people of the time. Lotus trees were often the targets of worship, as symbols of regeneration and resurrection associated with different Egyptian deities.

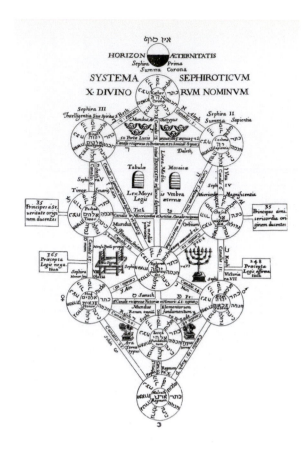

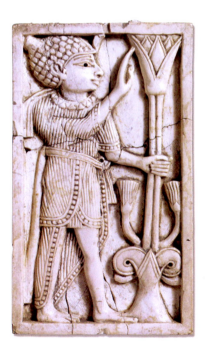

Fig. **5**

Kabbalistic tree of life

From Athanasius Kircher, *Oedipus Ægyptiacus* 1652–55

Illustration by the Jesuit scholar and polymath Athanasius Kircher (1601–80). Kabbalah (*aytz chayim* in Hebrew) is a Jewish mystical tradition; the term translates as "received," in reference to teachings passed through generations or directly from God. A pivotal element of the Kabbalah wisdom is the tree of life, an image composed of a diagram of ten circles, symbolizing ten pulses, or emanations, of divine energy. Central to esoteric Judaism, Kircher's version of the Kabbalah tree has been popular among mystical groups in both Europe and North America.

evil, with the latter being a main component of the central tale of the fall of man, portrayed in numerous medieval illustrations and paintings | *Figs.* **6–8.** The Islamic sacred text of the Koran similarly makes mention of a sacred Tooba tree that stands at the center of paradise. Norse mythology across pre-Christian Scandinavia and northern Europe—a region once covered by dense forest—is filled with tales of Yggdrasil, a huge ash tree that binds earth, hell, and heaven together | *Fig.* **9.** Pagan Celtic society was crammed with tree tales and cultic practices in sacred groves; the word "druid" is tied with the oak tree and thought to have derived from a proto-Indo-European term meaning the "oak knower" or "oak seer." In ancient Greece, every sanctuary and temple of Athena had its sacred olive tree, which was regarded as a symbol of divine peace and protection.[4] Native American Navajos are believed to have had a tree of life in the form of a maize (corn) tree, also a recurrent subject in Ojibway culture. The Mayan, Aztec, Izapan, Olmec, and other Mesoamerican cultures produced numerous depictions of world trees; for the Mayans this motif took the shape of a ceiba tree, known variously as *wacah chan, yax imix che,* or simply as the Yaxche tree | *Fig.* **10.** Hinduism reveres numerous sacred trees, such as the *ashoka, bael, neem, tulsi,* and champac trees | *Fig.* **11;** most famously its Vedic tree of Jiva and Atman and its *Ashvattha,* or sacred fig tree—also called the Bodhi tree by Buddhists—under which Gautama Buddha is believed to have meditated and attained enlightenment | *Figs.* **12–13.** Finally, in Tibetan Buddhism, the Gelug lineage, based on a school founded by Je Tsongkhapa in the fifteenth century, has often been portrayed as a refuge tree that features representations of many of its eminent lamas and gurus | *Fig.* **14.**

The omnipresence of these symbols reveals an inherently human connection and fascination with trees that traverse time and space and go well beyond religious devotion. This fascination has seized philosophers, scientists, and artists, who were drawn equally by the tree's inscrutabilities and its raw, forthright, and resilient beauty. Trees have a remarkably evocative and expressive quality that makes them conducive to all types of depiction. They are easily drawn by children and beginning painters, but they also have been the main subjects of renowned artists throughout the ages. It would be inconceivable to mention every artist who has contemplated trees, but it's certainly hard to talk of Vincent van Gogh without mentioning his dramatic and invigorated treatment of trees | *Fig.* **15** or even recall Gustav Klimt without conjuring the image of his acclaimed *The Tree of Life* | *Fig.* **16.**

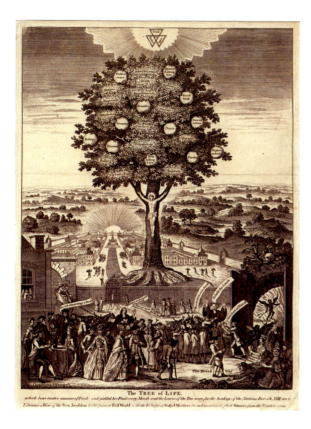

Fig. 7
Hans Sebald Beham
The Fall of Man
ca. 1525–27

Woodcut print of the fall of man
with a forest in the background,
showing Adam grabbing an apple
out of Eve's left hand and Eve taking
another apple from the leaning serpent.
At the center of the tree's trunk, above
the coiled serpent, is an oversize skull,
a reminder of the consequences of
disobedience to God. In a later version
of this same scene, the German
engraver Beham features the skull with
a full-bodied skeleton intertwined with
the tree of knowledge of good and evil.

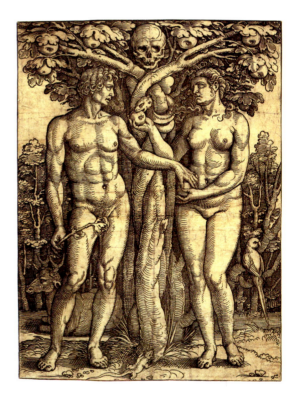

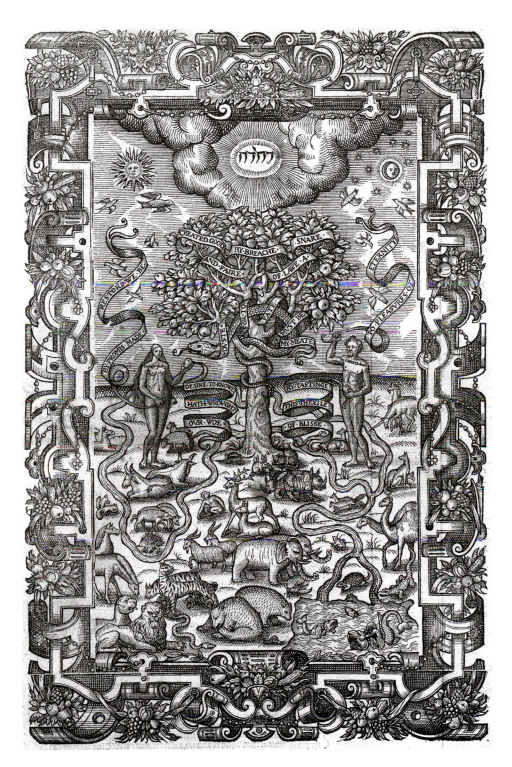

Fig. **8**
Anonymous
The fall of man
Sixteenth century

Illustration, probably the frontispiece to a sixteenth-century edition of the New Testament, featuring the well-known biblical tale of the fall of man. The fall is one of the most widely depicted scenes of Christian theology, generally portraying Adam and Eve next to the tree of knowledge of good and evil, holding an apple and being tempted by a leaning serpent to eat it. This particular version depicts several animal species surrounding Adam and Eve in the Garden of Eden, enclosed by a beautifully ornamented frame.

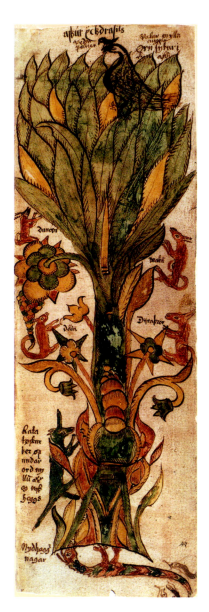

Fig. **9**
Anonymous
Yggdrasil tree
ca. 1680

Illustration of Yggdrasil, part of *Edda oblongata*, an Icelandic manuscript from 1680 containing several illustrations of Norse mythology. This particular drawing features the world tree, or cosmic ash tree, Yggdrasil, surrounded by the various animals that live in and on it. Of particular relevance is Ratatoskr, a green squirrel on the bottom left, who, according to Norse mythology (notably the thirteenth-century poem "Grímnismál"), runs up and down Yggdrasil to carry messages between the eagle, shown at the top of the tree, and the dragon, Níðhöggr, who gnaws at the roots.

Fig. **10**
Anonymous
Tablet of the cross
ca. 698

Drawing based on a bas-relief panel located in the Temple of the Cross, the most noteworthy pyramid of a group of temples in the Palenque site, in the jungle of Chiapas, Mexico. Palenque was a Mayan city-state that flourished in the seventh century AD and whose ruins date back to 226 BC. The panel depicts the tree of life, a cross or world axis that, according to Mayan mythology, can be found in the center of the four directions, or center of the world. This intersection connects three worlds: the underworld, the earth, and the heavens. Most of its accompanying inscriptions recount the beginning of creation and detail a dynastic list of the rulers of Palenque.

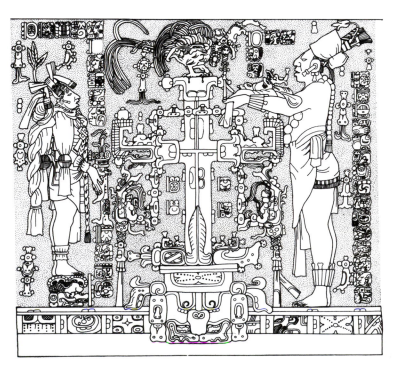

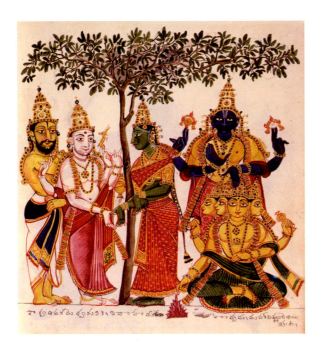

Fig. 11
Anonymous
Marriage of Shiva and Parvati
ca. 1830

Watercolor painting of the marriage of Hindu deity Shiva and his wife, Parvati, under a sacred tree. The four-headed Brahma, seated, is performing a *homa* (a ritual fire sacrifice). The central tree could possibly be a *bael* or a *Magnolia champaca*, also known as *Michelia champaca*—an evergreen tree considered to be sacred to Shiva and whose flowers are employed in the worship and religious observance of other Hindu deities.

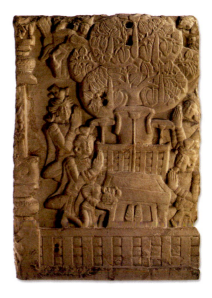

Fig. 12
Anonymous
Bodhi tree
ca. third century AD

Relief limestone drum-slab depicting Gautama Buddha's scene of enlightenment, with an empty throne under the holy Bodhi tree. The Bodhi tree was a large fig tree (or banyan tree) located in Bodh Gaya, northeastern India, under which Buddha (Siddhartha Gautama) is thought to have attained enlightenment—the most common English translation of the original Sanskrit *Bodhi*, which stands for "awakened." Underneath the throne stands the footprints of the Buddha (known as *Buddhapadas*), featuring two engraved *dharmachakras*, or "wheel of law," a recurrent motif of Buddhist symbology based on Buddha's teachings.

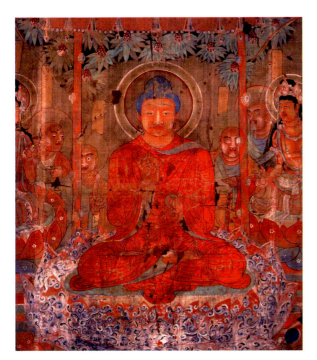

Fig. 13
Anonymous
Painting of Buddha
ca. 701–750

A detail of a silk painting depicting Buddha seated under an adorned Bodhi tree, preaching to his disciples.

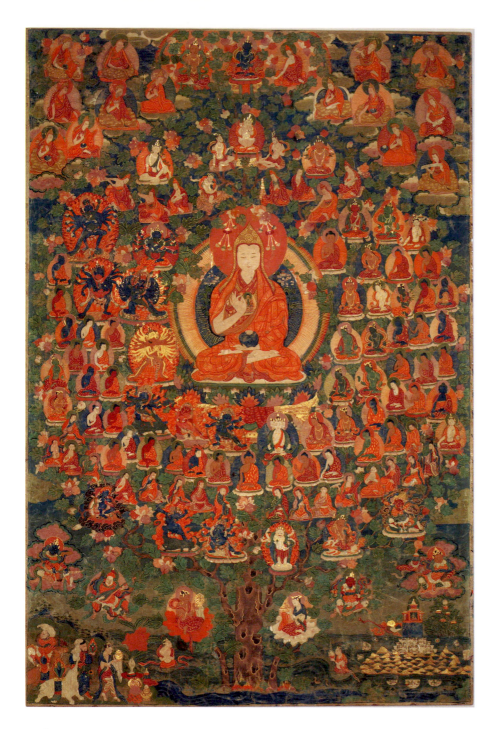

Fig. **14**
Konchog Gyaltsen
Tsongkhapa refuge host field tree
ca. eighteenth century

A Tibetan cotton painting with fine gold line, also known as a *thangka*, depicting Je Tsongkhapa at the very center of the field (tree) for the Accumulation of Merit. Je Tsongkhapa (1357–1419) was an illustrious philosopher and Tibetan religious leader whose undertakings led to the formation of the dominant Gelug school of Buddhism. This painting places Tsongkhapa at the center of a tree, surrounded by a multitude of meditational deities, confession Buddhas, bodhisattvas, arhats, and protectors. These religious figures are seated in the tree, which rises from a blue pond below. Surrounding the pond, at the bottom of the composition, are the seven jewels of Royalty, Four Direction Guardians, Brahma, and Vishnu. Above the tree is the incarnation lineage of Panchen Lama, the highest-ranking lama after the Dalai Lama in the Gelug lineage of Tibetan Buddhism.

© Rubin Museum of Art / Art Resource, New York

Fig. 15
Vincent van Gogh
The Mulberry Tree
1889

View of a mulberry tree painted in October 1889, less than a year before van Gogh died. The painting depicts a tree growing out of a rocky terrain, seen from the garden of the Saint-Paul Asylum in Saint-Rémy-de-Provence, southern France, where van Gogh was staying following the notorious incident with Paul Gauguin. In this painting, which apparently held some fascination for van Gogh, who wrote about it to his brother and sister, we can see autumn taking over the tree, with yellow and orange leaves dominating the composition, in contrast with the blue sky. Van Gogh was particularly interested in the mutations of foliage, affected not just by the season but also by changes of tone in the sky.

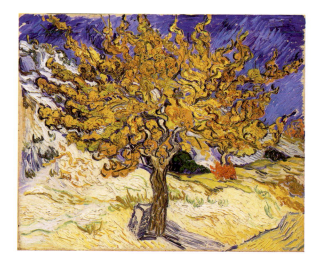

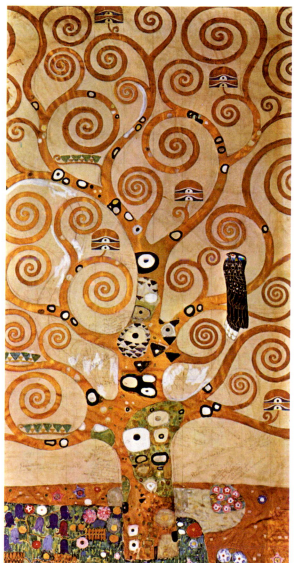

Fig. 16
Gustav Klimt
The Tree of Life
1901

Detail of *The Tree of Life*, one of the most reproduced oil paintings in modern times. Painted during a productive period for Klimt, *The Tree of Life* reflects the painter's obsession with this recurrent theme. The painting is organized in an enigmatic spiraling configuration, with branches forming a convoluted whirlwind enclosing various symbols, including geometric fruits and leaves, as well as animals such as birds and butterflies.

The allure of trees captivated even one of the most prominent figures of the Renaissance, Italian polymath Leonardo da Vinci (1452–1519). Leonardo left behind roughly six thousand sheets of notes and drawings relating to his broad array of interests in painting, sculpture, architecture, anatomy, botany, geometry, engineering, and astronomy. In one of his notebooks on botany for painters, Leonardo observed a particular mathematical relationship between the size of a tree's trunk and the size of its branches | *Fig.* **17**. Essentially, he noted that as trees branch out, at any given height, the total cross-sectional area of the daughter branches equals roughly the area of the mother trunk or branch. As it turns out, Leonardo's rule holds true for almost every species of tree and has been an essential principle for modeling realistic computer-generated trees.

This phenomenon has intrigued scientists for years, but it has always lacked a logical explanation. Then, in 2011, Christophe Eloy, a visiting physicist at the University of California, San Diego, and affiliated with Aix-Marseille University in France, took an entirely different approach to the enigma. As a specialist in fluid dynamics, Eloy immediately realized that the pattern has nothing to do with the flow of water through the tree's branching scheme, as previously thought, but with its resistance to wind. As Eloy's model demonstrates, the fractal structure of most trees following Leonardo's rule is primarily determined by the need to withstand the bending forces exerted by wind on their branches. This is in itself a significant discovery, but such a formula for calculating wind tolerance can have further applications to numerous man-made technologies, particularly in the design of efficient, wind-resistant objects and buildings.

As our knowledge of trees has grown through this and many other scientific breakthroughs, we have realized that they have a much greater responsibility than merely providing direct subsistence for the sheltered ecosystems they support. Trees perform a critical role in moderating ground temperatures and preventing soil erosion. Most important, they are known as the lungs of our planet, taking in carbon dioxide from the atmosphere and releasing oxygen. As a consequence, trees and humans are inexorably intertwined on our shared blue planet.

Our primordial, symbiotic relationship with the tree can elucidate why its branched schema has provided not only an important iconographic motif for art and religion, but also an important metaphor for knowledge-classification systems. Throughout human history the tree structure has been used to explain almost every facet of life: from consanguinity ties to cardinal virtues, systems of law to domains of science, biological associations to database systems. It has been such a successful model for graphically displaying relationships because

it pragmatically expresses the materialization of multiplicity (represented by its succession of boughs, branches, twigs, and leaves) out of unity (its central foundational trunk, which is in turn connected to a common root, source, or origin).[5] It is indeed so powerful that over time tree metaphors have become deeply embedded in the English language, as in "branches" of knowledge or science or the "root" of a problem. The model continues to bear a great significance in genetics, linguistics, archaeology, epistemology, philosophy, genealogy, computer science, and library and information science, among many other fields.

To begin tracing the provenance of the epistemological model of the tree, we have to turn to the great Aristotle, his classification of knowledge and the natural world, and the subsequent expansion of his ideas by the Greek philosopher Porphyry (see Timeline). Porphyry is credited with the logical principle underlying the oldest known tree diagram, called the Porphyrian tree, a dichotomous scheme based on Aristotle's ordering of nature | *Fig.* **18**.

While Aristotle and Porphyry set the foundations of this epistemological model, the most critical stage in the development of the tree metaphor took place during a time of bustling scholasticism in medieval Europe. Compelling evidence suggests tree charts, or stemmata, were used by Roman lawyers to convey regulations pertaining to parentage and marriage, but the tree only became a common structure for visualizing, mapping, and classifying knowledge during the High Middle Ages (ca. 1000–1300), a period of great social and political change and rapidly increasing population growth. While biblical literature and liturgical texts were still the main educational foundation of monks and elite clergy, the twelfth century witnessed an incredible influx of knowledge from the ancient world, which in turn drove a series of attempts to rationalize, organize, categorize, and ultimately represent this new body of information. At the same time, biblical exegesis was evolving from a simple exercise in allegorical breakdown to a complex analytical process with several degrees of intricacy. Soon, textual analysis was augmented by diagrams, which became useful teaching tools for explaining these novel multipart systems. The diagram had numerous benefits for an exegesis student, who could use it to grasp at a glance the various levels, relationships, and chains of events expressed in biblical texts | *Fig.* **19**. "In the books produced to teach the new exegesis, images began to take on an increasingly significant role," according to researchers from Yale University. "While in some cases a visual representation preceded an exegetical text as a summary of what was being taught, at other times it was the primary focus, with the text merely serving as an introduction for that which was taught via

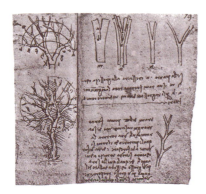

Fig. **17**
Leonardo da Vinci
Tree Branching
ca. 1515

Study of a tree branching, produced a few years before Leonardo's death, in which he proposes a possible equation for the branching scheme of trees. Leonardo's rule is fairly simple, stating that "Every year when the boughs of a tree have made an end of maturing their growth, they will have made, when put together, a thickness equal to that of the main stem."**6** This engineering principle has recently been recognized as the main source of trees' resilience to wind and other external forces.

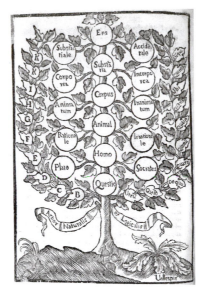

Fig. **18**
Ramon Llull
Porphyrian tree
From *Logica Nova*
1512

A representation of one of the oldest known tree archetypes, derived from the work of the Greek philosopher and logician Porphyry in the third century AD, based on ideas earlier expressed by Aristotle in his *Categories*. The tree embodies Porphyry's scale of being through a treelike structure, composed of a central trunk containing the series of genus and species and two adjacent columns of succeeding dichotomous divisions. Although the original ontological structure by Porphyry hasn't survived, several interpretations were made during the Middle Ages. This figure is a literal arboreal translation of the Porphyrian tree, as drawn by the great thirteenth-century Spanish poet, mystic, and philosopher Ramon Llull.

Fig. **19**
Anonymous
Tree of life
From *Speculum theologiae*
ca. 1300

Tree illustration, part of a collection of eight folios of figures and didactic diagrams commonly called *Speculum theologiae*, produced at the Cistercian abbey of Kamp in Germany. This diagrammatic tree is a remarkable example of medieval visual exegesis and *ars memorativa*, working as a type of meditational mnemonic device for the study of scriptural texts. It displays twelve branches and their respective fruits, corresponding to various events in the life of Christ, accompanied by several biblical passages and quotations. Rooted in a verse from Revelation, this diagram embraces the arboreal composition to assist meditative visualization for improving memory recall and retrieval.

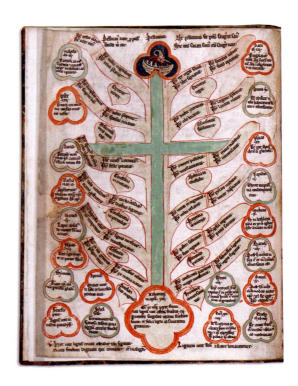

the image and its inscriptions."[7] This medieval emphasis on visual exegesis is probably the most crucial genesis of many of the ideals guiding present-day information design and data visualization.

One of the best ways to understand the motivations behind medieval visual exegesis is to look closely at *ars memorativa* (the art of memory). This Latin term designates a set of mnemonic principles and techniques used to improve memory impressions and recall and, at the same time, to support combinatorial invention and creativity. Arising in ancient Greece and propagated throughout the Middle Ages, *ars memorativa* gained considerable traction with early Christian monks as a means to better read, interpret, and meditate upon the Bible. Saint Thomas Aquinas and the Dominican Order were strong proponents of the art and many of its mnemonic techniques as devices for studying the sacred texts. Its general principles involved the elevation of the visual sense and spatial orientation, the importance of the ordering and positioning of images, and, ultimately, the power of associating terms and values. With a natural order characterized by growth and splitting; an easily apprehended structure of branches, leaves, and hanging fruits; and multiple allegorical associations, the tree was an obvious graphical choice for representing *ars memorativa*.[8]

The English scholar Peter L. Heyworth sees the tree diagram as a powerful teaching tool for conveying the rich biblical heritage: "In this period, the art of preaching itself came to be likened to a tree. *Praedicare est arborizare*: the well-grown sermon must be rooted in a theme, that flourishes in the trunk of a biblical *auctoritas*, and thence grows into its branches and twigs: the divisions and subdivisions whereby the preacher extends his subject matter."[9]

The High Middle Ages witnessed not just some of the earliest and most vivid tree diagrams but also the emergence of its most popular and enduring archetypes. Genealogical trees are among the first examples of the model, mostly employed in the portrayal of royal and noble families as well as in illustrations of religious kinship | *Figs.* 20–21. Trees also became a metaphor to represent a wider conception of society. The *scala naturae* (natural ladder), also known as the "great chain of being," was a popular medieval philosophical concept that saw the world as an immutable tree of perfection. Derived from Aristotle's teleological conception of an essential hierarchical scale of beings and an absolute view of the universe, the *scala naturae* depicted various species rising in a linear order, normally beginning with inanimate minerals and proceeding through fossils to plants, animals, humans, celestial beings, and, ultimately, God. Other versions placed a stronger emphasis on the monarchy and the absolutist divine right of

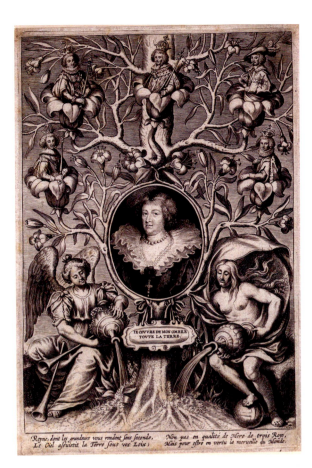

Fig. **20**

Lucas Vorsterman

Family tree of Marie de Médicis

ca. 1632

A portrait-medallion of Marie de Médicis (1575–1642) surrounded by branches of her family tree. Marie was a member of the wealthy and powerful House of Medici and was the second wife of King Henry IV of France. From the tree's main branches, blossoming lilies give origin to portraits of her five children: Louis XIII of France; Henrietta Maria, Queen of England and Scotland; Elisabeth, Queen of Spain; Gaston, Duke of Orléans; and Christine, Duchess of Savoy.

Fig. **21**

Hartmann Schedel

Genealogy

From *Nuremberg Chronicle*

1493

Illustration from the *Nuremberg Chronicle*, also know as *Liber Chronicarum* (Book of chronicles)—a remarkable, densely illustrated and technically advanced incunabulum (a book printed before 1501) containing 1,809 woodcuts produced from 645 blocks. This universal history of the world was compiled from older and contemporary sources by the German physician, humanist, and historian Hartmann Schedel (1440–1514). Some of the book's maps were the first illustrations ever produced of certain cities and countries. This image, showing the descendants of the biblical Noah's son Japheth, is part of a section on the origin of tribes and nations that features numerous genealogies. Illustrations similar to this one were employed throughout the book to elucidate the highly complex familial relationships described in the text. Instead of the more common family tree, the designer here uses a peculiar botanical motif of vines to link the various family members.

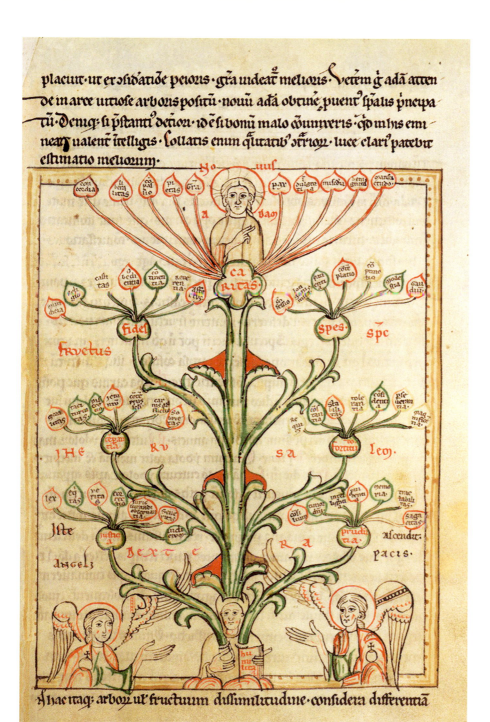

Fig. 22
Anonymous
Tree of virtues
From Conrad of Hirsau,
Speculum virginum
ca. thirteenth century

Illustration from *Speculum virginum* (Mirror for virgins), published in the first quarter of the thirteenth century and produced at the Cistercian Abbey of Himmerod in Germany. This work was one of the earliest theologies of life produced in the religious cloisters and served as a spiritual guide for nuns. The book contains twelve illustrations, including this striking tree diagram. A common theme in medieval visual exegesis, the tree of virtues depicts a set of human qualities related to heavenly morality (cardinal virtues), which could easily be understood and followed as theological lessons by its pious readers, specifically women who pursued a religious devoted life.

kings, placing the king at the peak of the scale, followed by lords and noble families, several inferior social classes, and on down to the last serf, who appeared immediately above the animals, plants, and minerals. The *scala naturae* was an obvious reflection of the feudal social stratification in place throughout Europe during the Middle Ages, further reinforcing and consolidating its artificial order. Although it maintained its influence well into our days in various manifestations of hierarchical class systems, this chain of gradations was eventually abandoned as a system of formal classification during the eighteenth century.

Other related concepts arose in the twelfth century, notably the moral tree, which consists of two complementary types: the tree of virtues and the tree of vices | *Fig.* 22. The former lists a series of human qualities related to heavenly morality (cardinal virtues); the latter, in opposition, portrays a set of qualities associated with earthly immorality (cardinal sins). This juxtaposition of good and bad provided a recurrent structure in which medieval monks could interpret and contemplate the associations between principal virtues and greater sins or vices.

The tree figure was also used during this period to convey various expressions of law, such as papal bulls or decrees, legal treatises, and the rulings and verdicts of monarchs | *Figs.* 23–24. One of the most common of these representations was the tree of consanguinity, which depicted kinship relations among family members encompassing several generations. Since marriage within seven degrees of separation was not allowed until 1215, when the number was reduced to four by the Fourth Council of the Lateran, this type of diagram was an important tool for mapping the various blood ties among relatives. Spanning hundreds of years, the tree of consanguinity can be traced as far back as the seventh century and its main progenitor, Isidore of Seville (see Timeline), and his magnum opus, *Etymologies* | *Fig.* 25.

Arising also in the twelfth century, the tree of Jesse was an immensely popular theme in Christian art and medieval iconography and important to the consolidation of the tree metaphor as a schematic representation of a genealogy. Also known as the *radix Jesse* (root of Jesse), the tree of Jesse traces Jesus's genealogy back to the father of King David, Jesse of Bethlehem. The lineage was based on various biblical references establishing Christ's descent from David, largely found in the books of Isaiah, Matthew, and Luke. This arboreal representation is normally highly stylized and decorated with sophisticated garnishing. Jesse himself is usually lying on the bottom of the tree or vine, reclining or sleeping, with twigs or branches leaving his body and tying the

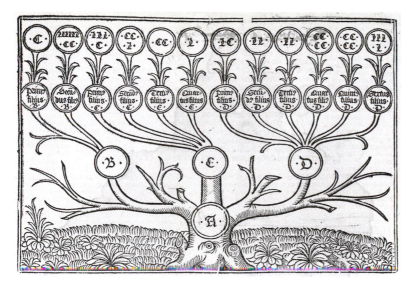

Fig. **23**

Arbor seu figura declarativa titul. De iure patro.

From Pope Clement V and Egidio Perrino, *Clementinae: Clementis Quinti Constitutiones*
1559

Part of a compendium of papal *constitutiones* (a series of formal announcements or decrees) from Pope Clement V (1305–14). This tree chart maps a series of decrees on the law of patronage. The original document contains a half page of supporting text, expanding on the various letters showcased in the diagram. Just above the tree we can read, in Latin, what translates to: "Since the matter of this title is too intricate, difficult, and quotidian: it might be easier to comprehend using the figurative art of a trunk."

Fig. **24**

Tree of substitutions

From Apud Hugonem à Porta, *Infortiatum: Pandectarum Iuris Civilis Tomus Secundus*
1552

Illustration from *Corpus Juris Civilis* (Body of civil law), also known as the Code of Justinian—arguably the most important work ever produced in jurisprudence and law history. Developed from 529 to 534 by a committee of jurists established by order of Byzantine emperor Justinian I, this fifty-book work collects a series of past laws and opinions, as well as explanatory outlines of the law and Justinian's own novel decrees. The second and most important part of this series is called *Digestum* (Digest) or *Pandectarum* (Pandect). It collects almost a millennium's worth of Roman legal thought, including opinions and fragments of legal treatises on a plethora of topics ranging from the rights of municipalities to divorce regulation. This tree diagram appears in the second part of the digest (books twenty-four through thirty-eight), entitled *Infortiatum*. It was thought to have been given this name because it consisted of a widely used section dealing with successions, substitutions, and other related matters.

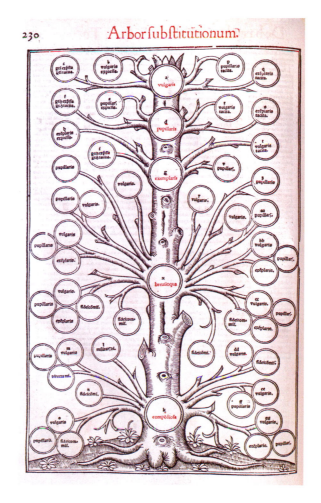

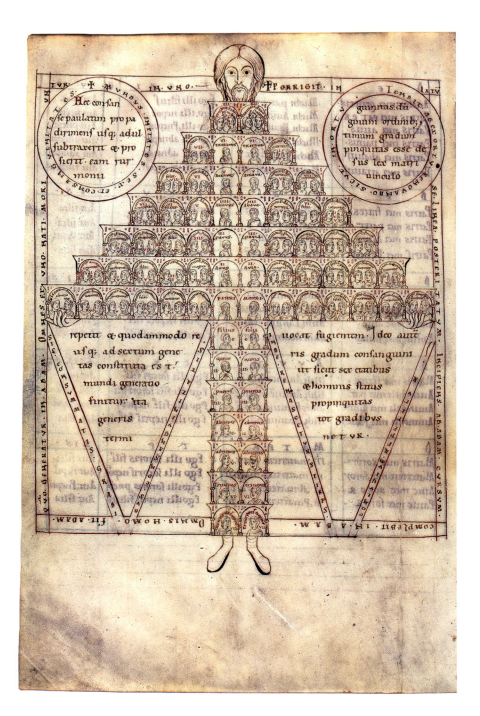

Fig. 25
Consanguinity chart
From Isidore of Seville,
Etymologies
ca. 1160–65

Chart from *Etymologies* (compiled between ca. AD 615 and 630 by Saint Isidore of Seville). Consisting of 449 chapters across twenty volumes and intended as the summa of universal knowledge, *Etymologies* formed a critical link between late antiquity and the early Middle Ages, expounding on numerous topics, such as medicine, grammar, agriculture, war, tools, law, astronomy, mathematics, and religion. From a medieval edition produced in the Prüfening Abbey in Germany in the twelfth century, this archetypal consanguinity tree shows the familial blood ties of a single person. Close family members, such as father, mother, son, and daughter, are located near the center, while more distant relatives are placed toward the periphery. Although highly stylized, this chart embraces a hierarchical, pyramidal tree layout of great complexity. Many versions of this tree, displaying various degrees of embellishment, were created in succeeding centuries, making it one of the most familiar tree archetypes (see Chapters 01 and 02).

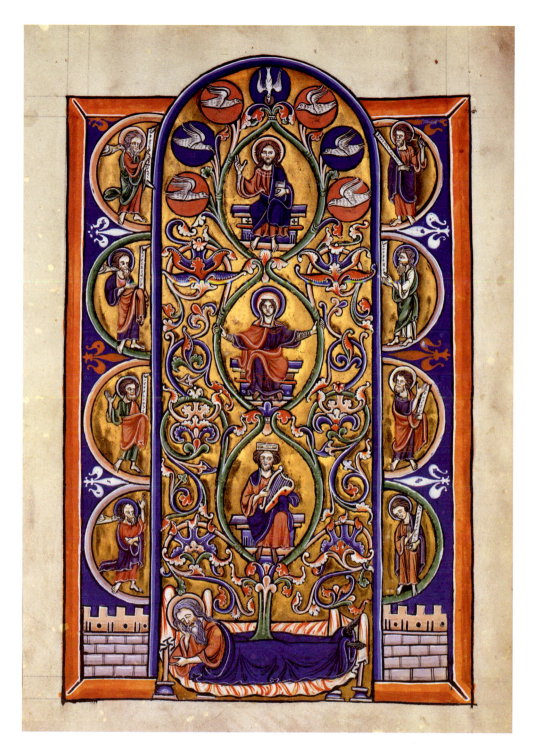

Fig. **26**
Master of the atelier of
Blanche of Castile
Tree of Jesse
ca. 1230

A beautifully ornamented tree of Jesse, from the *Psautier de Saint Louis et de Blanche de Castile*. The lineage, depicted in ascending order, consists of Jesse, Abraham, David, Mary, and Jesus Christ. The tree is flanked on both sides by Old Testament figures, such as Malachi, Daniel, and Isaiah.

various ancestors of Christ. The number of depicted figures varies greatly; there could be up to forty-three generations between Jesse and Jesus. This motif can be found in a variety of paintings, drawings, and illuminated manuscripts spanning several centuries, as well as in the ornamentation of major churches around the world, from Westminster Abbey in London, England, to Chartres Cathedral in Chartres, France | *Fig.* **26**.

Even though many figures were pivotal in the development of the exegetical tree figure during the High Middle Ages, including early scholars and encyclopedists such as Lambert of Saint-Omer and Joachim of Fiore (see Timeline), one person stands out as a progenitor: thirteenth-century Spanish scholar and philosopher Ramon Llull. There appears to be some evidence that Llull encountered the significant works of Lambert of Saint-Omer and Joachim of Fiore in his many travels. However, his passion for graphic communication seems to have started long before. "Ramon Llull clearly shared in the scholastic fascination with the way diagrams and graphic structures can be imposed on or generate texts," explains the professor of medieval culture and literature Mary Franklin-Brown. "Even early in his career, before his extensive travels, he experimented with tree figures as exegetical and didactic tools."[10] Tree figures appear in most of Llull's work, and he is known for having devised several moral trees delineating ethics, virtues, and vices, as well as different versions of the tree of Porphyry (see *Fig.* **18**). But it is in his extensive and distinctive encyclopedia *Arbor scientiae* (Tree of science), first published in 1296, that Llull distinguishes himself in the development of the tree model | *Fig.* **27**. In this magnificent compilation of sixteen trees of science, mapping a variety of knowledge domains, Llull forms a complex organizational structure made of intricate connections, where the tree represents a central element of his vision and his search for a universal science or wisdom. *Arbor scientiae* and its striking tree models became a pivotal influence through subsequent centuries, particularly on the classification systems that emerged in Renaissance Europe.

The tree metaphor continued to flourish during the Renaissance—surprisingly enough, not just in diagrammatic images and arboreal illustrations. In their written efforts to categorize knowledge, the philosophers Francis Bacon and René Descartes described dense classification arrangements in the form of trees (see Timeline). Bacon is thought to have been influenced by Ramon Llull's arboreal representations, and his own epistemological scheme in turn fostered much subsequent thinking, becoming a major inspiration for Descartes's conception of the tree of knowledge, as well as for the treelike table of contents in

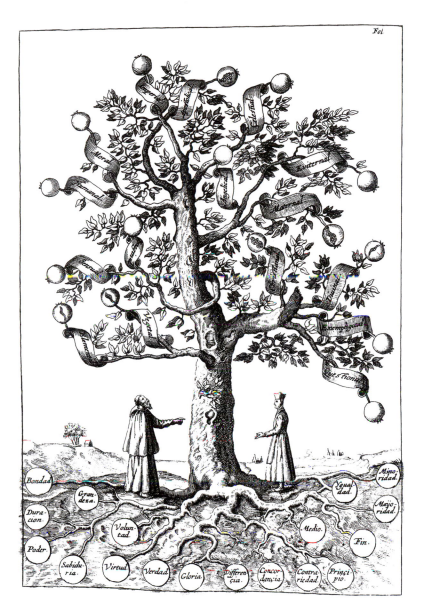

Fig. **27**

Tree of science

From Ramon Llull, *Arbol de la ciencia de el iluminado maestro Raymundo Lulio*
1663

Illustration appearing in the introduction of a 1663 Spanish edition of *Arbor scientiae (Tree of science)*, published in Brussels. This emblematic tree embodies Llull's pursuit of a universal science and serves as a table of contents for his influential encyclopedic work. While the main branches with wrapped labels represent the sixteen domains of science, each with a corresponding tree featured in subsequent pages, its eighteen roots are divided between nine divine attributes (goodness, greatness, eternity, power, wisdom, will, virtue, truth, and glory) and nine logical principles (difference, concord, contrariety, beginning, middle, end, majority, equality, and minority). The notion of a unified trunk of science has remained to this day, employed figuratively in phrases such as "the branches of science." Several versions of this tree were developed in the centuries after Llull's death, employing various design styles.

Denis Diderot and Jean le Rond d'Alembert's French *Encyclopédie*, first published in 1751 (see Chapter 01).

But it was in Enlightenment biology that the tree diagram found one of its most welcoming hosts. Marked by a rise in observational science, the Enlightenment was a time of strong eagerness for describing and categorizing the influx of novel plants and animals from the New World. Of the various classification efforts that emerged in the eighteenth century, it was the taxonomy set forth by the Swedish zoologist Carl Linnaeus (see Timeline) in his seminal *Systema Naturae* that truly revolutionized the way we sort, group, and name the species that inhabit our planet. Even though his system of biological classification and nomenclature has lasted hundreds of years, his work fell out of fashion during the Victorian era, mostly due to English naturalist Charles Darwin (see Timeline) and his famous theory of the universal common descent through an evolutionary process.

Darwin's contribution to biology—and humanity—is of incalculable value. His ideas on evolution and natural selection still bear great significance in genetics, molecular biology, and many other disparate fields. However, his legacy of information mapping has not been highlighted frequently. During the twenty years that led to the 1859 publication of *On the Origin of Species by Means of Natural Selection*, Darwin considered various notions of how the tree could represent evolutionary relationships among species that share a common ancestor. He produced a series of drawings expanding on arboreal themes; the most famous was a rough sketch drawn in the midst of a few jotted notes in 1837. Years later, his idea would eventually materialize in the crucial diagram that he called "the tree of life" and featured in the *Origin of Species* | *Fig.* **28**.

Darwin was cognizant of the significance of the tree figure as a central element in representing his theory. He took eight pages of the chapter "Natural Selection," where the diagram is featured, to expand in considerable detail on the workings of the tree and its value in understanding the concept of common descent. Furthermore, in a letter to his publisher, John Murray, sent a few months before the debut of his scientific landmark on May 31, 1859, Darwin wrote: "Enclosed is the Diagram which I wish engraved on Copper on *folding* out Plate to face latter part of volume.—It is an odd looking affair, but is *indispensable* to show the nature of the very complex affinities of past & present animals.—I have given full instructions to Engraver, but must see a Proof."[11] Here we can grasp the importance of the illustration, not as a secondary element to his narrative, but as a crucial manifestation of his thinking. As it turned out,

Fig. 28

Charles Darwin

Tree of life

From *On the Origin of Species by Means of Natural Selection*

1859

The only illustration featured in the first edition of Darwin's *On the Origin of Species*. The tree is an essential demonstration of his evolutionary thinking and the theory of universal common descent. In the base of the diagram, Darwin lists a series of hypothetical ancestral species spaced irregularly, from A to L, in order to emphasize their distinction, while above them are various branching schemes indicating subsequent varieties and subspecies. Each division along the vertical axis, from I to XIV, represents one thousand generations. Even though other trees of life tying species together had been created before by figures such as Jean-Baptiste Lamarck, Edward Hitchcock, and Heinrich Georg Bronn, Darwin was the first to introduce a mechanism of change over time, making this the first evolutionary tree of life.

it was the tree diagram, accompanied by Darwin's detailed explanations, that truly persuaded a rather reluctant and skeptical audience to accept his ground-breaking ideas.[12]

Following Darwin's embrace of the tree metaphor, the German naturalist, zoologist, philosopher, and artist Ernst Haeckel became one of the most prolific tree makers and a main promoter of the arboreal scheme as an illustration of evolutionary processes (see Timeline). Although he is perhaps better known for the stunning multicolor illustrations of animals and sea creatures in his *Kunstformen der Natur* (Art forms of nature), during his long career Haeckel created hundreds of beautifully illustrated genealogical trees relating to all life-forms (see Chapter 01). Haeckel also coined many now ubiquitous terms, such as "phylum," "ecology," and "phylogenetics" (the study of evolutionary association across different groups of organisms). Phylogenetics is a growing area of research that has proved pivotal to our contemporary classification of species. Central to its study is the phylogenetic tree: a hierarchical representation of evolutionary relationships among ranges of biological species that share a common ancestor, which is continuously being updated as new scientific knowledge comes into view.

Even as the tree diagram was in the midst of an enthusiastic revival in the biological sciences, the fields of cartography and statistical graphing—pioneered by Scottish engineer William Playfair in his seminal work *The Commercial and Political Atlas* (1786) and undergoing a burst of originality by the mid-nineteenth century—remained somehow immune to its appeal. Nonetheless, numerous depictions of trees continued to surface throughout the following decades, mapping a growing number of topics while slowly acquiring a generic nonfigurative design.

From powerful metaphors with divine associations, tree diagrams have slowly become pragmatic and utilitarian, and are nowadays predominantly the tools of computer science and the mathematical field of graph theory. It is not clear exactly when tree diagrams started abandoning their realistic, arboreal configurations and adopting more stylized, abstract constructs. Some, in fact, never did. As we can see in Chapter 01, the primeval figurative approach—spanning almost one thousand years—shows no sign of disappearing. Nevertheless, at some point, someone must have realized that the hierarchical logic of a tree could be conveyed without many of its arboreal embellishments. This must have in turn opened the door to a more abstract and diagrammatic way of thinking, causing a major shift that reverberates to this day.

Vertical and horizontal schemes were in all likelihood the first types of abstraction to appear, since they maintained a strong resemblance to actual trees. Splitting from a single point of origin (top or bottom in the case of vertical trees, left or right in the case of horizontal trees), these alternative visual models are the early progenitors of all modern node-link diagrams. Using simple lines instead of branches and common circles or squares instead of the ancient leaves or bunches of shrubbery, the descendants of these primeval node-link schemes are still widely used to depict all sorts of taxonomical data and are an integral part of many computer operating systems, allowing for the organization, display, and browsing of files and folders. Occasionally, even among the earliest tree models, a scheme does not conform to a single orientation but instead resembles the organic, multidirectional layouts widely employed now and created by means of advanced computer-generated algorithms.

Another symbol found in countless cultures, associated with notions of unity, wholeness, and infinity, the circle has been used for centuries to depict all types of concepts and information. It was therefore just a matter of time before it became a vessel for representing hierarchical structures, resulting in radial tree diagrams that take advantage of the circle's space efficiency and alluring pictorial strength.

A recent alternative to radial trees, hyperbolic trees have been popularized with the advent of computer-generated, interactive visualizations. Instead of occurring in Euclidean space, hyperbolic trees take advantage of hyperbolic space, allowing for a magnifying (or "focus and context") feature that is effective at displaying and permitting interaction with large hierarchies.

The computer, the Internet, and new algorithmically generated models have fostered an array of new methods and designs. The past two decades alone have witnessed an explosion of originality in the representation of hierarchical structures—particularly with the introduction of alternative space-filling techniques and adjacency schemes, which have expanded the benefits and functionality of older node-link diagrams. Many of these new models integrate multiple types of quantitative data attributes, such as size, length, price, time, and temperature, and they use color in a meaningful way, to indicate qualities such as type, class, gender, and category.

In the early 1990s Ben Shneiderman suggested the notion of successively decomposing a given area into ever-smaller elements, allowing for the integration of numerous hierarchical levels. This breakthrough led to the creation of the treemap—a space-filling visualization model that uses polygonal areas

and nesting to indicate different ranking levels. In a rectangular treemap, each branch or section of the tree is represented by a rectangle, which is tiled with smaller rectangles representing its subsections.

This major milestone in turn propelled the emergence of other variants. Many of the new alternatives, such as the circular treemap and the Voronoi treemap, are similar in principle to the rectangular model set forth by Shneiderman but use different polygonal constructs. But as of today, the original rectangular treemap—notwithstanding a few algorithmic tweaks and enhancements—is still the most popular of its kind and one of the most widespread methods for visualizing hierarchical structures.

Sunbursts, the area-based cousin of radial trees, probably emerged as a variant of pie charts, which explains why they are also known as multilevel pies, or, simply, nested pie charts. It's conceivable that the sunburst diagram was simply developed as a way of accommodating subdivisions of the primary sections of the pie chart (the earliest known example of which is credited to William Playfair's *Statistical Breviary* from 1801).

The last (and perhaps least-known) model is the icicle tree, also known as the icicle plot, which was developed in the early 1980s by statisticians including Beat Kleiner, John Hartigan, Joseph Kruskal, and James Landwehr. Considered the adjacency diagram counterpart of vertical and horizontal trees, icicle trees employ a series of sequential, juxtaposed rectangles to imply a given ranking, but despite their highly adaptable layout, icicle trees have not been widely employed. There have been other complementary models, such as bubble trees, cone trees, and ring trees, some venturing into tridimensional space; however, all these models have been somewhat marginal and experimental and to this day haven't proved particularly useful.

As one of the most ubiquitous and long-lasting visual metaphors, the tree figure is an extraordinary prism through which we can observe the evolution of human consciousness, ideology, culture, and society. From its entrenched roots in religious exegesis to its contemporary secular digital expressions, the multiplicity of mapped subjects cover almost every significant aspect of life throughout the centuries. But this dominant symbol is not just a remarkable example of human ingenuity in mapping information; it is also the result of a strong human desire for order, balance, hierarchy, structure, and unity. When we look at an early twenty-first-century sunburst diagram, it appears to be a species entirely distinct from a fifteenth-century figurative tree illustration. However, if we

trace its lineage back through numerous tweaks, shifts, experiments, failures, and successes, we will soon realize there's a defined line of descent constantly punctuated by examples of human skill and inventiveness.

This long succession of steps has led to a wide array of contemporary techniques for depicting and analyzing hierarchical structures. What this diversity also shows us is that there is not a right or wrong approach, but rather a choice of the most effective model for the task at hand. As with most systems we choose to map, hierarchical structures can be portrayed from various angles and by a broad number of visual methods. Like any map, a visualization is always an interpretation, a single viewpoint from which to understand the system. However, as we can witness from the examples of the Porphyrian tree, the tree of Jesse, the consanguinity tree, Llull's tree of science, and Darwin's tree of life, when sustained by a unique thesis or proposition, a visualization can become an immensely powerful tool and an enduring, contagious meme. What this book ultimately conveys, through hundreds of tree diagrams, is the power of visual aids in facilitating understanding. It shows us, simply, the power of visual communication.

A TIMELINE OF SIGNIFICANT CHARACTERS

Aristotle

(384–322 BC)

Known by medieval Muslim scholars as "the First Teacher," Aristotle was highly dedicated to the tangible world and the notion of essentialism—the presence of an immutable essence in every thing. This conception provided the foundational yearning for an absolute taxonomy of nature, in which all species could be organized in a natural hierarchy from lowest to highest. In the text *Categories*—part of a series of works on logic called *Organon* (40 BC)—Aristotle assembles every entity of human understanding under one of ten categories: substance, quantity, quality, relation, place, time, position, state, action, and affection. As the basis of his ontology, substance is the most important of the ten classes, since it is the primary characteristic on which all remaining features are predicated. Aristotle further expands his fundamental view of classification in *Topics*, by providing a list of five classifiers (predicables) of the possible relations between a predicate and its subject: *horos* (definition), *genos* (genus), *diaphora* (difference), *idion* (property), and *sumbebekos* (accident). A major influence on all subsequent classification efforts, Aristotle's syllogistic structure is not just a single-layered grouping; it implies a specific hierarchical mechanism, whereby a sequence of premises are based on an original first principle—the source of all subsequent truths.

Porphyry

(AD 234–ca. 305)

Some centuries after Aristotle's fundamental classification work, Greek philosopher and logician Porphyry further developed it in his short *Isagoge* (Introduction) to Aristotle's *Categories*. Produced between AD 268 and 270 and widely circulated throughout medieval Europe following a Latin translation by the Roman philosopher Anicius Manlius Severinus Boethius (ca. AD 480–524 or 525), *Isagoge* became a highly influential

textbook on logic, inspiring subsequent scholars such as the Muslim philosopher and polymath Averroes and the English Franciscan friar and philosopher William of Ockham.

In addition to reframing Aristotle's original fivefold list of predicables and replacing *horos* (definition) with *eidos* (species), Porphyry introduces a hierarchical scheme of classification—what became known as the Porphyrian tree, also known as *scala praedicamentalis*. Resembling an arboreal construct, the model is a diagrammatic representation of the logical division of the highest genus, or substance, into succeeding dichotomies until the *infima species* (lowest species) is reached. It essentially portrays the basis of Aristotle's proposition in a memorable, easy-to-grasp, treelike visual scheme. Even though Porphyry's original scheme is not extant, the model was continuously adapted in numerous works throughout the Middle Ages and the Renaissance. The Porphyrian tree is, as far as we know, the earliest metaphorical tree of human knowledge.

Isidore of Seville

(ca. 560–636)

Born in Cartagena, Spain, Isidore of Seville is widely considered the last scholar of the ancient world. He received his elementary education in the cathedral school of Seville and went on to become archbishop of Seville for thirty-seven years. Known for his open-mindedness and love of learning, Isidore promoted the teaching of all branches of knowledge, including the arts and medicine, in seminaries across Spain.

A master of Latin, Greek, and Hebrew, Isidore was a prolific and versatile writer, leaving behind several treatises and other works. But his most grandiose piece was the attempt to compile the summa of universal knowledge, in what became one of the most influential and revered medieval encyclopedic works. Compiled between ca. AD 615 and 630, *Etymologies* comprises twenty volumes with quotes from 154 Christian and pagan authors of antiquity. Considered a repository of classical learning on topics such as medicine, law, natural

phenomena, architecture, and agriculture, *Etymologies* is filled with remarkable illustrations and maps, including the earliest printed example of a T-O map of the world (a medieval map style representing the world as a letter *T* inside a circle). Among the illustrations are a few hierarchical schemes, notably a renowned consanguinity tree introduced for the first time by Isidore and replicated in several works throughout the succeeding centuries (see Chapter 01).

Lambert of Saint-Omer

(ca. 1061–ca. 1125)

Little is known about the French medieval scholar, Benedictine monk, and chronicler Lambert of Saint-Omer. We know that he frequented the ancient and influential monastery of Saint Bertin in northern France, as well as several prominent French schools, and was well versed in grammar, theology, and music. Lambert became a prior at Saint Bertin at a young age and in 1095 was elected abbot by the monks at the monastery and the canons of Saint-Omer. He is most famously known for *Liber floridus* (Book of flowers), compiled between the years 1090 and 1120, when he was a canon of the church of Our Lady in Saint-Omer. The book was the first of the encyclopedias of the High Middle Ages, which slowly supplanted Isidore of Seville's magnum opus *Etymologies*. Fearing that all the knowledge from previous centuries would be lost in the future, Lambert gathered a vast number of texts and manuscripts to construct a universal history of the world, divided into 161 sections on topics such as astronomy, philosophy, and natural history. This stunning work is beautifully illustrated with various charts, diagrams, and maps, including two impressive tree figures: a mystical palm tree of virtues (see Chapter 01) and a single root that splits into two horizontal trees of virtues and vices (see Chapter 03).

Joachim of Fiore

(ca. 1135–1202)

Joachim of Fiore was a Cistercian monk, mystic, and theologian known for having developed an intriguing philosophy of history based on three stages of the world: the ages of the Father, the Son, and the Holy Spirit. Following his election to abbot in the Cistercian Abbey of Corazzo, in southern Italy,

and with the direct support of several succeeding popes, Joachim spent years working on multiple volumes of biblical exegesis, before retiring to the hermitage of Pietralata and founding the monastic order of San Giovanni in Fiore. Apart from his absorbed study of the scriptures, Joachim was also a poet and talented artist, and there's no better place to contemplate his lyrical visual imagination than in the extraordinary *Liber figurarum* (Book of figures). Published posthumously in 1202 and only discovered in 1937, the book contains one of the most stunning collections of symbolic theology from the Middle Ages. Joachim's vision of the stages of history is expressed through a series of exuberant, blossoming trees depicting a variety of topics based on characters and institutions from the Old and New Testament, such as the centrality of Christ, the gradation of biblical protagonists, and the links with the past (see Chapter 01).

Ramon Llull

(ca. 1232–ca. 1315)

A prolific and multifaceted author, poet, logician, and philosopher, Ramon Llull left behind hundreds of works in Catalan, Latin, and Arabic, and was a key proponent of Neoplatonism throughout medieval Europe. He is at times considered a pioneer of computation theory for his most renowned piece, *Ars magna* (The great art). First published in 1271, this work sets the foundation of Llull's intriguing combinatorial art—a universal system of knowledge, which was later expanded by Gottfried Leibniz, in what's considered to be a distant forerunner of modern computer science.

Llull's magnificent *Arbor scientiae* (Tree of science), first published in 1296, is arguably one of his most significant contributions to information mapping. In addition to a primary tree of scientific domains that provides the structure for the whole text of the encyclopedia (see Introduction, page 37), the book has fourteen main and two supplementary trees and covers both profane (natural) and religious knowledge. Among them are the *arbor elementalis* (physics, metaphysics, and cosmology), the *arbor vegetalis* (botany and medicine), the *arbor humanalis* (anthropology and the studies of humankind), the *arbor apostolocalis* (ecclesiastical studies and the organization of the church), and the *arbor celestialis* (astronomy and astrology).

Francis Bacon

(1561–1626)

Published in 1605 by the English philosopher, scientist, statesman, and author Francis Bacon, *The Advancement of Learning* is one of the most important philosophical works written in English and a central text of scientific empiricism. With his emphasis on observation, measurement, and experimentation (moving away from traditional divine philosophy), Bacon provides an unparalleled and exhaustive systematization of the whole of human knowledge. He begins by allocating three main areas of human understanding, the roots of his system: "The parts of human learning have reference to the three parts of Man's Understanding, which is the seat of learning: History to his Memory, Poesy to his Imagination, and Philosophy to his Reason."[1] While expanding and contextualizing the remaining subcategories of these primary domains of history, poesy, and philosophy, Bacon provides an evocative reference to the great tree of knowledge, by stating that "the distributions and partitions of knowledge are not like several lines that meet in one angle, and so touch but in a point; but are like branches of a tree, that meet in a stem, which hath a dimension and quantity of entireness and continuance, before it comes to discontinue and break itself into arms and boughs."[2]

René Descartes

(1596–1650)

Known as the father of modern philosophy, René Descartes continued exploring Bacon's ideas for an arboreal organization of science, most notably in *Principia Philosophiae* (*Principles of Philosophy*). Published in 1644, the work was divided into six parts: (I) The Principles of Human Knowledge, (II) The Principles of Material Things, (III) The Visible Universe, (IV) The Earth, (V) Living Things, and (VI) Human Beings. In a letter to the French translator of *Principia Philosophiae*, expounding on the underlying logic of his principles, Descartes invokes the tree of knowledge: "All Philosophy is like a tree, of which Metaphysics is the root, Physics the trunk, and all the other sciences the branches that grow out of this trunk, which are reduced to three principal, namely, Medicine, Mechanics, and Ethics." He continues, suggesting that such a scheme also expresses a specific learning order: "It is not from the roots or the trunks of trees that we gather the fruit, but only from the extremities of their branches, so the principal utility of philosophy depends on the separate uses of its parts, which we can only learn last of all."[3]

Carl Linnaeus

(1707–78)

The Swedish botanist, physician, and zoologist Carl Linnaeus laid the foundation for the modern binominal naming of species, and his fundamental work on biological classification made him the father of modern taxonomy. The Linnaean taxonomy, as it was later called, was set forth in his *Systema Naturae* (Natural system), from 1735, and divided nature into a nested hierarchy starting with three main domains, or kingdoms: Regnum Animale (animal), Regnum Vegetabile (vegetable), and Regnum Lapideum (mineral). Each kingdom is then subdivided in sequential ranks (from highest to lowest): class, order, family, genus, and species, providing a unifying, hierarchical grouping mechanism for classification. Organisms were grouped by their shared physical traits, and despite gradual changes over the years (the most recent resulting from the disclosure of new scientific knowledge from DNA sequencing), many are still organized in arrangements similar to Linnaeus's original classification. At the time of its tenth edition, *Systema Naturae* classified 4,400 species of animals and 7,700 species of plants. One of the system's greatest innovations was its labeling of species, which abandoned the traditional unwieldy Latin names in favor of the now familiar binomial labels (composed only of two parts—genus and species) for each animal or plant.

Charles Darwin

(1809–82)

Charles Darwin was a key proponent of the tree metaphor. His only illustration in the groundbreaking *On the Origin of Species by Means of Natural Selection* was a branching tree scheme, central to his theory, which he called the "tree of life." Darwin delves into tree symbolism in order to elucidate his evolutionary idea:

The affinities of all the beings of the same class have sometimes been represented by a great tree. I believe this simile largely speaks the truth.…At each period of growth all the growing twigs have tried to branch out on all sides, and to overtop and kill the surrounding twigs and branches, in the same manner as species and groups of species have at all times overmastered other species in the great battle for life.[4]

The notion of a tree as a foundational system for the organization of species was, of course, nothing new. The botanists Augustin Augier and Nicolas Charles Seringe, the paleontologist Heinrich Georg Bronn, and the biologist Jean-Baptiste Lamarck had all explored hierarchical charts in their depictions of species. However, Darwin introduced a critical—and destabilizing—factor: time. Darwin's evolutionary tree was not a static, immutable taxonomical image of the present; it was a shifting, dynamic model, encompassing generations of change and adaptation.

Ernst Haeckel

(1834–1919)

As one of the main advocates and followers of Darwin, the German naturalist, zoologist, philosopher, physician, and illustrator Ernst Haeckel became one of the key proponents of the tree diagram as a means for mapping evolutionary ties between species. After completing his doctoral degree in medicine in 1857, Haeckel centered his efforts on zoology, and in 1862 he became a professor of comparative anatomy at the University of Jena, in Germany. In the following years Haeckel discovered, named, and described thousands of new species.

In his *Generelle Morphologie der Organismen* (General morphology of organisms), published in 1866, Haeckel explicates many of his evolutionary ideas, accompanied by several beautifully drawn trees of life, which he continued developing in many subsequent versions. While Darwin's trees were hypothetical in nature, Haeckel's more fully realized arboreal illustrations employed a meticulous biological classification method. As one of the greatest proponents of the tree figure, Haeckel was the final coalescing element in a long succession of giants—from Linnaeus to Lamarck to Darwin—whose work fostered new interest in the epistemological model of the tree and its ability to explain and communicate intricate biological processes.

Ben Shneiderman

(b.1947)

The author of several books and a professor in the Department of Computer Science, as well as a member of the Institute for Advanced Computer Studies, at the University of Maryland, College Park, the American computer scientist Ben Shneiderman is a pioneer researcher in the field of human-computer interaction, particularly in the area of information visualization.

In addition to his work in direct-manipulation interfaces, he is famously known for creating the treemap method for the representation of hierarchical data. In 1990, while trying to resolve the problem of a filled hard disk, Shneiderman decided to abandon the traditional node-link approach and instead explore a space-filling technique using a series of nested rectangles. The newly invented treemap algorithm builds a tree structure through a succession of rectangles (branches) that are then tiled with smaller rectangles (subbranches), in a recursive mechanism able to accommodate large hierarchical schemes. Shneiderman's major breakthrough has become one of the most celebrated and popular visualization models, but, most important, it has opened the door to a vast number of space-filling treemap types, fostering an enthusiastic creative burst in modern information visualization.

FIGURATIVE TREES

Trees have been not only important religious symbols for numerous cultures through the ages, but also significant metaphors for describing and organizing human knowledge. As one of the most ubiquitous visual classification systems, the tree diagram has through time embraced the most realistic and organic traits of its real, biological counterpart, using trunks, branches, and offshoots to represent connections among different entities, normally represented by leaves, fruits, or small shrubberies.

Even though tree diagrams have lost some of their lifelike features over the years, becoming ever more stylized and nonfigurative, many of their associated labels, such as roots, branches, and leaves, are still widely used. From family ties to systems of law, biological species to online discussions, their range of subjects is as expansive as their time span. The first and last images of this chapter are separated by eight hundred years—the first mapping the main characters and stories told in the Bible, the last portraying the most popular blogs of 2012—clearly indicating that despite its constant adaptation, the figurative tree shows no sign of vanishing. These early pictorial diagrams are also the predecessors of a wide array of contemporary visualization models, discussed in subsequent chapters.

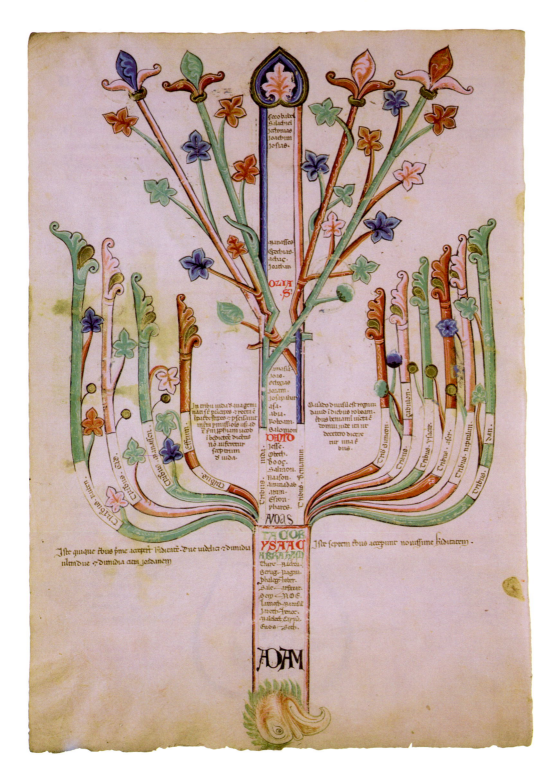

Tree-eagle

From Joachim of Fiore,
Liber figurarum (Book of figures)
1202

Illustration by the Italian abbot
and founder of the monastic order
of San Giovanni in Fiore, southern

Italy, Joachim of Fiore (ca. 1135–1202).
This remarkable figure represents the
advent of the age of the Holy Spirit.
The main trunk features a hierarchical
list of several biblical generations, from
Adam (bottom) to Zorobabel (top). The
lower branches symbolize the twelve
tribes of Israel, separated into the

tribes that first entered the promised
land (left) and the tribes that arrived
later (right). The eagle, a powerful
symbol of spiritual enlightenment and
contemplation, is prominently featured
at the base of the tree.[1]

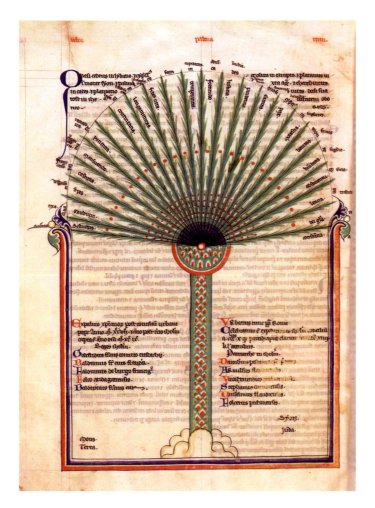

Anonymous
Tree of virtues
From *Speculum theologiae*
ca. 1300

Illustration of a tree of virtues, a recurrent medieval motif that represents human qualities related to heavenly morality (cardinal virtues). It offered a composition in which monks could understand and meditate on the associations between good principles and main virtues. The seven branches and respective fruits, pointing upward toward heaven, are based on a scriptural passage in Galatians 5:22 alluding to the seven gifts of the Holy Spirit.[2]

Tree of virtues
From Lambert of Saint-Omer,
Liber floridus (Book of flowers)
ca. 1250

Palm tree illustration from the *Liber floridus* (Book of flowers), among the oldest, most beautiful, and best-known encyclopedias of the Middle Ages. Compiled between the years 1090 and 1120 by Lambert, a canon of the church of Our Lady in Saint-Omer, the work gathers extracts from 192 different texts and manuscripts to portray a universal history or chronological record of the most significant events up to the year 1119. It is divided into 161 sections on cosmographical, biblical, and historical topics. This mystical palm tree, also known as the "palm of the church," depicts a set of virtues (fronds) sprouting from a central bulb. The palm tree was a popular early Christian figure, rich in moral and symbolic associations, often used to represent the heavens or paradise.

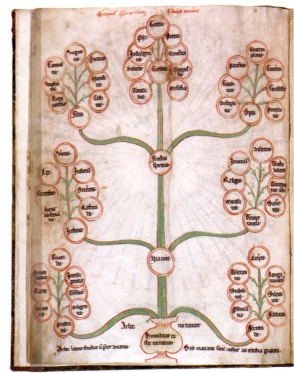

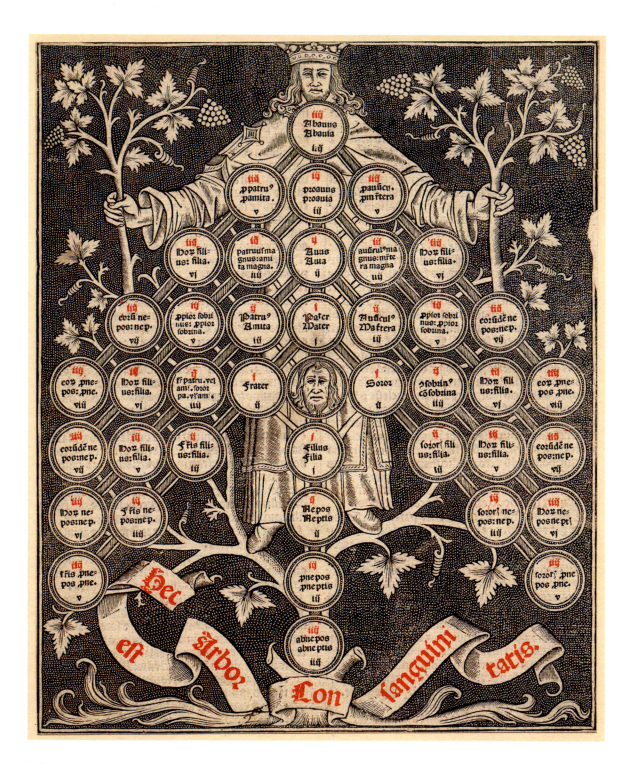

Anonymous
Tree of consanguinity
From *Decretalium copiosum argumentum*
ca. 1450–1510

A woodcut depicting the various ties between family members in the popular archetype of the tree of consanguinity. The illustration, part of a manuscript containing texts on canon law and papal decrees during the reign of Pope Gregory IX (ca. 1170–1241), features a hierarchical breakdown of blood relationships of a given person (possibly a king), who stands behind the tree while holding two of its branches. Superimposed on the traditional arboreal composition is a diagrammatic, orthogonal lattice tying together the forty-one degrees of relationship. This particular configuration of the tree of consanguinity has been explored in numerous manuscripts throughout the Middle Ages.

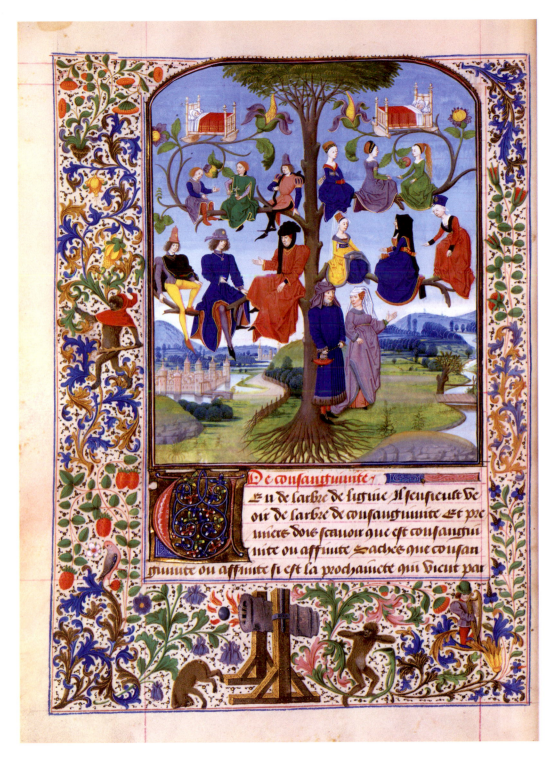

Loyset Liédet
Tree of consanguinity
1471

Illustration by Loyset Liédet (1420–79), a Dutch miniaturist and illuminator whose patrons included Philip the Good (the duke of Burgundy from 1419 to 1467) and Charles the Bold (the duke of Burgundy from 1467 to 1477). This particular illustration is part of a manuscript on jurisprudence and illustrates the various kinship relations among family members. It is accompanied by a text covering the explicit conditions of marriage, in order to avoid any risk of incest and consanguinity.

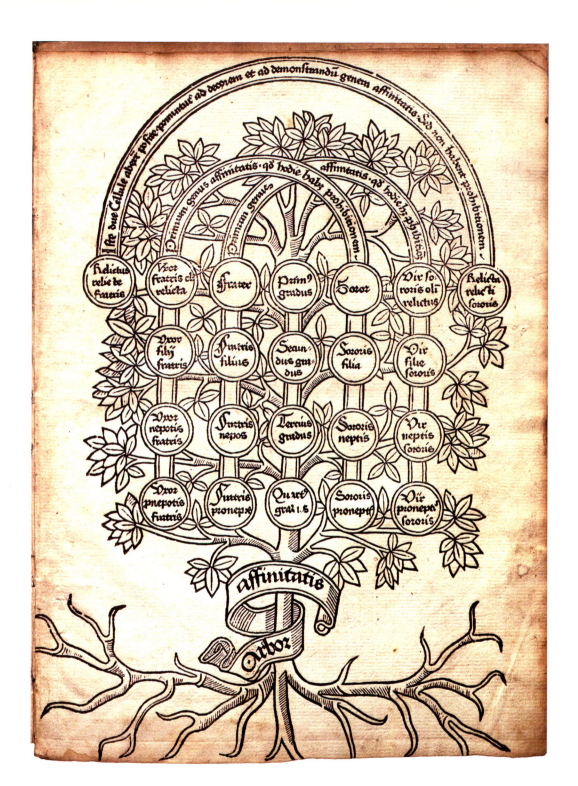

Tree of affinity

From Johannes Andreae, *Super Arboribus Consanguinitatis, Affinitatis et Cognationis Spiritualis et Legalis*
1478

A remarkable tree produced by the Italian expert in canon law Johannes Andreae (1270–1348) and published posthumously in 1478. This illustration maps laws and regulations on kinship and marriage decreed by the ecclesiastical authority of the Catholic Church. It was part of a text on the same topic that was highly esteemed in Europe; roughly forty-five editions, with occasional variations of the tree, were published before 1500.

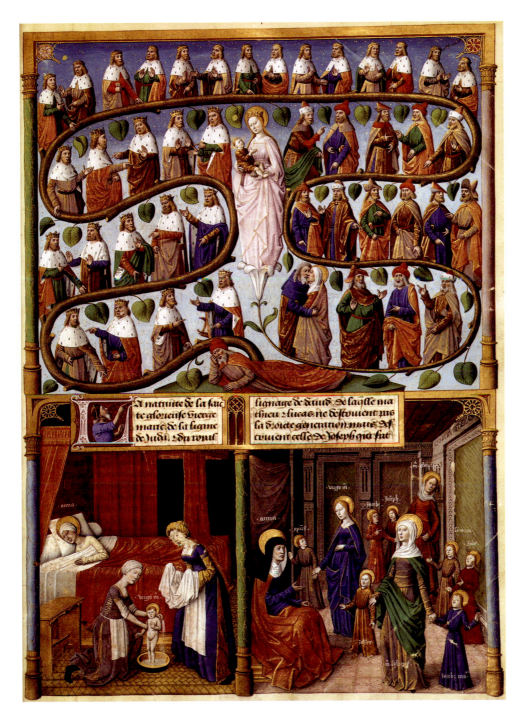

Tree of Jesse

From Jacobus de Varagine,
Legenda Aurea
ca. 1480

Illustration from *Legenda Aurea* (The Golden Legend) by the Italian chronicler and archbishop of Genoa Jacobus de Varagine, in Italian Giacomo da Varazze (ca. 1230–98), a medieval manuscript bestseller, of which hundreds of copies have survived. The book covers the lives of various saints and ecclesiastical leaders and is enriched with numerous illustrations. In this outstanding woodcut, each ancestor is placed between leaves of the single winding vine that represents the core of the genealogy. The last position before the Virgin is occupied by a couple kissing, an allusion to Mary's parents; the Virgin is depicted arising on the end of the branch in a long, white dress—evoking the flower of royalty—and holding Jesus in her arms. In the illustration's lower part, separated into two boxes, is painted the Nativity of the Virgin (left), and the holy kinship (right)—a model family, peaceful and united, with Mary holding Jesus by the hand.

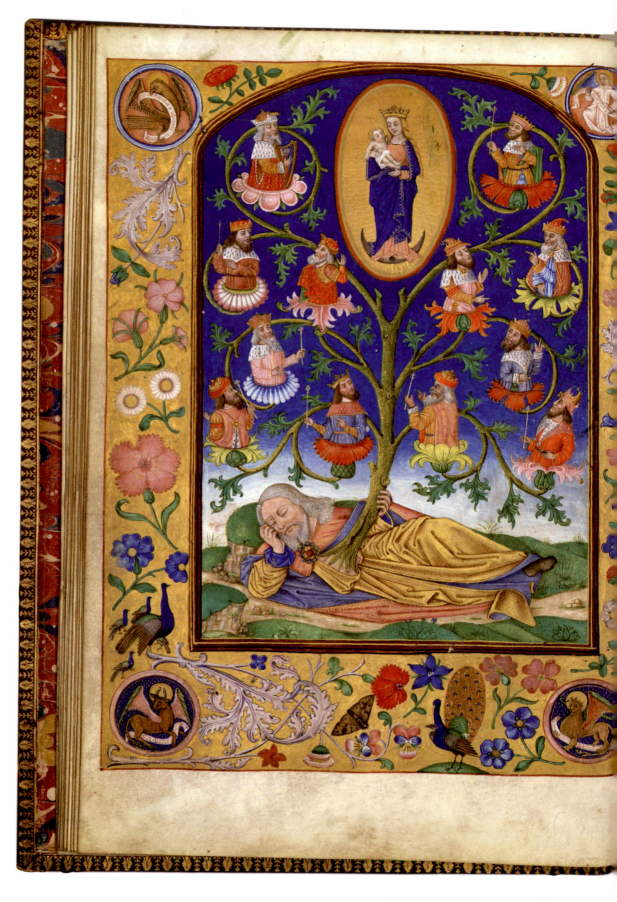

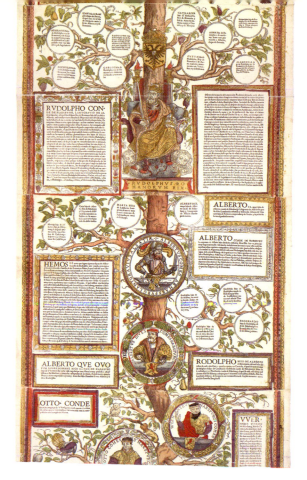

Anonymous
Tree of Jesse
From *Psautier Flamand*
ca. 1500 (opposite)

Fully illuminated page portraying the tree of Jesse, part of a richly decorated Flemish Psalter, from the library of the Irish College in Paris, and made in Bruges, Flanders, around 1500.

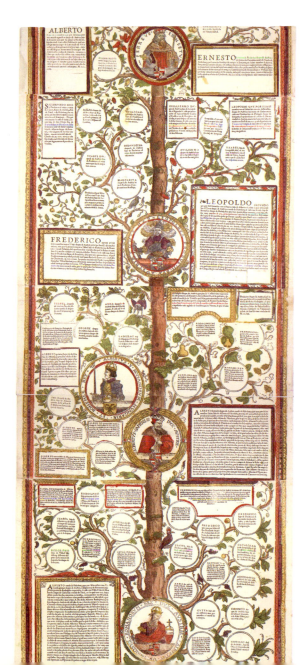

Robert Peril
Genealogical tree of the House of Habsburg
1540

An outstanding woodcut produced during the Renaissance to celebrate the genealogy of the House of Habsburg, a European royal house that ruled the Austrian Empire. Shown here are six of the twenty-two sheets that compose the full tree. This long scroll was meant to be either hung on a wall or rolled onto a flat surface for a full apprehension of its composition. The lengthy tree starts with King Pharamond (ca. 370–427) on the bottom, seated on its trunk, and ends with Charles V, Holy Roman Emperor (1500–58), on the top.

Tree of exceptions
From Apud Hugonem à Porta,
*Digestum Novum: Pandectarum
Iuris Civilis Tomus Tertius*
1551 (left)

This arboreal scheme, part of a surviving sixteenth-century edition of *Corpus Juris Civilis* (Body of civil law, see Introduction, page 33) by Apud Hugonem à Porta, maps a set of exceptions related to a particular treatise.

Tree of fiefs
From Apud Hugonem à Porta,
Volumen: hoc complectitur
1553 (right)

An integral part of *Corpus Juris Civilis* (Body of civil law) appearing in the *Codex Justinianus* (Code of Justinian), the first part of the work. The *Codex Justinianus* contains a thorough list of the existing imperial *constitutiones* (formal announcements or decrees), in respect to various topics, particularly laws on religion and mandates against heresy and paganism. This illustration shows an arboreal scheme of fiefs (fees or feudal tenures) and is followed by seven pages of detailed feudal legislation as it relates to this diagram.

Genealogical tree of Charles Magius
From Paul Veronese, *Codex Magius*
1568–73 (opposite)

Part of an eighteen-page manuscript featuring a series of highly finished miniature paintings on vellum describing the adventures and misfortunes of the noble Venetian Charles Magius, also known as Carlo Maggi. This tree depicts Magius's lineage.

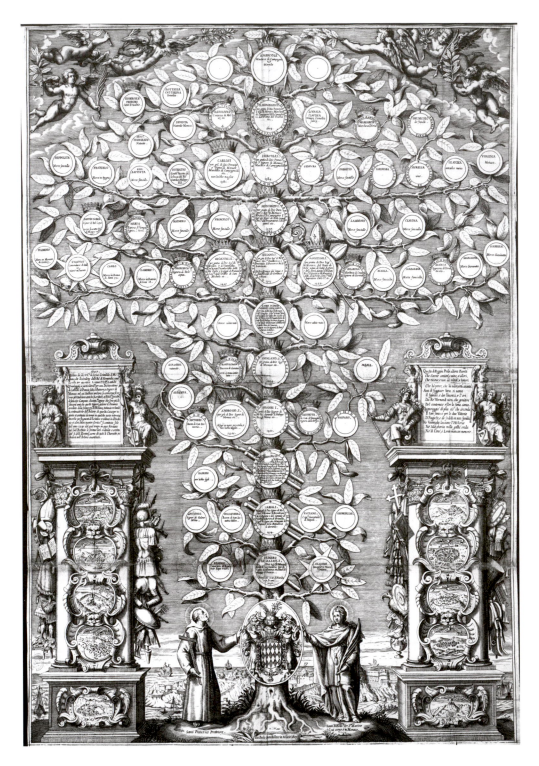

Giovanni Paolo Bianchi
Genealogical tree of the House of Grimaldi
1627

Genealogical tree created by Giovanni Paolo Bianchi, a Milanese printmaker, engraver, and draftsman. Descending from Grimaldo, a Genoese statesman born in the twelfth century, the Grimaldi are a prominent dynasty associated with the Republic of Genoa, Italy, and the current ruling family of Monaco. This illustration ties the various ancestors of the House of Grimaldi, starting with Rainier I of Monaco, Lord of Cagnes (1267–1314), at the very bottom of the tree, to Honoré II, Prince of Monaco (1597–1662).

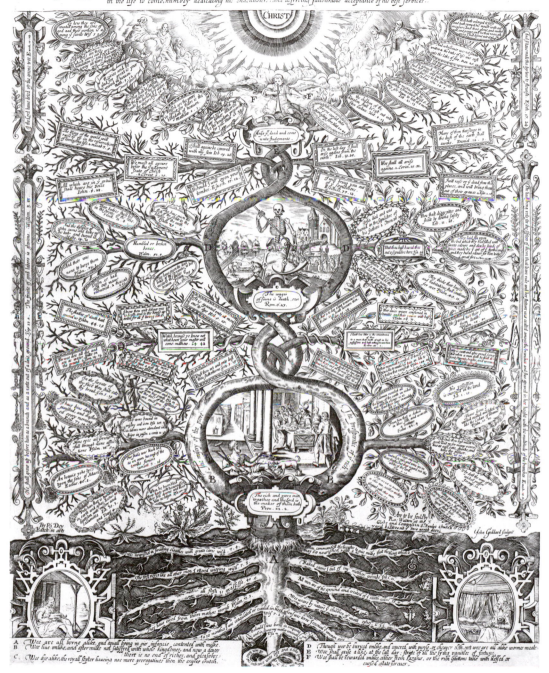

John Goddard

The Tree of Man's Life

ca. 1639–50

Impressive composition by the engraver John Goddard, summarizing the various events of a man's life through the shape of an enormous tree ascending to the skies. The tree's trunk bifurcates and twirls to frame two scenes: death with a scythe in a burial setting (above) and the biblical parable of the rich man and Lazarus (below). Underground, on both sides of the tree's roots, two complementary scenes are depicted: a poor woman nursing her baby (left) and a rich woman breast-feeding her child (right). In the heavens above appears the irradiated name of Christ. The tree's roots, branches, and leaves are filled with scriptural passages and inscriptions.

© The Trustees of the British Museum. All rights reserved.

Livius Tagocius

Genealogical tree of the Portuguese monarchy

1641

Family tree of the kings of Portugal, from King Afonso I (1109–85), commonly known as Afonso Henriques, to King João IV

© National Library of Portugal. From E. 909 A.

Simon Fyodorovich Ushakov
Praise to icons of Virgin Mary of Vladimir
ca. 1668

Tree by the Russian graphic artist Simon Ushakov (1625–86), depicting Our Lady of Vladimir, or the Virgin of Vladimir, one of the most revered Orthodox icons and a great example of Eleusa Byzantine iconography. The Virgin is placed at the very center of the tree, surrounded by Russian state figures.

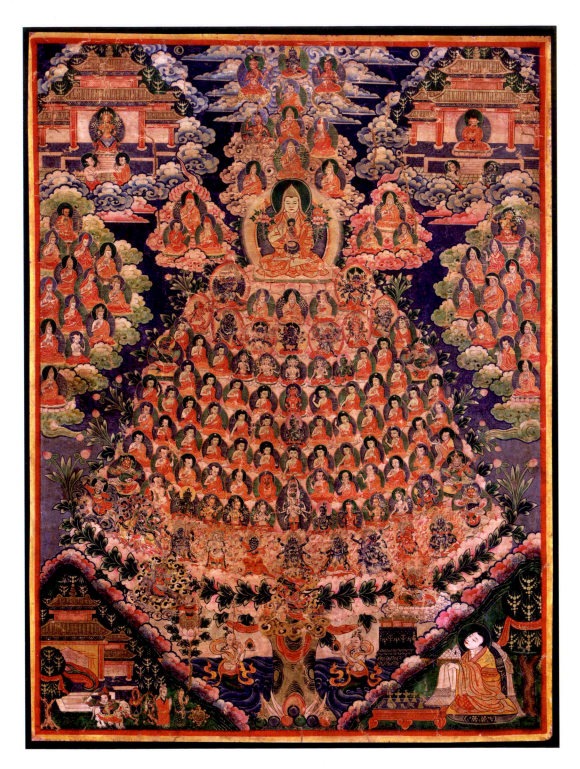

Anonymous
Gelug lineage refuge tree
ca. eighteenth century

A Tibetan *thangka* depicting a refuge tree of the Gelug lineage. In Tibetan Buddhism, a refuge tree, refuge field, or merit field is normally a representation of a lineage of gurus and their respective denominations, sects, and disciplic successions. *Thangkas* that trace lineage and transmission of teachings in this type of visual mind map are used as mnemonic devices to improve meditative visualization. This particular *thangka* depicts the lineage of the dominant Gelug school of Buddhism, founded by Je Tsongkhapa.
© Rubin Museum of Art / Art Resource, New York

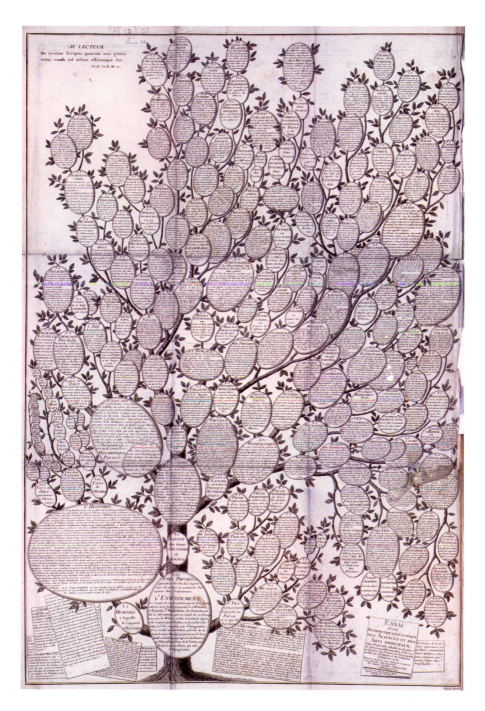

Chrétien Frederic Guillaume Roth
***Essai d'une distribution
généalogique des sciences et
des arts principaux* (Genealogical
distribution of arts and sciences)**
From Denis Diderot and Jean
le Rond d'Alembert, *Encyclopédie*
1780

 A remarkable tree featured as a
foldout frontispiece in a later 1780
edition of the French *Encyclopédie*,

by Denis Diderot and Jean le Rond
d'Alembert, first published in 1751.
The *Encyclopédie, ou dictionnaire
raisonné des sciences, des arts et des
métiers* (Encyclopedia, or a systematic
dictionary of the sciences, arts, and
crafts) was a bastion of the French
Enlightenment and one of the largest
encyclopedias produced at that time.
It consisted of 3,129 illustrations and
twenty million words in 71,818 articles
over thirty-five volumes. The tree

depicts a genealogical structure of
knowledge, with its three prominent
branches following the classification
set forth by Francis Bacon in *The
Advancement of Learning* (1605):
memory and history (left), reason and
philosophy (center), and imagination
and poetry (right). The tree bears fruit
in the form of roundels of varying sizes,
representing the domains of science
known to man and featured in the
encyclopedia.

Vicente José Ferreira Cardoso
da Costa
Portuguese civil code
1822

Tree diagram given as a gift to the first Portuguese parliament, following the liberal revolution of 1820. Vicente José Ferreira Cardoso da Costa (1765–1834) was a Portuguese jurist, magistrate, politician, intellectual, and author of numerous works on law and politics. On the left (the front side of the tree) he places a series of obligations ("Law of Obligations"), such as "Honor Your Father," "Do Not Kill," and "Do Not Commit Adultery." On the right (the back side of the tree) he lists a series of rights ("Property Law"), such as "Not to Be Stolen," or "Not to Be Killed."

W. Jillard Hort
The Mythological Tree
From *The New Pantheon; or an Introduction to the Mythology of the Ancients*
1825

Tree that served as the frontispiece to the title above, illustrating the relationships among famous figures from Greek and Roman mythology, including Jupiter, Juno, Pluto, Cupid, Nemesis, and Apollo.

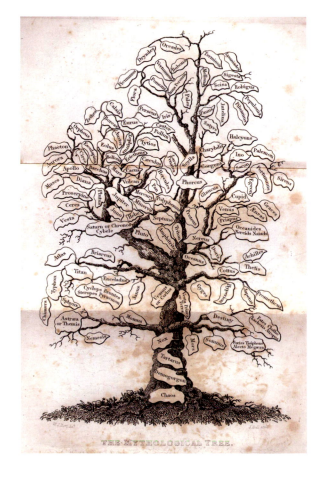

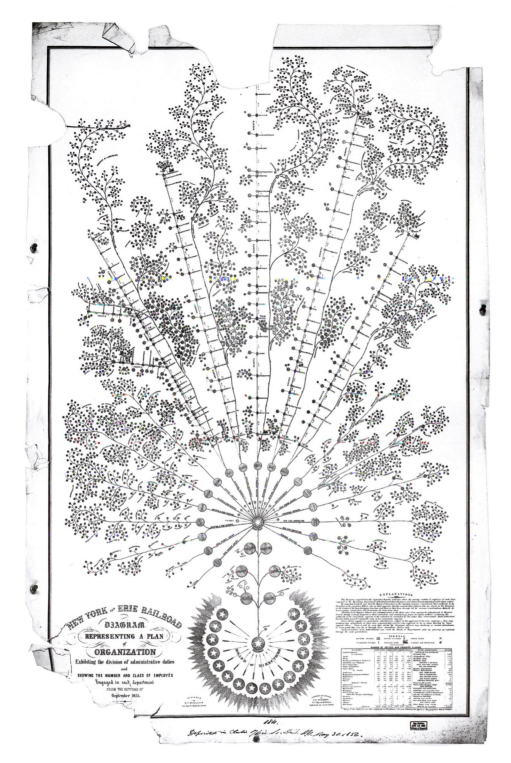

Daniel Craig McCallum

Plan of Organization of New York and Erie Railroad

1855

Diagram viewed by economists as one of the first organizational charts. This plan represents the division of administrative duties and the number and class of employees engaged in each department of the New York and Erie Railroad. Developed by the railroad's manager, the engineer Daniel Craig McCallum, and his associates, the scheme features a total of 4,715 employees distributed among its five main branches (operating divisions) and remaining boughs (passenger and freight departments). At the roots of the imposing tree, in a circular, are the president and the board of directors.

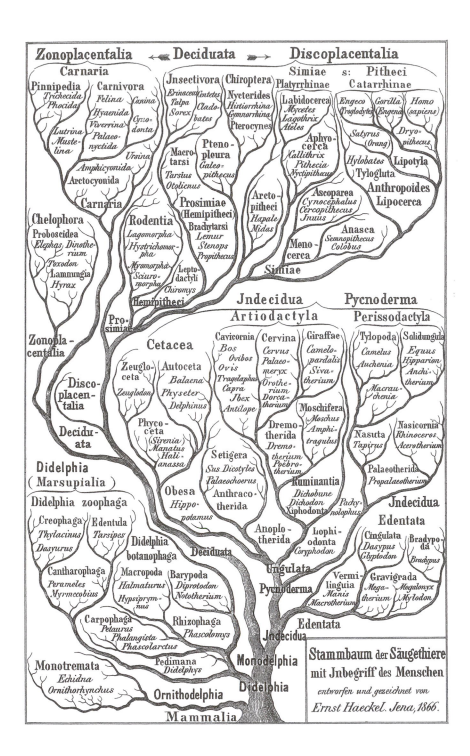

Ernst Haeckel

Family tree of mammals

From *Generelle Morphologie der Organismen*
1866

Illustration from *Generelle Morphologie der Organismen*, by Ernst Haeckel, an attempt to elaborate on the biological reform and evolutionary ideas set forward by Darwin in *On the Origin of Species* (1859). The work aims to provide a natural system of biological categorization, drawing on Lamarck's and Darwin's principles of descent and selection. It is embellished with a number of remarkable tree illustrations describing the evolution of worms, mollusks, and medusas, among others. This image represents one of the first detailed evolutionary trees organizing all mammals, including humans, into families, genera, and species, on the basis of progressive skeletonization.

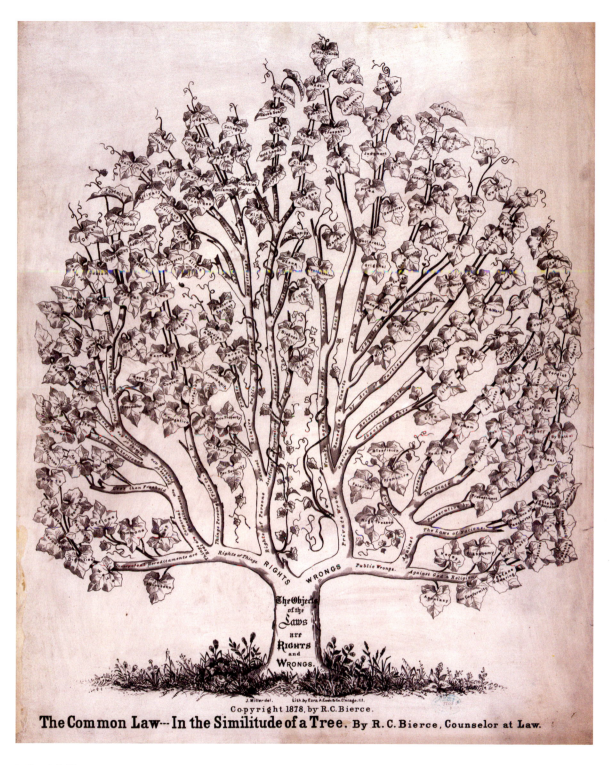

The Common Law---In the Similitude of a Tree. By R. C. Bierce, Counselor at Law.

Copyright 1878, by R.C. Bierce.

J. Miller del. Lith. by Ezra A. Cook & Co. Chicago, Ill.

Royal C. Bierce

The Common Law—In the Similitude of a Tree
1878

Tree created by Royal Bierce, born in Connecticut in 1808, describing common law. After moving with his family to Portage County, Ohio, Bierce studied law with John Crowell and later became a lawyer himself. This tree diagram illustrates Sir William Blackstone's *Commentaries on the Law of England* (1765–69), an influential treatise widely regarded as the leading work on the development of English law and subsequently in the development of the American legal system. The tree has two major branches for the "rights" and "wrongs" of the law, which are then divided into topics following the outline of Blackstone's *Commentaries*. It was probably produced as a visual aid to study Blackstone's landmark work.

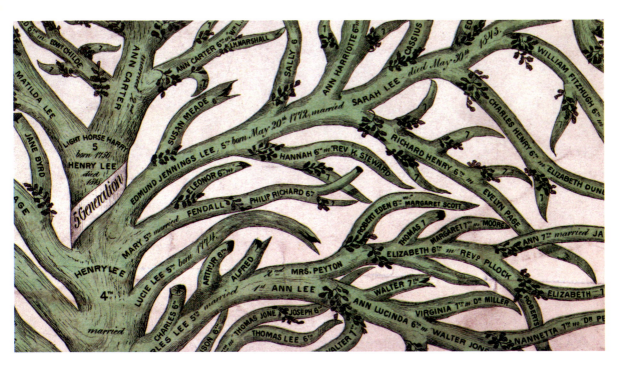

Hattie Mann Marshall
**Genealogy of the Lee family
of Virginia and Maryland**
1886

A beautifully illustrated genealogical
tree, whose pedestal reads: "This
tree, with its 460 limbs, contains
the Genealogy of the Lee Family—
descended from Col. Richard Lee,
of Virginia. Each generation is
represented by a distinct branch, and
its descendants by smaller off-shoots.
Where one has died, a broken limb
remains as a memento. The roots
represent those antique progenitors,
who, being far remote, have long since
passed from memory's page; while the
twining vine, in each circuit around
the trunk, marks the time when each
generation gave place to its successor."

Anonymous
The Petroleum Tree
1957

Diagram produced in 1957 by Socony-Vacuum Oil Company, later known as Mobil, which then merged with Exxon in 1999. This tree maps the numerous subproducts and uses of crude oil, most of which had emerged in the first half of the twentieth century.

Karl Kempf
The Computer Tree
From Electronic Computers within the Ordnance Corps
1961

Evolutionary tree of electronic digital computers from 1945 to the 1960s. This illustration is part of a monograph on the innovative contributions of the US Army Ordnance Corps in the field of automatic electronic computing systems between 1942 and 1961. At the base of the tree's trunk is ENIAC, the world's first electronic general-purpose computer. The trunk divides into three distinct limbs, the two most prominent ones representing EDVAC and ORDVAC, which subsequently originated several new branches.

Ernst Kleiberg, Huub van de
Wetering, and Jarke J. van Wijk
**Botanical Visualization of Huge
Hierarchies**
2001

A computer-generated three-
dimensional tree representation, used
to visualize the directory structure of
a hard disk. Folders are mapped onto
branches, while sets of files in a folder
are shown as spheres (fruits) with
colored cones depicting individual
files. This project, driven by advanced
computer-generated algorithms
and fed by large amounts of data,
is a milestone in the contemporary
development of the tree metaphor.

Yugo Nakamura
Ecotonoha
2003

A pioneering and widely popular interactive online visualization created by Yugo Nakamura for NEC Corporation in 2003. The core of the project was a virtual tree that users could nurture collaboratively, by leaving text messages that transformed into green typographical leaves. They also could interact with trees created in the past and even use them as computer screen savers. By making virtual trees grow within the Ecotonoha virtual environment, users were helping the real environment to cope with global warming, as NEC planted real trees on Kangaroo Island in Australia. More than six hundred were planted during Ecotonoha's prolonged online existence.

Hans van der Riet
On Bots
2006

A tree visualization of 105,971 web pages traced over one year with Yahoo!'s web crawler Slurp. Yahoo! Slurp was an Internet bot that continuously browsed the World Wide Web looking for new pages to index. Each page is depicted as a line (branch) whose length is based on the number of times the bot visited the page. The project included a comparison among the main commercial web crawlers at the time (Yahoo! Slurp, Googlebot, and msnbot), producing a unique tree for each. The authors found Slurp to be the most active bot, crawling more than a hundred thousand nodes in a year.

Alessandro Capozzo (TODO)
OneWord
2006

An interactive visualization that gathers text messages and displays them as part of a dynamic tree structure. The tool can be used during large-scale public events in order to display a crowd's collective voice. Single-word text messages are sent to a predetermined number. As new messages arrive, the software generates new branches with the word, creating over time a dense textual foliage of words.

Minivegas and Heimat Berlin
CNN Ecosphere Project
2011

A graphical representation of the Twitter discussion surrounding the United Nations Conference on Sustainable Development, also know as Earth Summit 2012 and hosted in Rio de Janeiro, Brazil. To create this abstract global forest, the authors constructed a "digital ecosphere," where trees representing topics and conversations at the conference would sprout in a dynamic, three-dimensional globe. Trees of different colors (indicative of distinct categories) are made up of individual tweets using the #cop17 hashtag. During the conference, the Ecosphere website was projected on a wall as an installation, which allowed the various delegates present to become active nodes in the global climate discussion.

Juan Osborne
In Obama's Words
2011

Visualization of the words used in eight hundred of US president Barack Obama's speeches from January 2009 to November 2011. These words were isolated from any remaining text (mostly containing words from other people or press questions). Using custom tools, Juan Osborne analyzed the most-used words in these "cleaned" speeches as well as combinations of two and three significant words. Words were sized according to the number of times they appeared and were plotted in an arboreal layout, with less frequently used words placed farther from the main trunk in a succession of increasingly smaller branches.

Lolcat

"keep" "delete"

THE KEPT

The 100 longest **Article for Deletion (AfD)** discussions on Wikipedia,
which did **not** result in deletion of the article (i.e. it was kept, merged or redirected).

Moritz Stefaner, Dario Taraborelli,
and Giovanni Luca Ciampaglia
Notabilia
2011

A visualization of the one hundred
longest online discussions on Wikipedia
articles up for deletion. The basis of the
user-generated online encyclopedia
Wikipedia is a collaborative editing
process, with occasional discussions
on whether a given article should be
deleted. These discussions last for
at least seven days, until consensus
is reached on which of a series of
proposed actions (such as keep, merge,
rename, or delete) should be performed
on a page. Starting from a common
root, this visualization maps each
one hundred articles as an individual
branch, with color segments and shape
determined by the sequence of "keep"
(green) and "delete" (purple) votes. The
final arch of each branch indicates the
voting results, bending toward either
the left (keep) or the right (delete).

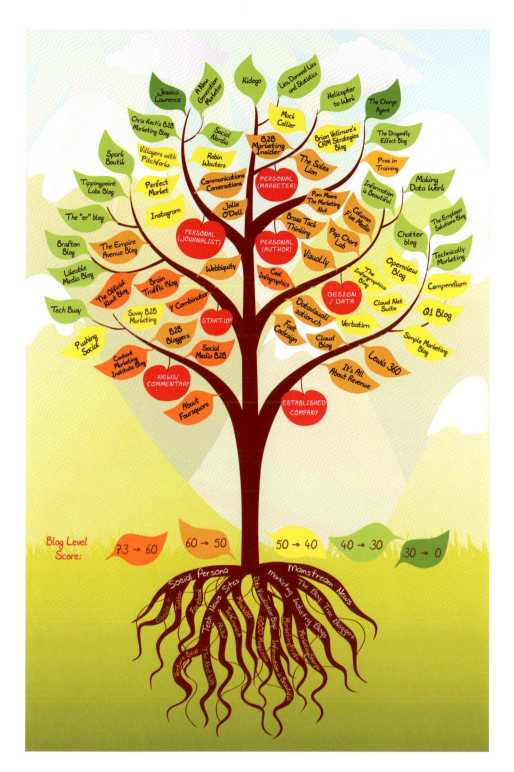

Blog Level Score:
73 → 60 | 60 → 50 | 50 → 40 | 40 → 30 | 30 → 0

Leslie Bradshaw, Jesse Thomas, Tiffany Farrant-Gonzalez, Joe Chernov, and Jesse Noyes
The Blog Tree: New Growth
2012

A tree of connections among a group of popular, recently launched blogs. The marketing firm Eloqua, partnering with the creative agency JESS3, took a holistic look at the dynamic marketing blogosphere in this colorful diagram, evocative of earlier medieval executions. Each blog is represented as a leaf, its color indicating a specific ranking determined by traffic to the site, from orange (high score) to dark green (low score). Blogs are grouped on different branches by categories depicted as red fruits, including "start-up" and "design/data."

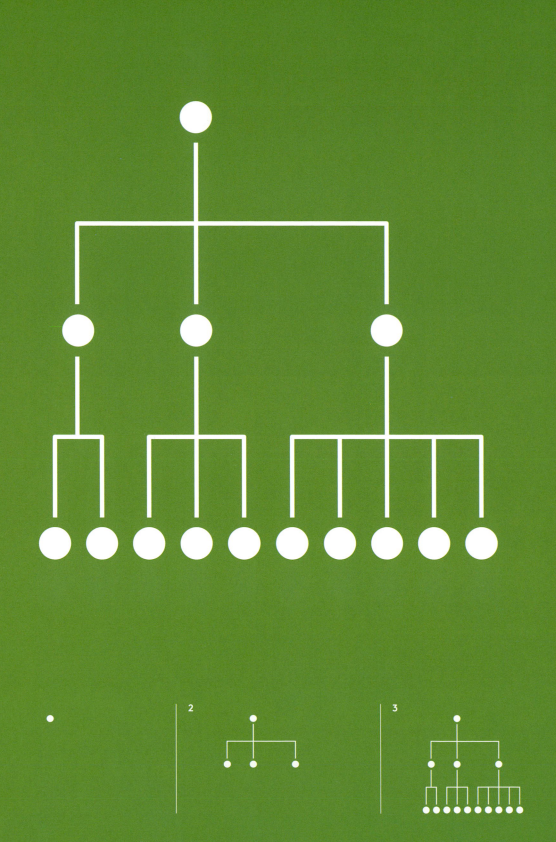

VERTICAL TREES

The transition from realistic trees to more stylized, abstract constructs was a natural progression in the development of hierarchical representations, and a vertical scheme splitting from top or bottom was an obvious structural choice. Even though many of these illustrations have lost their literal leaves and shrubberies, their branches have persisted—albeit with a more schematic look, tying individual entities that are commonly represented by circles, squares, or other simplified polygonal shapes.

Of all visualization models, vertical trees are the ones that retain the strongest resemblance to figurative trees, due to their vertical layout and forking arrangement from a central trunk. In most cases they are inverted trees, with the root at the top, emphasizing the notion of descent and representing a more natural writing pattern from top to bottom. Although today they are largely constrained to small digital screens and displays, vertical trees in the past were often designed in larger formats such as long parchment scrolls and folding charts that could provide a great level of detail. These long vertical trees were frequently hung as wall posters for attentive study and analysis.

As one of the most familiar kinds of node-link diagrams, the vertical tree graph is now widely used to depict taxonomical knowledge, in various renditions of organizational charts, family trees, decision trees, evolutionary trees, diagrams of file systems, and site maps.

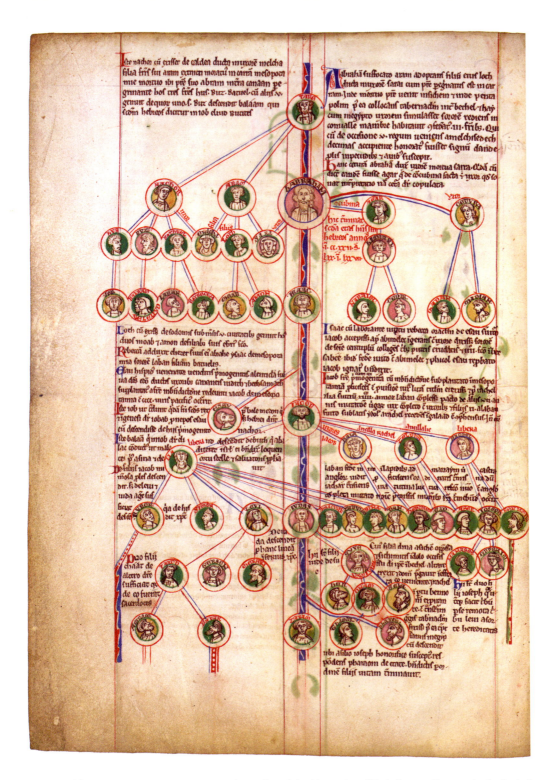

Peter of Poitiers
Genealogy of Christ
ca. 1130–1205

Part of a remarkable early thirteenth-century parchment scroll by the French scholastic theologian and chancellor of the University of Paris from 1193 to 1205, Peter of Poitiers. The long scroll shows the genealogy of Christ in descending order through a series of connected portraits in roundels, accompanied by text explaining the historical background of Christ's lineage. It also includes several biblical passages, including the stories of Adam and Eve, Noah's ark, the crucifixion, and the resurrection. The roll was designed as a visual teaching aid for use in the classroom, and it's a compelling example of medieval visual exegesis.

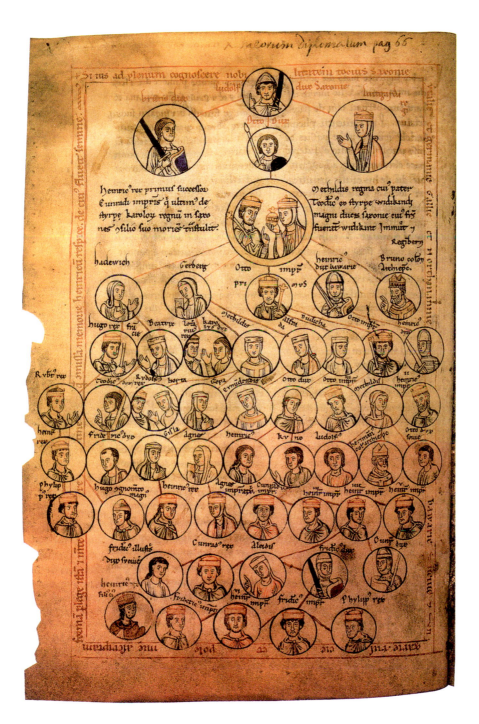

Anonymous
Genealogy of the Ottonians
ca. twelfth century

Vertical tree representation of the Ottonians (also known as the Liudolfings after the earliest member, Liudolf), a dynasty of German kings (919–1024) seen as the successors of the Frankish Carolingian dynasty (750–887). This diagram is part of a manuscript known as *Chronica regia Coloniensis* (Royal chronicle of Cologne) that was produced by an unidentified canon of Cologne, Germany. The manuscript is essentially a Latin prose chronicle of the kings and emperors of the Roman (German) Empire, but it also contains a wealth of historical information on the region of the Electorate of Cologne.

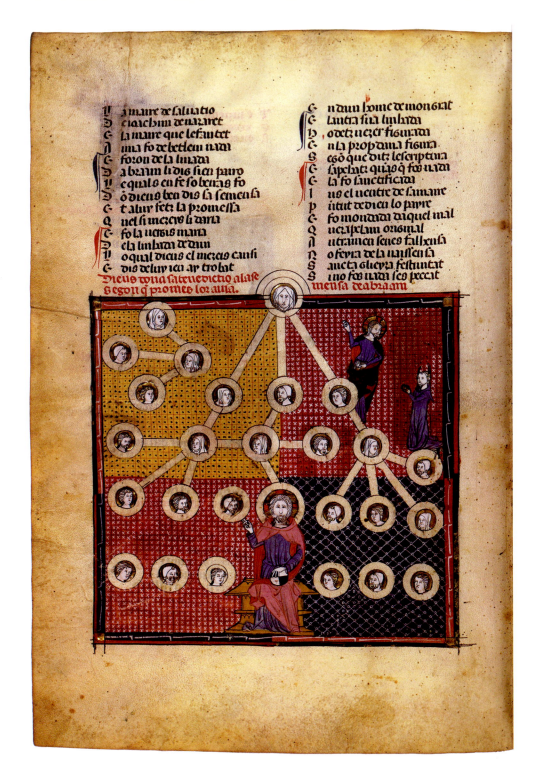

Genealogy of Christ
From Matfre Ermengaud,
Le Breviari d'amor
ca. fourteenth century

Chart from one of the most famous works of Matfre Ermengaud, a Franciscan friar and legist from Béziers, in southern France. *Le Breviari d'amor* (The breviary of love), begun in 1288, was a lengthy medieval Occitan grammar containing close to thirty-five thousand lines of verse. Comprising twelve full manuscripts, the work is divided into parts and reads as an encyclopedic poem. It covers various themes of popular Christian theology, including creation, the Trinity, and natural law. This chart depicting the genealogy of Christ is from a section on the love of God, which covers different Christian creeds, biographies of saints and ecclesiastical leaders, and the life of Christ.

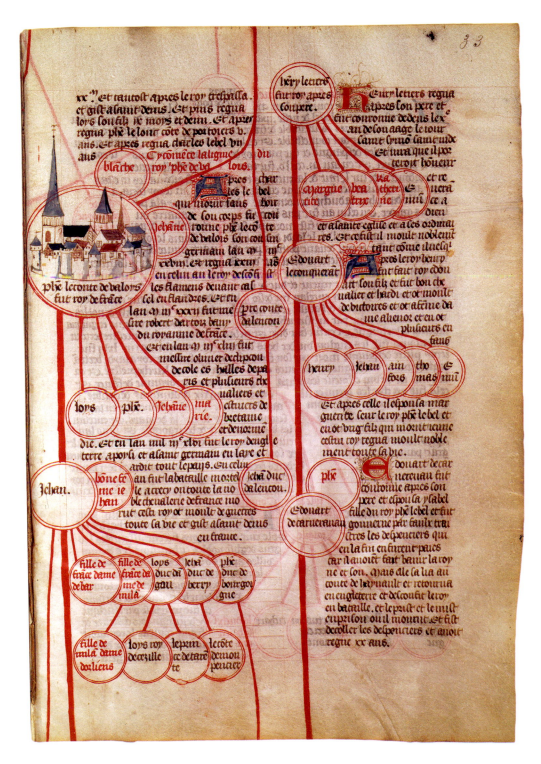

Anonymous
La Chronique Universelle
ca. 1440

A remarkable chart, part of a fully illustrated thirty-three-foot-long fifteenth-century French manuscript scroll, known to modern scholars by its generic title *La Chronique Universelle* (The universal chronicle). Created in a workshop in the Loire Valley of central France in 1440, the chronicle draws on sacred and secular sources to describe the history of the world through a series of parallel genealogies tying together biblical stories, ancient Greece and Rome, and the royal houses of France and England. This beautifully illustrated work proved quite popular in medieval Europe and was copied at least thirty-four times.

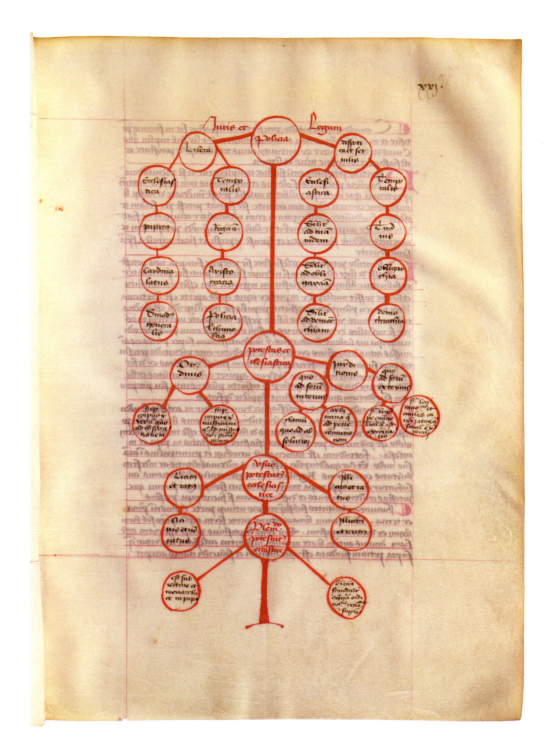

Jean de Charlier de Gerson
Arbor de origine juris et legum (Tree on the origin of law and statues)
ca. 1450

Diagram by Jean de Charlier de Gerson (1363–1429), a French scholar, educator, and poet widely recognized by contemporaries as one of the most powerful theologians of his generation.

He was also an eminent orator and a strong advocate of the clear exposition of the principles of theology. Gerson wanted to make theology plain and simple, and like the renowned scholastic philosopher William of Ockham, he embraced the philosophical principles of nominalism—the belief in real individuals and the rejection of metaphysical universals or abstract entities. Visual

exegesis—ideal for communicating the inherent complexities of theological themes in a clear, comprehensible way—must have been a useful tool for expressing Gerson's ideological beliefs. In this diagram, part of Gerson's *On Ecclesiastical Power*, he depicts the entire system of human justice in a schematic vertical tree.

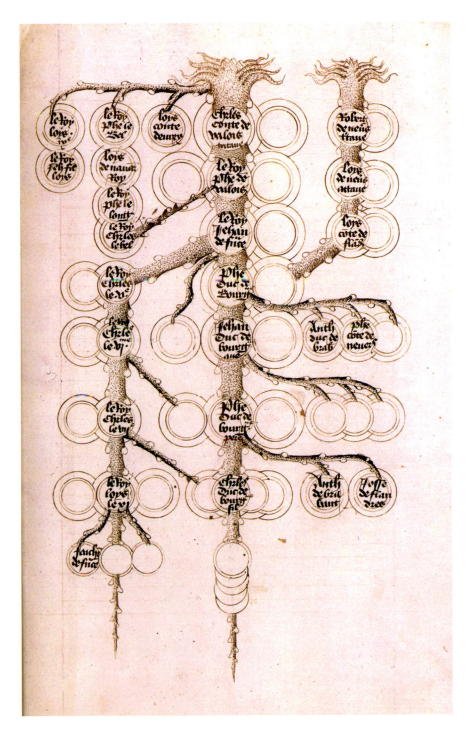

Jean Miélot
Genealogical tree of Charles the Bold
ca. 1468

Vertical tree diagram by Jean Miélot, an author, scribe, priest, and manuscript illuminator born in Gueschard, between Abbeville and Hesdin, in the north of France. Between 1449 and 1467 Miélot worked for Philip the Good, Duke of Burgundy, in the translation of many works from Latin or Italian into French, as well as in the production of new material for his own titles. In 1468, the estimated date of this figure, Miélot became the chaplain of Louis de Luxembourg, Count of St. Pol. In this illustration Miélot depicts the genealogy of the last Valois duke of Burgundy, Charles the Bold, also known as Charles the Rash (in French, Charles le Téméraire); it was created following the death of Charles's father and Miélot's former employer, Philip the Good. This illustration, despite still exhibiting a noticeable arboreal influence, displays the more diagrammatic and structured style characteristic of many subsequent vertical tree models.

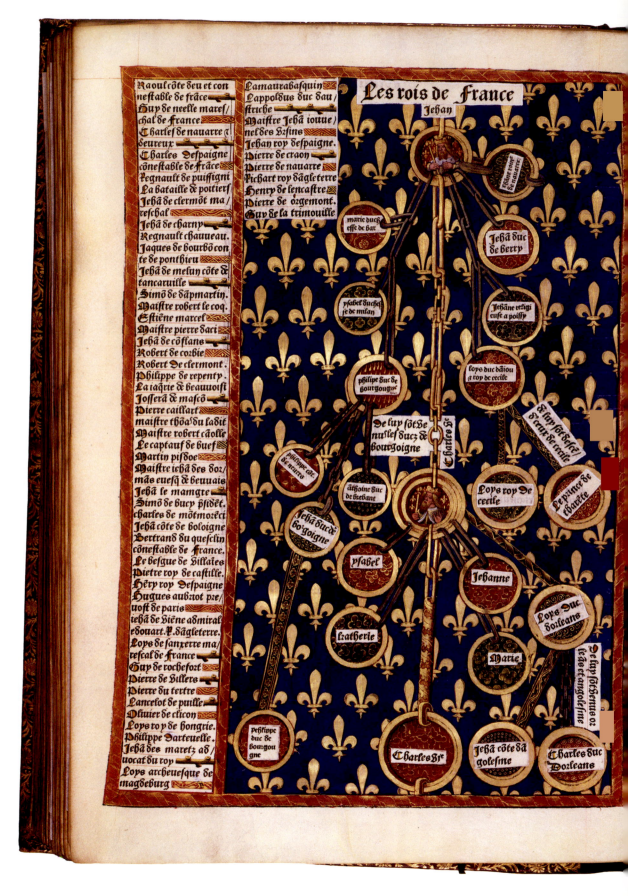

John Bunyan

**A Mapp Shewing the Order &
Causes of Salvation & Damnation**
1691

A diagram by the English Christian
writer and preacher John Bunyan
comparing and contrasting different
ways of life (originally published in
1664). The vertical tree starts with the
Holy Trinity at the top and then splits
into two branches: the line of grace and
salvation (on the left) leading to heaven
and the line of justice and damnation
(on the right) leading to hell. The series
of connected roundels on both sides
feature various scriptural quotations
related to each line of conduct.
© The Trustees of the British Museum.
All rights reserved.

Tree of consanguinity
From Petrus Murillo, *Cursus Juris
Canonici, Hispani, et Indici*
1763

Consanguinity tree by the Spanish
missionary, jurist, cartographer,
historian, and poet Petrus Murillo (1696–
1753). This tree starts with the subject's
great-great-grandmother at the very
top and maps all direct descendants in
its central column: great-grandmother,
grandmother, mother, "Petrus" (the
central figure of the tree), daughter,
granddaughter, great-granddaughter,
and, finally, great-great-granddaughter.
The lateral columns map all other types
of relatives, for example sisters, aunts,
and nieces.

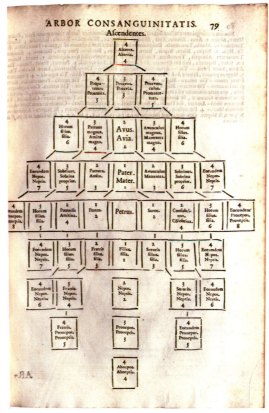

Genealogy of the kings of France
From Guillaume le Bret and Pierre
Le Rouge of Chablis, *La mer des
histoires* (The sea of stories)
1488 (opposite)

A superb woodcut from *La mer des
histoires*, one of the rarest French
illustrated incunabula and an
adaptation of the Latin *Rudimentum
Novitiorum*, first published at Lübeck,
Germany, in 1475. The universal chronicle
contains an abridged compilation of

world history and several important
maps. This illustration, thought to have
been produced by the engraver Pierre
Le Rouge of Chablis, depicts a subset
of the genealogy of the kings of France,
starting with John II of France (in French
Jean Le Bon, 1319–64) on the top.

Aloisius Edouard Camille Gaultier
Table of general questions on geography
1821

Part of an appendix entitled "General Questions on Geography," from a complete course of geography conveyed by means of instructive games, devised by the French Catholic priest and educational reformer Aloisius Edouard Camille Gaultier. Gaultier was a pioneer in teaching children through games and amusement, or, in modern terms, game mechanics. The chart demonstrates Gaultier's innovative thinking on how to teach a variety of common geographical elements and reads as a vertical decision tree. Questions originating at the diagram's top give birth to a forking arrangement of answers that descend toward its bottom.

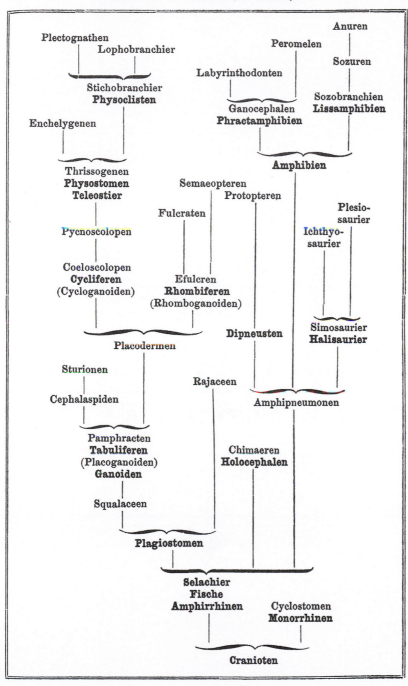

Stammbaum der amnionlofen Wirbelthiere.

Ernst Haeckel

Amniote tree

From *Natürliche Schöpfungsgeschichte* (The history of creation) 1870

A family tree of amniote vertebrates—four-limbed animals with backbones or spinal columns, which have been traditionally classified into three orders: Reptilia (reptiles), Aves (birds), and Mammalia (mammals). This vertical tree displays the bracketed graphical style common to a number of other diagrams in Haeckel's book, and is reminiscent of the charts (more often with a horizontal layout) created by Enlightenment biologists, encyclopedists, and philosophers (see Chapter 03).

VERTICAL TREES

**Genealogical tree of
the Nam family**

From Arthur Howard Estabrook
and Charles Benedict Davenport,
*The Nam Family: A Study in
Cacogenics*
1912 (above)

Chart showing the genealogy of the
(fictitiously named) Nams, a family
from western Massachusetts. Together
with the Jukes, the Zeros, and the
Kallikaks, the Nams were the subjects
of a series of sociological studies on
human heredity conducted at the
beginning of the twentieth century. In
this seven-generation chart, squares
indicate males while circles represent
females. Numbers in squares specify
the number of individuals represented
by the symbol, while Roman numerals
moving from top to bottom refer to
generations.

Anonymous
**Manhattan Project organization
chart**
1946 (right)

Diagram showing the people
behind the Manhattan Project, the
American-led World War II research and
development project that produced the
first atomic bomb. Staff were organized
in a top-down structure typical of
most corporations, governments, and
the military; charts such as this one
have been popular since the mid-
nineteenth century as a way to make
sense of the growing complexity of
these organizations. This chart dates
from May 1946, nine months after two
atomic bombs developed by the project
were dropped on Japan. The Manhattan
Project was split in August 1947, and
its work was taken over by the United
States Atomic Energy Commission.

Christopher Collins, Gerald Penn,
and Sheelagh Carpendale
***Bubble Sets: Revealing Set
Relations with Isocontours over
Existing Visualizations***
2009 (left)

A visualization based on a machine
translation algorithm that establishes
translations by building multiple
syntax trees. In this image, a Chinese
sentence appears on the bottom as
the main textual input. The software
draws on a collection of English-
language fragments to piece together
a grammatical parse tree whose
leaves, when read left to right, are an
appropriate translation of the Chinese
sentence. The bubble contours show
which tree nodes share a common
fragment. Bubble colors reveal the
type and popularity score of each tree
fragment.

Jeffrey Heer, Michael Bostock,
and Vadim Ogievetsky
Flare package tree
2010 (above)

A visualization that reveals the code
structure of the open-source software
package Flare visualization toolkit (a
flexible ActionScript library created by
the Visualization Lab of the University
of California, Berkeley) by showing
its various hierarchical classes and
subclasses in a vertical tree diagram.

Joe Stone
X-Men Family Tree
2011

An enticing and playful family tree charting the many convoluted relationships—whether they be romantic, genetic, or otherwise—of the X-Men characters from Marvel Comics.

X-MEN FAMILY TREE

DESTINED TO BE TOGETHER

ALTERNATE REALITY

CONFUSED? READ MORE COMICS.

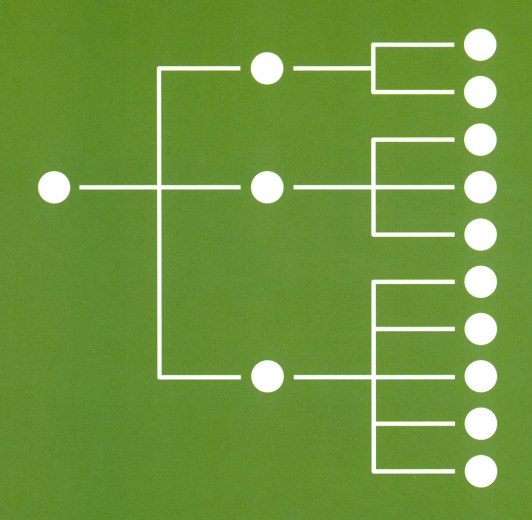

1

2

3

HORIZONTAL TREES

With the adoption of a more schematic and abstract construct, deprived of realistic arboreal features, a tree diagram could sometimes be rotated along its axis and depicted horizontally, with its ranks arranged most frequently from left to right. Horizontal trees probably emerged as an alternative to vertical trees to address spatial constraints and layout requirements, but they also provide unique advantages. The nesting arrangement of horizontal trees resembles the grammatical construct of a sentence, echoing a natural reading pattern that anyone can relate to. This alternative scheme was often deployed on facing pages of a manuscript, with the root of the tree at the very center, creating a type of mirroring effect that is still found in many digital and interactive executions. Horizontal trees have proved highly efficient for archetypal models such as classification trees, flow charts, mind maps, dendrograms, and, notably, in the display of files on several software applications and operating systems. If you are a computer user, there is a strong chance you have interacted with some version of a horizontal tree—perhaps on a daily basis.

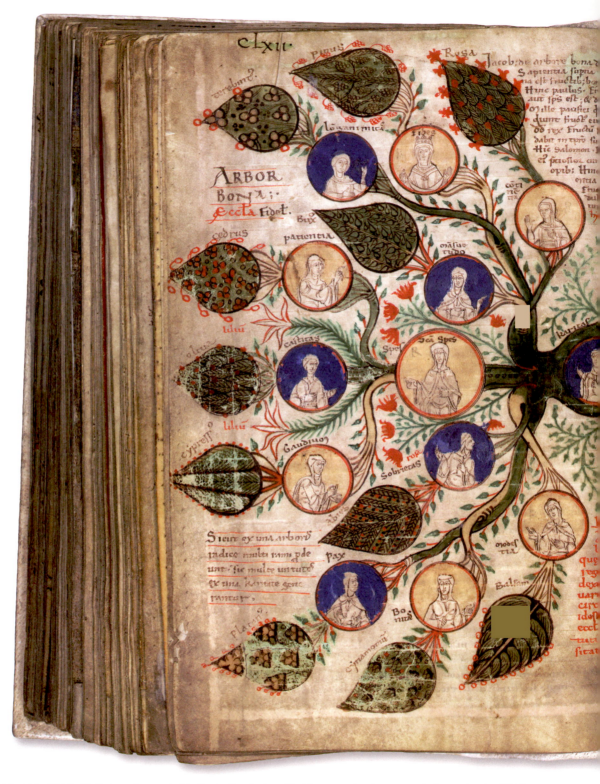

Tree of virtues and tree of vices
From Lambert of Saint-Omer,
Liber floridus
1121

A remarkable illustration featured in *Liber floridus* (Book of flowers; see Timeline, page 45), depicting two opposing arboreal schemes in the form of fig trees: a tree of virtues (*arbor bona*) on the left and a facing tree of vices (*arbor mala*) on the right. The

arbor bona sprouts from a trunk exhibiting a medallion with a personification of charity, while the *arbor mala* emerges from cupidity. Each contrasting tree bears twelve medallions, corresponding to twelve virtues and twelve vices.[1]

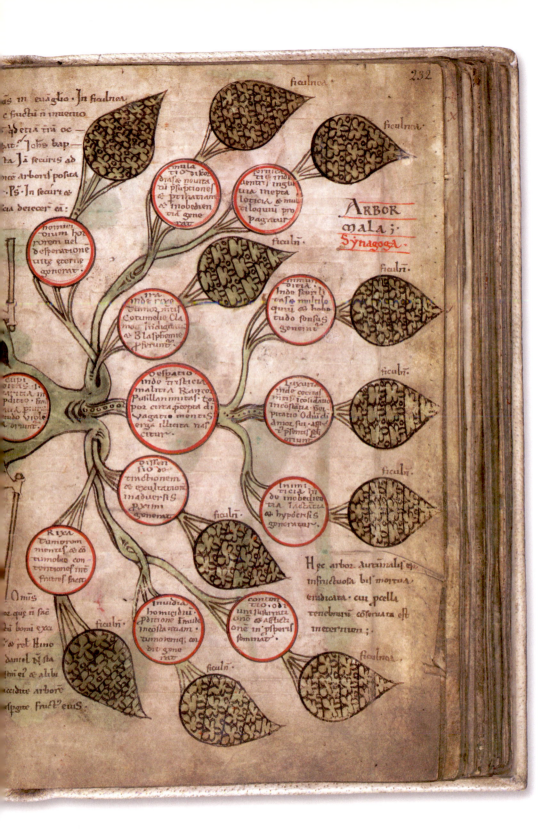

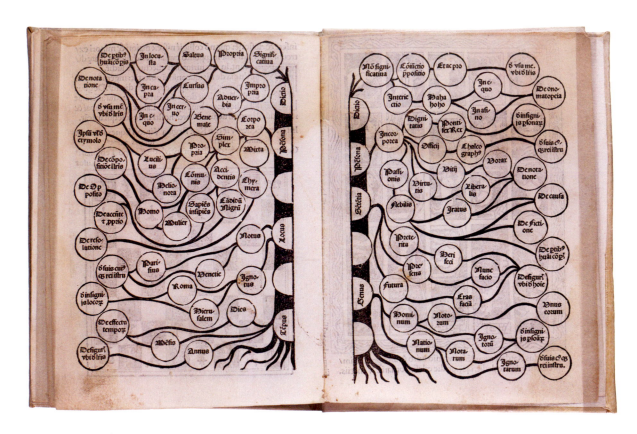

Porphyrian tree of qualities

From Jacobus Publicius, *Artes orandi, epistolandi, memoranda*
1485

Part of an incunabulum published by Erhard Ratdolt in Venice, which reads essentially as a handbook of rhetoric and the art of memory. The book contains intriguing images and illustrations meant to stand on their own as mnemonic tools; many figures are not even referred to in the text. Featured in the book's second edition of 1485 (the first edition had been published in 1482), this intricate illustration depicts the Porphyrian tree of qualities or virtues along a horizontal axis.

Jurisprudence

From Christophe de Savigny, *Tableaux accomplis de tous les arts libéraux* (Complete tables of all liberal arts)
1587 (opposite)

One of sixteen beautifully decorated tables covering grammar, rhetoric, dialectic, arithmetic, geometry, optics, music, cosmography, astrology, geography, physics, medicine, ethics, jurisprudence (shown here), history, and theology. *Tableaux accomplis*, published in Paris, consists mainly of these sixteen tables, each one accompanied by a one-page description. Enclosed by an oval decorative piece containing various graphic elements, each takes the form of a horizontal tree of topics and subtopics pertaining to its depicted discipline. The work was an important development in the visual representation of knowledge and became a key influence in the subsequent classification work of Francis Bacon.

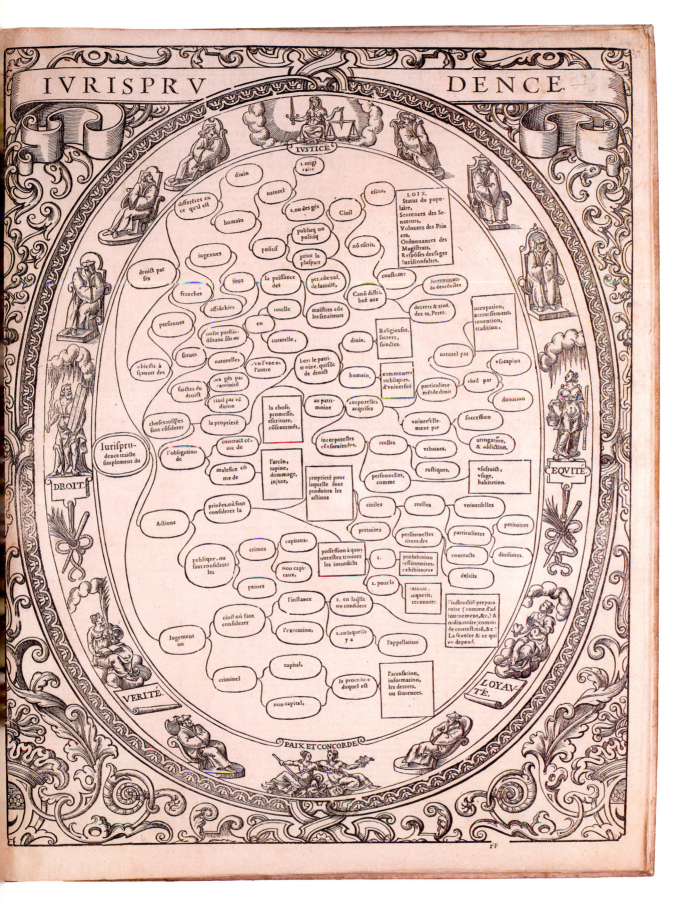

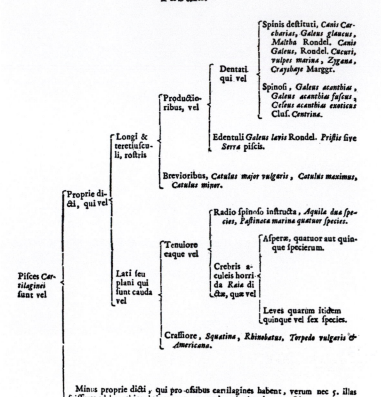

Table of cartilaginous fishes

From Francis Willughby and John Ray, *De Historia Piscium Libri Quatuor* (History of fishes in four books) 1686

Classification table of all cartilaginous fishes in a horizontal bracketed tree chart, part of a magnificent volume containing 187 beautifully engraved plates of various fish species published by the British scientific academy the Royal Society.

Table of contents

From Ephraim Chambers, *Cyclopædia* 1728

Part of the preface to the two-volume *Cyclopædia*, one of the earliest general encyclopedias written in English. This archetypal horizontal bracketed tree diagram shows the hierarchical ordering of all the subjects covered in the encyclopedia and serves as a graphical table of contents. The leftmost category of "knowledge" forks into a series of dichotomous main branches until reaching the last, rightmost branches (including astronomy, geography, alchemy, architecture, sculpture, commerce, and medicine), which represent the forty-seven individual disciplines covered in the book.

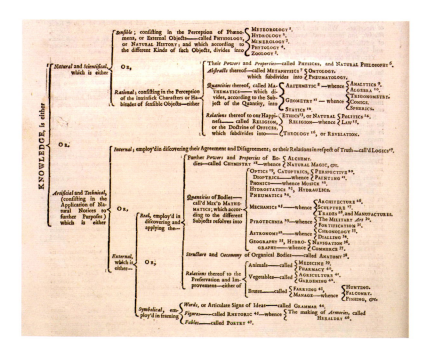

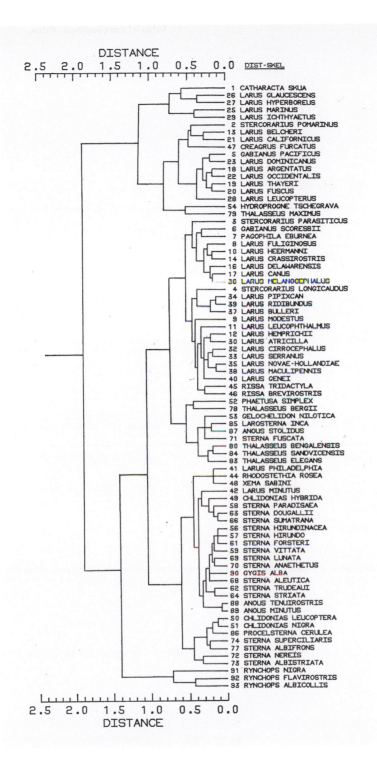

DISTANCE

2.5 2.0 1.5 1.0 0.5 0.0 DIST-SKEL

1 CATHARACTA SKUA
26 LARUS GLAUCESCENS
27 LARUS HYPERBOREUS
25 LARUS MARINUS
29 LARUS ICHTHYAETUS
2 STERCORARIUS POMARINUS
13 LARUS BELCHERI
21 LARUS CALIFORNICUS
47 CREAGRUS FURCATUS
5 GABIANUS PACIFICUS
23 LARUS DOMINICANUS
18 LARUS ARGENTATUS
22 LARUS OCCIDENTALIS
19 LARUS THAYERI
20 LARUS FUSCUS
28 LARUS LEUCOPTERUS
54 HYDROPROGNE TSCHEGRAVA
79 THALASSEUS MAXIMUS
3 STERCORARIUS PARASITICUS
6 GABIANUS SCORESBII
7 PAGOPHILA EBURNEA
8 LARUS FULIGINOSUS
10 LARUS HEERMANNI
14 LARUS CRASSIROSTRIS
16 LARUS DELAWARENSIS
17 LARUS CANUS
30 LARUS MELANOCEPHALUS
4 STERCORARIUS LONGICAUDUS
34 LARUS PIPIXCAN
39 LARUS RIDIBUNDUS
37 LARUS BULLERI
9 LARUS MODESTUS
11 LARUS LEUCOPHTHALMUS
12 LARUS HEMPRICHII
30 LARUS ATRICILLA
32 LARUS CIRROCEPHALUS
33 LARUS SERRANUS
35 LARUS NOVAE-HOLLANDIAE
38 LARUS MACULIPENNIS
40 LARUS GENEI
45 RISSA TRIDACTYLA
46 RISSA BREVIROSTRIS
52 PHAETUSA SIMPLEX
78 THALASSEUS BERGII
53 GELOCHELIDON NILOTICA
85 LAROSTERNA INCA
87 ANOUS STOLIDUS
71 STERNA FUSCATA
80 THALASSEUS BENGALENSIS
84 THALASSEUS SANDVICENSIS
83 THALASSEUS ELEGANS
41 LARUS PHILADELPHIA
44 RHODOSTETHIA ROSEA
48 XEMA SABINI
42 LARUS MINUTUS
49 CHLIDONIAS HYBRIDA
58 STERNA PARADISAEA
63 STERNA DOUGALLII
66 STERNA SUMATRANA
56 STERNA HIRUNDINACEA
57 STERNA HIRUNDO
61 STERNA FORSTERI
59 STERNA VITTATA
69 STERNA LUNATA
70 STERNA ANAETHETUS
90 GYGIS ALBA
68 STERNA ALEUTICA
62 STERNA TRUDEAUI
64 STERNA STRIATA
88 ANOUS TENUIROSTRIS
89 ANOUS MINUTUS
50 CHLIDONIAS LEUCOPTERA
51 CHLIDONIAS NIGRA
86 PROCELSTERNA CERULEA
74 STERNA SUPERCILIARIS
77 STERNA ALBIFRONS
72 STERNA NEREIS
73 STERNA ALBISTRIATA
91 RYNCHOPS NIGRA
92 RYNCHOPS FLAVIROSTRIS
93 RYNCHOPS ALBICOLLIS

2.5 2.0 1.5 1.0 0.5 0.0

DISTANCE

Gary D. Schnell
**A Phenetic Study of the
Suborder Lari**
1970

One of the first phenetic diagrams,
also known as "cladograms," produced
by numerical methods. It maps the
various phenetic relationships among
birds of the suborder Lari, part of the
order Charadriiformes, which includes
gulls, terns, skuas, and skimmers.
Reprinted from Gary D. Schnell, "A Phenetic
Study of the Suborder Lari (Aves) II.
Phenograms, Discussion, and Conclusions,"
Oxford Journal of Systematic Biology 19, no.
3: 264–302, with permission from Oxford
University Press.

Jeffrey Heer and Stuart Card
Degrees of interest tree
2004

Tree visualization of the Open Directory Project, a large, human-edited directory of the Internet, containing more than six hundred thousand nodes organized in multiple curated categories. The tree is laid out in a right-to-left orientation. Multiple folders have been selected; the expanded branches are allocated as much space as possible, given the display constraints.

Felix Nyffenegger
WikiMindMap
2007

A tool to easily and efficiently browse wiki content, inspired by the mindmap—a rough diagram, occasionally drawn by hand, that structures and outlines information visually. Pages in large public wikis (collaboratively developed and edited websites), such as Wikipedia, have become rich and complex documents. This tool aims to help users navigate this immense network of common knowledge by giving a structured, easily grasped overview of a topic. The maps exhibit the structure of a page and its entire body of links to other pages, as well as external references (assuming that they correspond to the page's most important keywords). Selecting the green symbol on the side of a node brings that topic to the center.

I

You

HAVE
DO
CAN
WANT
WILL
THINK
ARE
WOULD
AM
NEED
DID
KNOW
WAS
HAD
GOT
LIKE
WISH
MAY
TO
COULD
FOR
LOVE
AGREE
GET
HOPE
WANTED
FIND
THOUGHT
WITH
AND
WENT
USED
BELIEVE
DECIDED
SHOULD
TRY
GUESS
IN
TRIED
SEEING
VERY
MUST
HOW
WONDER
LOOK
LOOKING
SEE
CHOOSE

NOT
TO
A
THE
IT
BE
LIKE
THAT
I
YOU
HAVE
LOOKING
ANY
BEEN
FIND
SEE
YOUR
IN
THIS
GET
GOING
DO
VIEW
USE
NO
ABOUT
NEED
INTERESTED
WE
USING
OF
SEEN
WHAT
SURE
RECEIVE
WITH
NEVER
AN
HAD
VERY
MAKE
QUESTIONS
MUCH
ALSO
JUST
IF
AT
WANT
EVER
FOR

ChrisHarrison.net

Chris Harrison
Web trigrams
2008

An analysis of a subset of trigrams, three-word phrases such as "I love that" or "You wonder if." Extracting the number of times an n-gram (a short phrase) appears in Google's search corpus provides a good indication of its popularity. Following a release by Google of a set of n-gram data, Chris Harrison created a series of visualizations of trigrams and

fivegrams. This example juxtaposes two sets of trigrams starting with "I" and "You," which in turn generates a large number of possible horizontal trees with two common roots. After the top seventy-five trigrams beginning with "I" and "You" were analyzed, the frequencies of the second and third words were combined and rendered in decreasing popularity order. Word size is based on frequency, and a set of color-coded lines is used to reinforce the hierarchical tree of dependencies.

Chris Gemignani (Juice Analytics)
Patterns in keyword phrases
2008

A visualization tool that shows relationships and connections among groups of words that have been included in the same search string. In this incarnation of a horizontal word tree, the size of each word represents the frequency of occurrence in search queries (larger is more frequent), and the color represents the bounce rate (more red indicates a higher bounce). By typing a single word in the search field, the user can see connections among related words, with their frequency and bounce rate.

Martin Wattenberg and
Fernanda Viégas
Word Tree
2008

A word tree mapping all the sentences in the Bible that start with "And God." The diagram follows a successive horizontal forking as it completes all the sentences that begin with this phrase. The size of the initial set of words indicates each word's frequency—the total number of sentences that contains the specific word.

Andreas Lundqvist and
Donjan Rodic
Debian family tree
2011

Horizontal tree of the various projects
and distributions (distros) that have
emerged from the Debian computer
operating system since it was first
announced in August 1993 by Ian
Murdock. Debian is made of several free
and open-source software packages

that support the Linux, FreeBSD, and
Hurd kernels. As opposed to commercial
software, which normally has an orderly
progression of versions, open-source
products tend to have numerous splitting
versions and projects, and Debian is a
great example of such diversity.

Folder A ▶	Folder A1	Folder A5.1	Folder A5.3.1 ▶
Folder B	Folder A2	Folder A5.2	Folder A5.3.2
Folder C	Folder A3	Folder A5.3 ▶	Folder A5.3.3
Folder D	Folder A4	Folder A5.4	Folder A5.3.4
Folder E	Folder A5 ▶	Folder A5.5	Folder A5.3.5
Folder F	Folder A6	Folder A5.6	Folder A5.3.6
Folder G	Folder A7	Folder A5.7	Folder A5.3.7
Folder H	Folder A8	Folder A5.8	Folder A5.3.8

Manuel Lima
Navigational horizontal tree menu
2013

A model used by various computer operating systems that provides an intuitive way to browse, organize, and interact with files and folders by exposing a single branch at a time. In addition to being a natural means of representing pure hierarchical structures, this model also has proved particularly effective as a tool for faceted navigation, a common interaction design pattern that allows users to apply multiple filters to a single search.

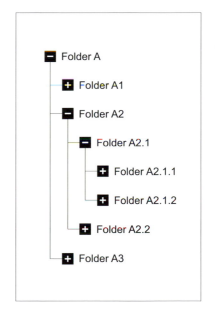

Manuel Lima
Indented tree
2013

A special type of horizontal tree that is widely used to represent digital file systems. The indentation of text labels helps to reinforce hierarchical levels and allows for rapid scanning. Indented trees normally occupy a considerable amount of vertical space, but because individual nodes can expand and contract, they allow for a very efficient interactive exploration of a ranked structure.

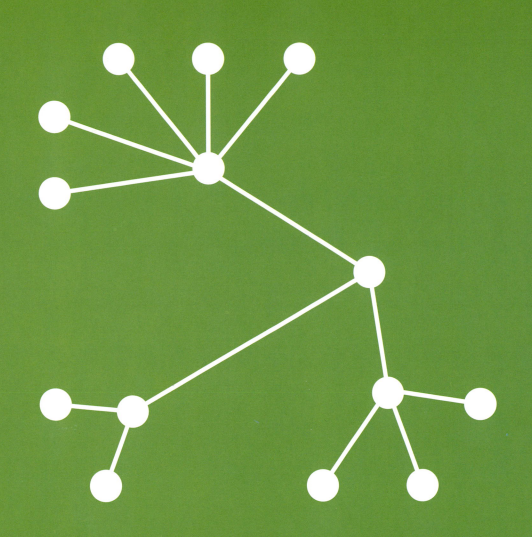

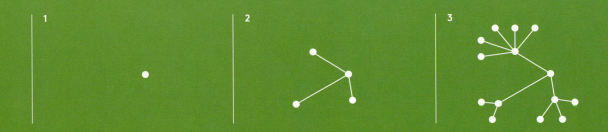

MULTIDIRECTIONAL TREES

Multidirectional trees display a flexible ordering, with hierarchical branching not rigidly structured along a vertical or horizontal axis, but instead following a free-flowing configuration. From an initial root or source within the plotted area, multidirectional trees expand toward the edges of the space, moving in distinct paths and periodically bifurcating. This leads to an organic, unconfined appearance—not to be confused with unordered or disorganized. This model might have in fact preceded vertical and horizontal trees, with some cases of free-flowing, multidirectional stemmata dating as far back as the fifth century.[1] Many recent multidirectional trees have been generated by computer, using specific algorithms to make an effective use of space. The adoption of advanced methods such as force-directed and even genetic algorithms has made multidirectional trees a highly efficient node-link variant that can be used to map large hierarchies through a resourceful manipulation of spatial boundaries. On the other hand, in part due to its flexible layout, its inherent ranking structure is not as easy to perceive as that of other types of tree models.

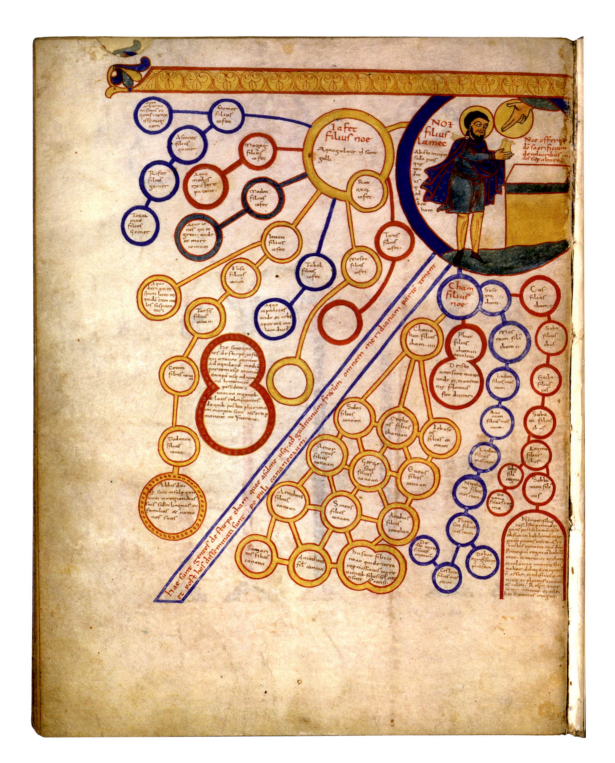

Biblical genealogy
From Stephanus Garsia Placidus,
Saint-Sever Beatus
ca. 1060

Illustration from the *Saint-Sever Beatus*, a lavish masterpiece of the European Romanesque by Stephanus Garsia Placidus, a prolific Spanish artist and illuminator who contributed to many ancient manuscripts. The *Saint-Sever Beatus* is one of the most beautifully illustrated and artistically relevant of the manuscripts conveying the work of the eighth-century Spanish monk Beatus of Liébana, providing the most complete text of his *Commentary* on the Apocalypse. The manuscript was illustrated by Stephanus and others under the supervision of Gregorio Muntaner, the abbot of Saint-Sever (1028–72). In this chart Stephanus depicts the biblical genealogy of the second age of the world, from Noah to Terah, the father of Abraham, with Noah sacrificing two doves in the miniature.

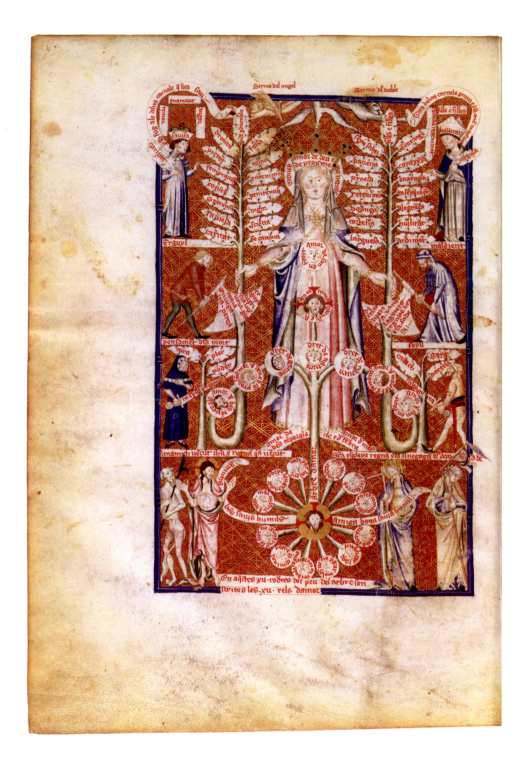

Tree of love

From Matfre Ermengaud,
Le Breviari d'amor
ca. 1365

Tree diagram on the typology of love by Matfre Ermengaud, from his famous *Le Breviari d'amor* (See Chapter 02, page 82). At the very beginning of the manuscript Ermengaud features a magnificent tree figure that schematizes all possible types of love, such as the love of god, the love of male and female, the love of children, and the love of temporal goods. Although Ermengaud makes references throughout the work to the chart as a single tree, the scheme is in fact multidirectional, consisting of several semiautonomous vertical branches. The most prominent is the central stem, overlaid on a woman embodying love, who is crowned with the love of God (*amor de deu*).[2] Many versions of this tree of love, some employing beautifully ornamented designs, have emerged in subsequent editions of the manuscript.

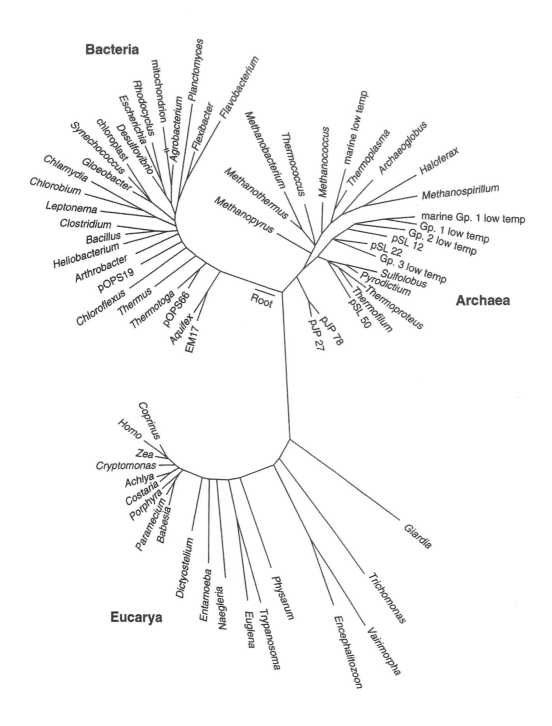

Bacteria

mitochondrion
Planctomyces
Rhodocyclus
Escherichia
chloroplast
Desulfovibrio
Agrobacterium
Flexibacter
Flavobacterium
Synechococcus
Gloeobacter
Chlamydia
Chlorobium
Leptonema
Clostridium
Bacillus
Heliobacterium
Arthrobacter
pOPS19
Chloroflexus
Thermus
Thermotoga
pOPS66
Aquifex
EM17

Methanobacterium
Thermococcus
Methanococcus
marine low temp
Thermoplasma
Archaeoglobus
Haloferax
Methanothermus
Methanospirillum
Methanopyrus
marine Gp. 1 low temp
Gp. 1 low temp
pSL 12
Gp. 2 low temp
pSL 22
Gp. 3 low temp
Sulfolobus
Pyrodictium
Thermoproteus
Thermofilum
pSL 50
pJP 78
pJP 27

Root

Archaea

Coprinus
Homo
Zea
Cryptomonas
Achlya
Costaria
Porphyra
Paramecium
Babesia
Dictyostelium
Entamoeba
Naegleria
Euglena
Trypanosoma
Physarum
Encephalitozoon
Vairimorpha
Trichomonas
Giardia

Eucarya

Norman R. Pace
Universal phylogenetic tree
1997

A tree diagram based on sixty-four
ribosomal RNA sequences grouped into
the three phylogenetic domains of life:
"Bacteria," "Archaea," and "Eucarya."
Reprinted from Norman R. Pace, "A Molecular
View of Microbial Diversity and the Biosphere,"
Science 276, no. 5313 (May 1997): 734–40, with
permission from AAAS.

ST-23 complex

T1
ST-5 complex

T8

T6

T5

ST-3439 group

ST-41/44 complex

T4

T2

T3
ST-3200 group

T7

ST-11 complex

Jui-Cheng Liao, Chun-Chin Li,
and Chien-Shun Chiou
Phylogenetic tree
2006

Phylogenetic tree depicting the clonal relationships among ninety-three different MLVA (multiple-locus variable number tandem repeat analysis) types. MLVA is a recurrent method used in the molecular typing of microorganisms such as bacterial species. The authors note: "Differences in loci [specific locations of a gene or DNA sequence on chromosomes] between two MLVA types are numbered. Circle size is proportional to the number of isolates belonging to a given MLVA type. Two or more MLVA types differing in four or less loci are regarded as a group."

Marcel Salathé
Websites as Graphs
2006

A multidirectional tree diagram of the HTML-tag structure of the Yahoo.com home page. HTML, the lingua franca of all websites, is made of tags nested in other tags—a detailed hierarchical structure that can be simply depicted through a tree graph. Salathé uses color to indicate the various types of tags: blue (links), red (tables), green (sections), violet (images), yellow (forms), orange (line breaks and block quotes), black (the root node), and gray (all other tags).

Stefanie Posavec
Writing Without Words
2008

An explanatory view of the hierarchical structure employed in Posavec's diagram of *On the Road* (opposite). The chart represents a single chapter in cyan, which is divided into a series of paragraphs in gray, sentences in blue, and finally words in brown.

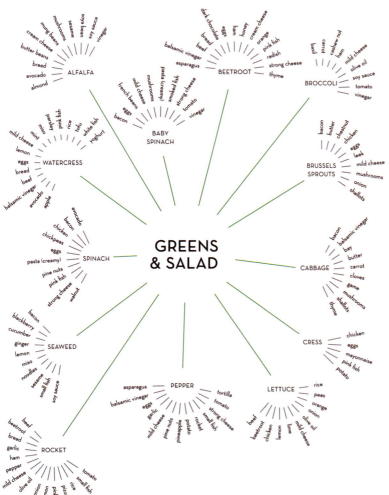

Taste Buds
From David McCandless and Willow Tyrer, *Information Is Beautiful*
2008

A visualization of complementary flavors and ingredients used in preparing various vegetables, such as broccoli, cabbage, lettuce, and spinach, from an analysis of more than one thousand recipes, created for the book *Information Is Beautiful* (HarperCollins, 2009).

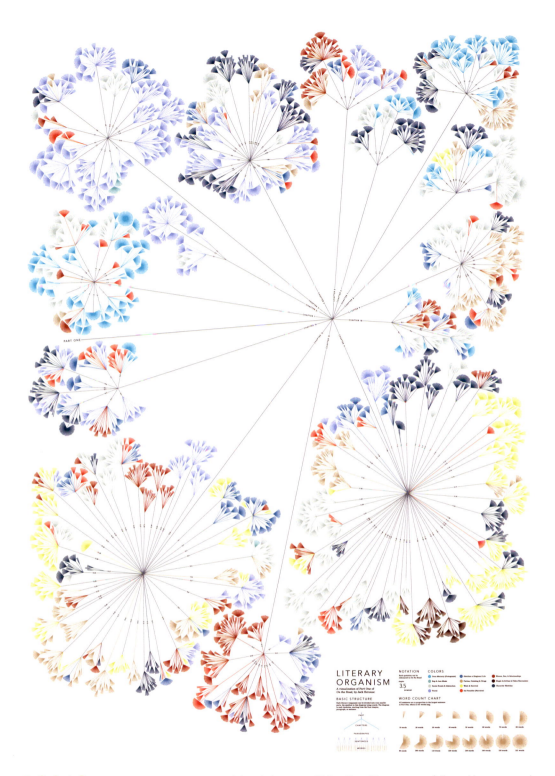

Stefanie Posavec
Writing Without Words
2008

A hand-drawn multidirectional tree mapping the structure of Part One from the book *On the Road* (1957) by Jack Kerouac. Each literary component is divided hierarchically into smaller units, starting with chapters (the main black branches bifurcating from the center), followed by paragraphs, sentences, and ultimately words—the smallest colored lines in the diagram. Colors relate to eleven thematic categories that Posavec identified within the book, such as "Travel," "Social Events & Interaction," and "Work & Survival."

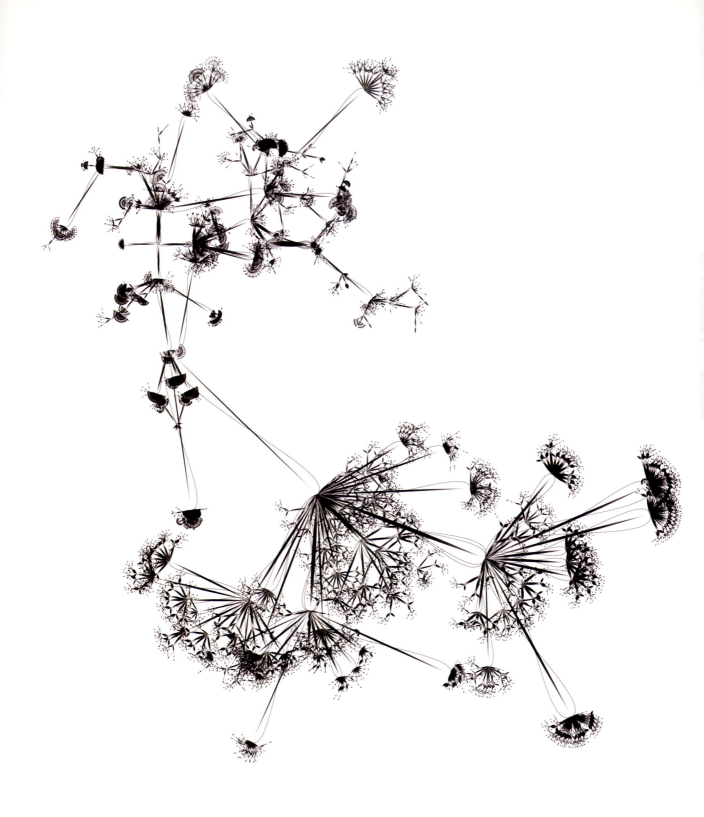

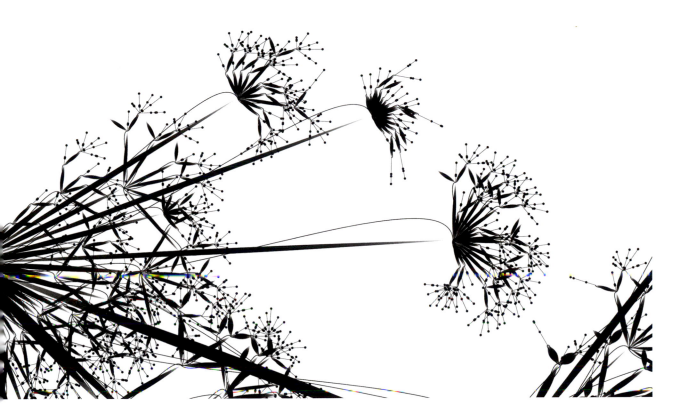

Oli Laruelle
Invisible Commitments
2009 (above and opposite)

An attempt at visualizing the data
and amount of effort behind an open-
source software development project,
in this case the Processing source code.
The branching structure of this diagram
mirrors that of the folders and code
used by the developer team. A branch's
thickness conveys the frequency with
which the developers worked in a given
folder, and its length is proportional to
the number of subfolders. At the end
of the branches are fruits symbolizing
files, organized by extension. Every
dot of a fruit represents a letter of the
file extension and is placed according
to alphabetical order: *a* and *z* are the
farthest apart, *a* and *b* the closest.

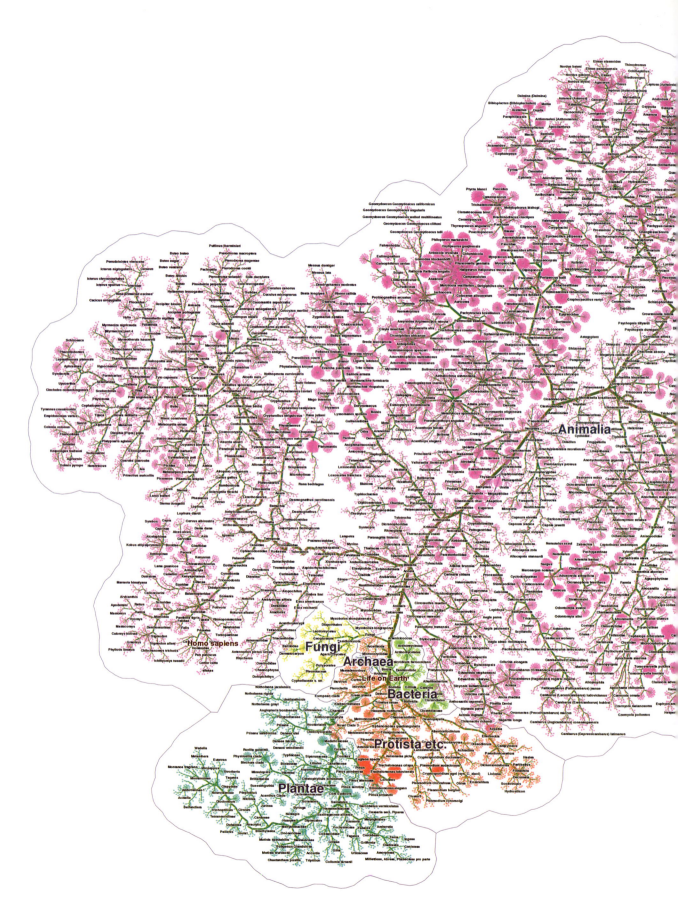

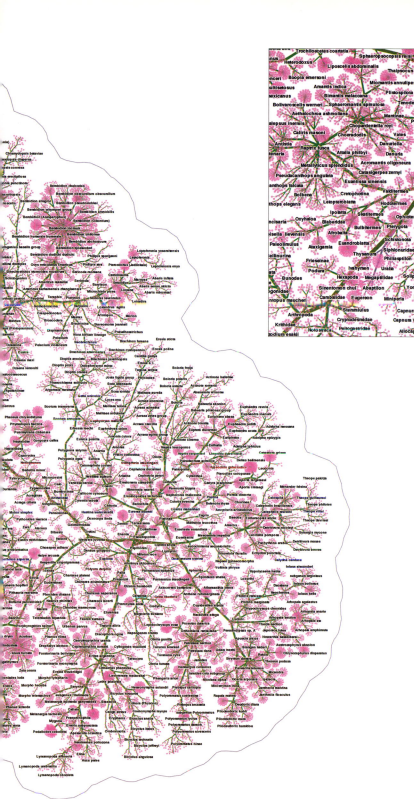

Yifan Hu (AT&T Labs—Research)
The Tree of Life
2011

An intricate chart depicting the phylogeny of 93,891 organisms—the history of their lineages and change through time—using data from the Tree of Life Web Project, a large online collaborative effort on biodiversity. The tree originates on the lower left of the chart ("Life on Earth," shown in red), and splits into the three main domains (branches) of life: "Bacteria" and "Archaea," adjacent to the root, and "Eukarya," the largest of the three, represented by the kingdoms "Fungi," "Protista," "Plantae" (sitting closer to the root), and "Animalia" (expanding toward the upper right areas of the diagram). A single colored dot represents a species or a group of species, which is continuously connected to higher clusters by an edge (branch). As complex as it might seem, the data used is not a faithful representation of reality, featuring only a minute fraction of all living species and giving disproportional prominence to animals (as a result of the large amounts of indexed data for this kingdom).

1

2

3

RADIAL TREES

Circles are among the most ubiquitous symbols around the globe, used in countless variations since the birth of humankind. Associated with notions of unity, wholeness, and infinity, the circle has been an important visual metaphor in a wide array of systems of thought, from cartography and astronomy to physics and geometry. It was therefore inevitable that it eventually would be used to represent hierarchical structures. The most popular radial construct places the tree root, source, or origin at the very center of the diagram, with splitting ranks moving toward the circle's periphery, aligned to a series of concentric rings. A succession of guiding rings, occasionally invisible, enhances the perception of hierarchy while providing a symmetrical sense of balance. One of the main advantages of the radial tree is its composed, optimal use of space; in opposition to vertical and horizontal trees, it can fit easily within the confines of a square. Radial trees are used extensively today, and are particularly popular for portraying genealogical and phylogenetic relationships.

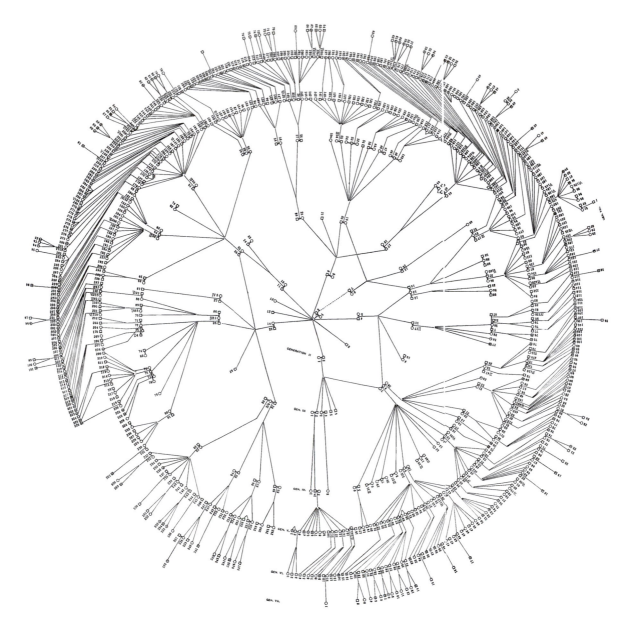

**Genealogical tree
of the Nam family**
From Arthur Howard Estabrook
and Charles Benedict Davenport,
*The Nam Family: A Study in
Cacogenics*
1912

Radial genealogical chart of the
Nam family (see Chapter 02, page
90). Squares indicate males, circles
represent females. Numbers in squares
specify the number of individuals
represented by the symbol, while
Roman numerals moving from the
center toward the edge refer to
generations.

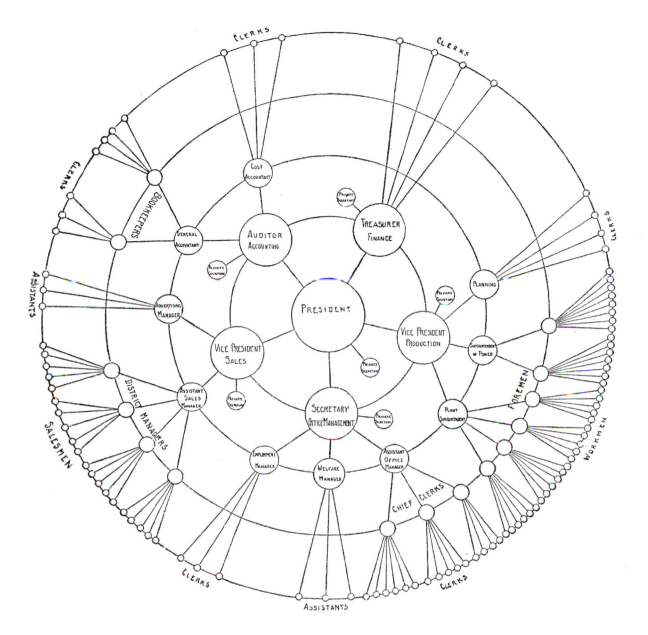

Organization chart

From William Henry Smith,
Graphic Statistics in Management
1924

Radial organization chart highlighting
the centralized decision-making process
of most companies, with the president
in the very core of the chart, followed
by successive levels of managers and
workers represented by sequential
concentric rings. The fundamental
process of rationalization effected
by the Industrial Revolution was a
central impetus for the solidification
of bureaucracy, corporate ranking,
and management models based on
centralized, hierarchical control. The
second half of the nineteenth century
and the beginning of the twentieth
witnessed the emergence of numerous
similar charts that embraced the
tree model to portray an increasingly
complex corporate structure.

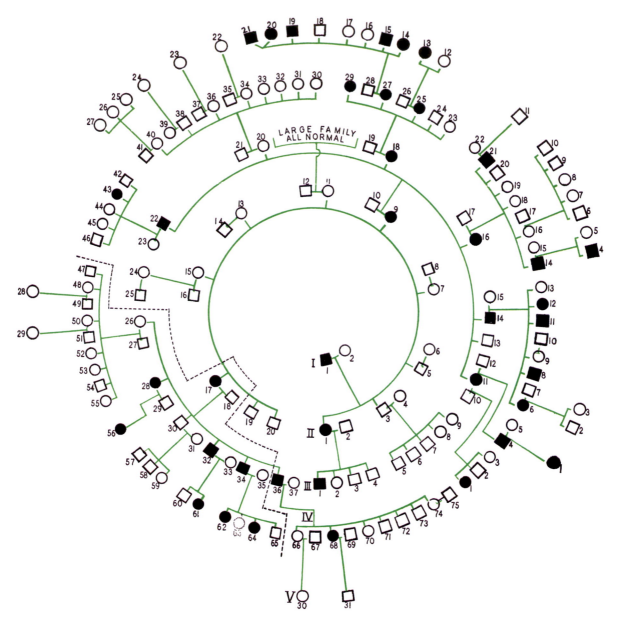

Marle R. Walter
Pedigree chart
1938

A radial chart showing five generations of a large family of mountaineers in West Virginia, part of a sociological study on inheritance. Reprinted from Marle R. Walter, "Five Generations of Short Digits," *Oxford Journal of Heredity* 29, no. 4: 143–44, with permission from Oxford University Press.

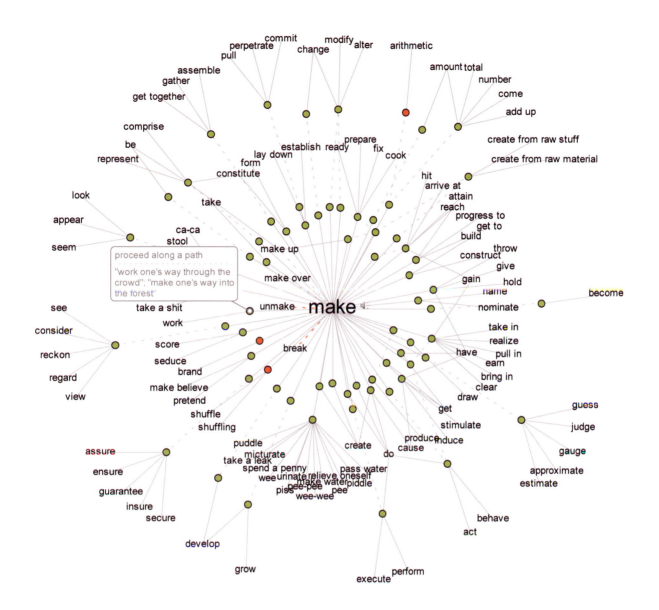

Thinkmap
Visual Thesaurus
2005

Word map from the *Visual Thesaurus*, an interactive dictionary and thesaurus that creates word maps that blossom with meanings and branch to related words. This innovative application was one of the first of its kind on the web and still exists, having inspired many imitators. Its dynamic, expanding radial tree has become a popular interaction model for many digital thesauri and visualizations of texts.

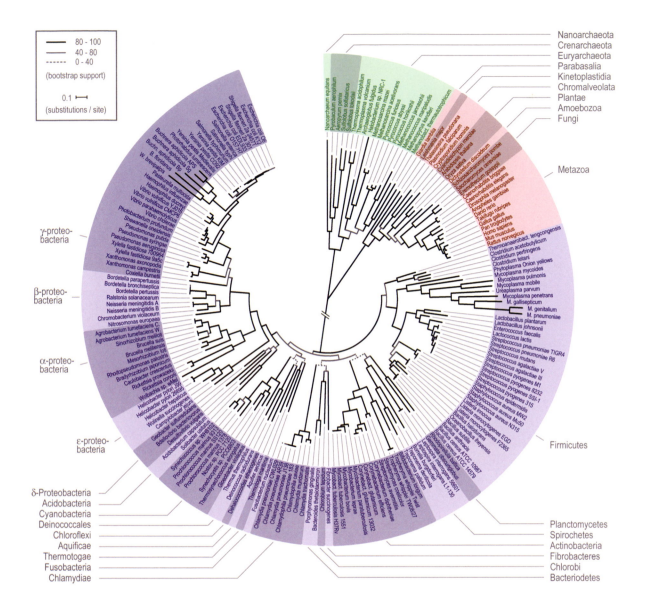

Francesca Ciccarelli, Peer Bork, Chris Creevey, Berend Snel, and Christian von Mering
TOL (tree of life)
2006

Radial tree of life mapping the evolutionary relationships (phylogeny) of 191 species with fully sequenced genomes (see Chapter 04, pages 114 and 121). Relationships are portrayed through a radial cladogram technique—a popular model in phylogenetics and cladistics (the grouping of organisms according to phylogenetic relationships) that uses a diagrammatic forking configuration of nested lines with different lengths to indicate generations. The chart comprises three primary sections corresponding to the main domains of cellular life: "Archaea" (green); "Eukarya" (red); and "Bacteria" (blue), with the largest number of mapped species. Labels and color shadings represent frequently used subdivisions.

Reprinted from F. D. Ciccarelli, T. Doerks, C. von Mering, C. J. Creevey, B. Snel, and P. Bork, "Toward Automatic Reconstruction of a Highly Resolved Tree of Life," *Science* 311, no. 5765 (March 2006): 1283–87, with permission from AAAS. Courtesy of Francesca Ciccarelli.

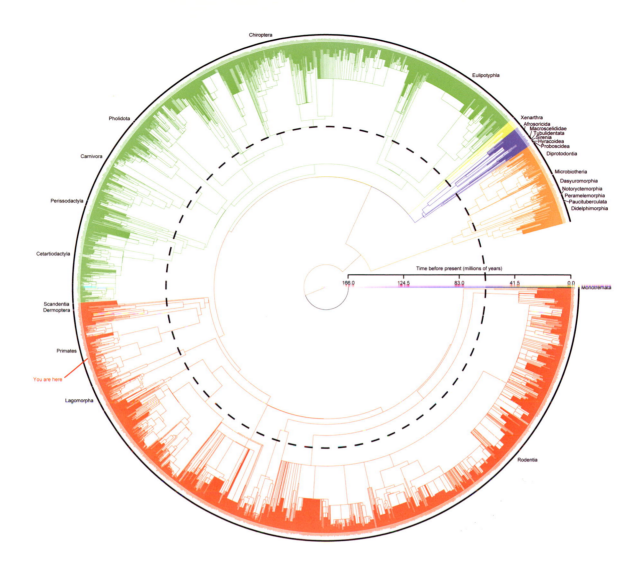

Olaf Bininda-Emonds,
Marcel Cardillo, Kate Jones,
Ross MacPhee, Robin Beck,
Rich Grenyer, Samantha Price,
Rutger Vos, John Gittleman,
and Andy Purvis
Species-level supertree of mammals
2007

The first complete phylogenetic
tree for all extant mammal species.
Using this supertree of roughly four
thousand species, the researchers
were able to show that mammalian

diversification was not strongly affected
by the mass extinction of dinosaurs
sixty-five million years ago, by exposing
peak rates and several splits some
tens of millions of years before. As in
the previous figure, relationships are
depicted through a cladogram approach.
The branches' colors represent the
major mammalian groups, shown in
clockwise order: "Monotremata" (black),
"Euarchonotglires" (red), "Laurasiatheria"
(green), "Xenarthra" (yellow), "Afrotheria"
(blue), and "Marsupialia" (orange).

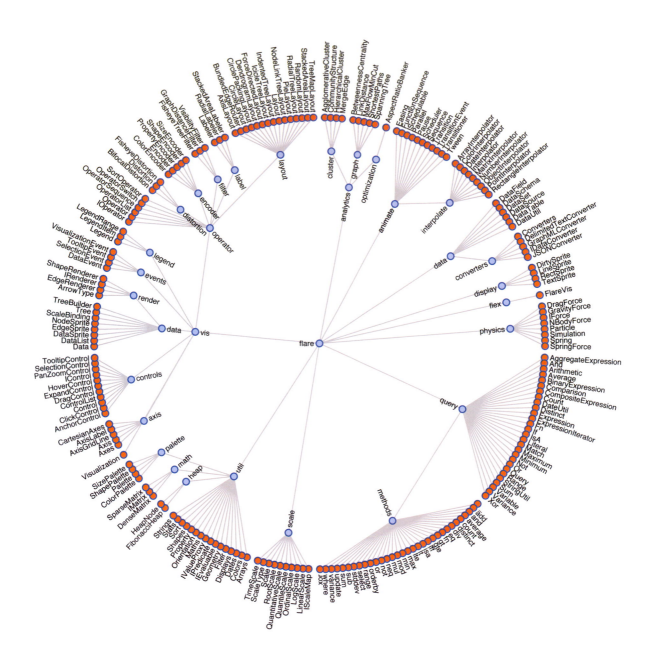

Jeffrey Heer, Michael Bostock,
and Vadim Ogievetsky
Flare package tree
2010

A visualization that depicts the code
structure of the open-source software
package Flare visualization toolkit
(see Chapter 02, page 93) by showing
its various hierarchical classes and
subclasses in a radial tree diagram.

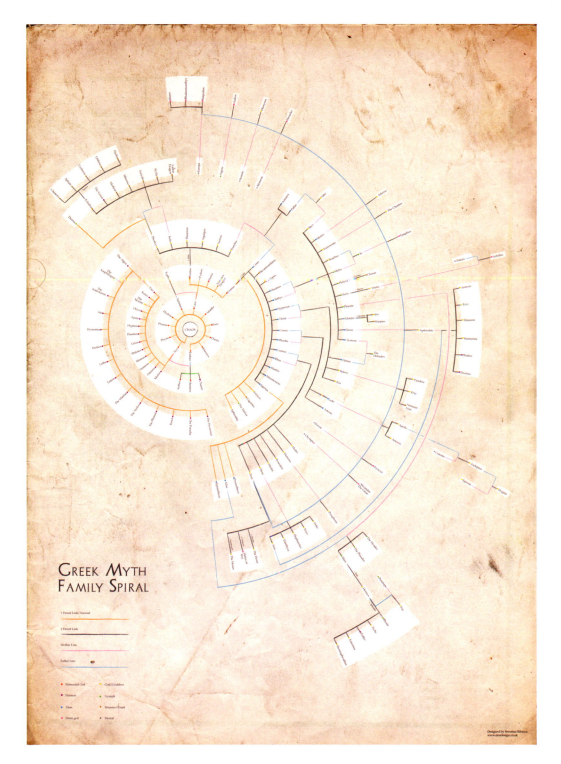

GREEK MYTH
FAMILY SPIRAL

Severino Ribecca
Greek mythology family tree
2011

A large genealogical chart depicting multiple types of connections among ancient Greek gods, mythical beings, and fabled figures. The diagram expands radially from its root, "Chaos," featuring eleven primordial immortal gods in the first ring, including Gaia, Ananke, Eros, Phanes, and Nyx. The largest branch in the chart descends from the goddess of earth, Gaia, and then splits into five successors, the most proliferous being Pontus and Uranus.

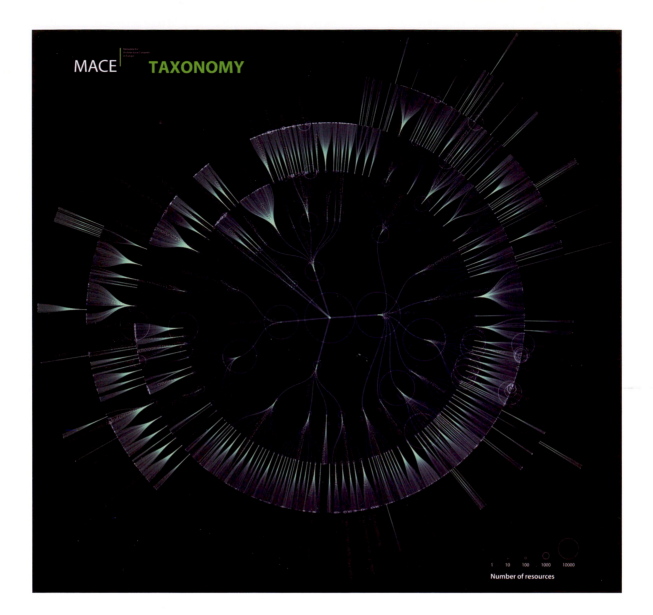

MACE TAXONOMY

Number of resources

1 10 100 1000 10000

Moritz Stefaner
MACE taxonomy
2011

A radial tree visualization
exposing the usage patterns of the
classification taxonomy used by
Metadata for Architectural Content in
Europe (MACE). The chart shows the
hierarchical structure of more than

2,800 tags employed by the system,
in a variety of languages. Each branch
forms a specialization path, from
more generic to more specific tags.
The circles of varying sizes overlaid on
certain nodes represent the number of
resources related to the tag, which in
turn suggest usage volume across the
entire taxonomy.

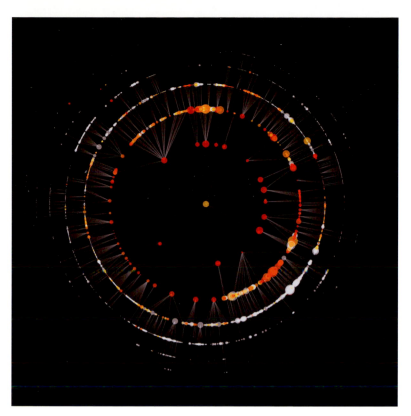

Wouter Van den Broeck and
Christian Thiemann
**SPaTo visualization in the
GLEAMviz Simulator application**
2012

A still from the dynamic SPaTo
visualization produced by the GLEAMviz
Simulator application—part of a system
that allows researchers and policy
makers to forecast the worldwide spread
of infectious diseases and the potential
impact of intervention strategies. This
tree visualization employs concentric
mapping, where nodes represent
population basins surrounding all the
commercial airports in the world. The
root node positioned in the center
corresponds to the population basin
that hosts the initial outbreak of an
infection, while the edges represent
direct travel connections between
the population basins. This tree thus
discloses the quickest paths for the
infection to spread globally as infected
individuals travel. The color of the nodes
is determined by the number of new
cases on a given day in a particular
population basin: white when there are
no cases, yellow when there are a few,
and red when there are many. The size
of each node also scales with the size of
the population.

Radial tree
From Hartmut Bohnacker, Benedikt
Groß, Julia Laub, and Claudius
Lazzeroni, *Generative Design:
Visualize, Program, and Create
with Processing*
2012

A diagram showing a radial tree of
a folder of images published in the
book *Generative Design*, an impressive
showcase of new methods, processes,
and experiments for producing
automated, generative design pieces,
many of them based on hierarchical
tree charts. Each node in this diagram
represents a given folder in the
structure. Color is determined by last
modification date, the most recent
being represented by the lightest color
and the oldest by the darkest.

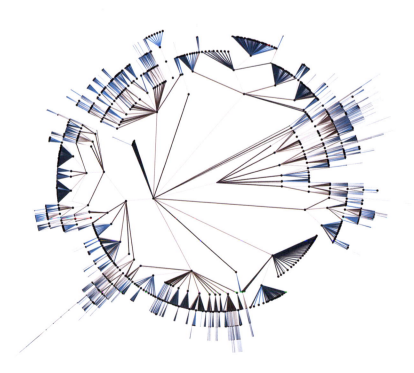

1

2

3

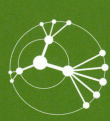

HYPERBOLIC TREES

A variation of the radial tree, the hyperbolic tree is a more recent, computer-aided visualization generated with advanced algorithms. While radial trees tend to graphically treat all nodes and their respective linkages in a similar way by using linear geometry, hyperbolic trees use a "focus and context" technique that emphasizes a given set of nodes by centering and enlarging them while giving less prominence to other dependencies, making them progressively smaller and closer to the periphery. Even though hyperbolic trees employ the same ranking principle as radial trees, based on a series of concentric circles, they do not operate in conventional Euclidean space, but instead within a spherical negative curvature based on hyperbolic geometry. Due to their magnifying feature, hyperbolic trees are useful for displaying and manipulating large hierarchies on a limited screen size. As visualizations ideally suited for direct manipulation, hyperbolic trees are rarely depicted in print and are found almost exclusively within the confines of their natural digital domain.

John Lamping, Ramana Rao,
and Peter Pirolli
**Hierarchical charts using
hyperbolic geometry**
1995

These graphs depict the first known
hyperbolic tree, created by a group
of researchers at the Xerox Palo Alto
Research Center in 1995. At the time
the "focus and context" technique—a
method that provides full detail (focus)
of a primary component of a system
while providing a complementary
overview (context) in the periphery—
had proved successful in many
information visualization experiments.
Inspired by M. C. Escher's *Circle
Limit IV (Heaven and Hell)* woodcut
and early successes of the "focus
and context" method, the authors
introduced the hyperbolic browser for
visualizing and manipulating large
hierarchical structures. According to
them, "the essence of this scheme is to
lay out the hierarchy in a uniform way
on a hyperbolic plane and map this
plane onto a circular display region,"
which in turn "supports a smooth
blending between focus and context,
as well as continuous redirection of
the focus."[1] This original use of
hyperbolic geometry triggered many
subsequent projects and is still a major
source of influence.

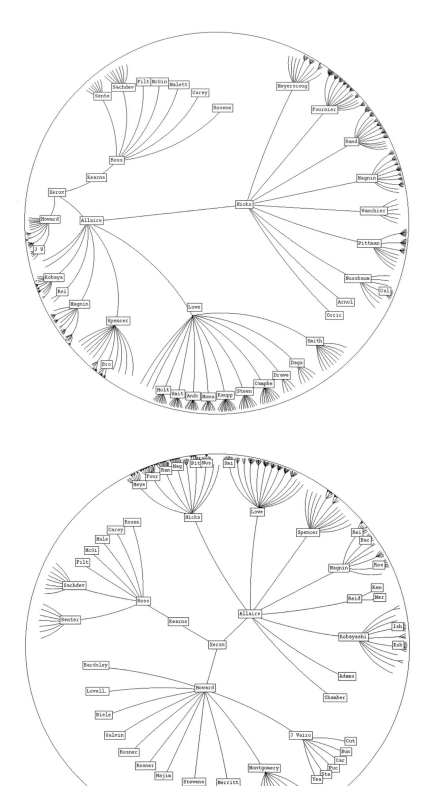

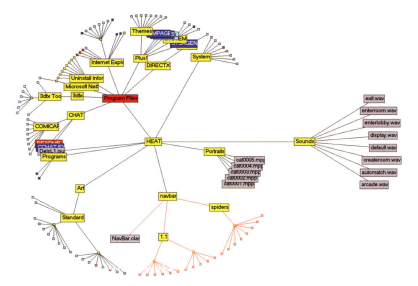

Ricardo Andrade Cava and Carla
Maria Dal Sasso Freitas
Bifocal tree
2001

A graph employing the "bifocal tree" technique for visualizing hierarchies, developed by a group of researchers in Brazil. Based on the "focus and context" method, the bifocal tree is divided into two separate subgraphs: a detail area with its own focus node and a context area depicting parent and siblings subtrees. Each subgraph embraces a radial layout, showing the selected node at the center of a circle and its descendants in a set of concentric rings.

Bernard Bou
Treebolic
2003

A hyperbolic tree, generated by Treebolic, depicting the various classes and species of the animal kingdom (Animalia). Its root is the class of mammals (Mammalia) depicted in red. Treebolic is a Java component (widget) whose purpose is to provide a hyperbolic rendering of hierarchical data. Trees are rendered with nodes and edges, but display space is subject to a particular curvature typical of a "focus and context" technique, allocating more room to focus nodes while the parent and children, still in the immediate visual context, appear slightly smaller.

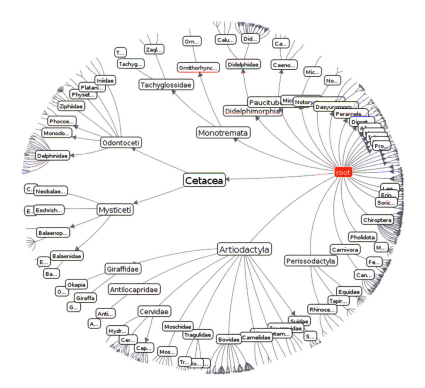

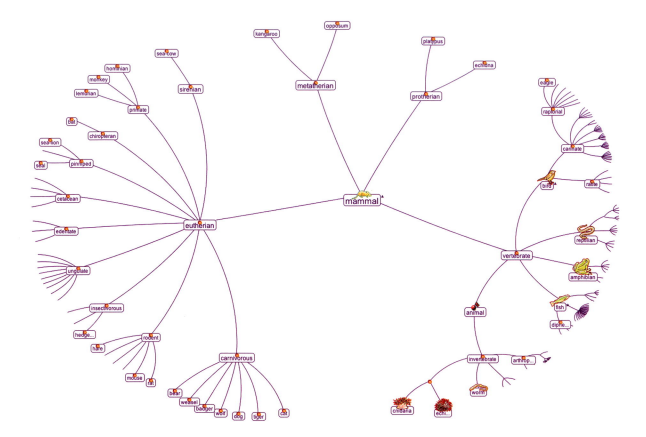

Bernard Bou
Treebolic
2003

An alternative visual treatment of Treebolic depicting the various classes and species of the animal kingdom, divided between vertebrates (with a backbone or spinal column) and invertebrates (without a backbone or spinal column).

Jeffrey Stamps
OrgScope
2003

Visualization that forms part of an OrgScope demo mapping the organizational structure of a company with roughly four thousand employees. Created in 2003 by Jeffrey Stamps, OrgScope maps the complexity of hierarchies through graphs that facilitate visualization, navigation, and analysis. In this view, the company's entire organization chart is depicted as a hyperbolic tree, with positions connected by their direct reporting relationships. OrgScope calculates each position's level and color-codes it accordingly. Nonmanagerial staff, the last hierarchical level, is displayed in black.

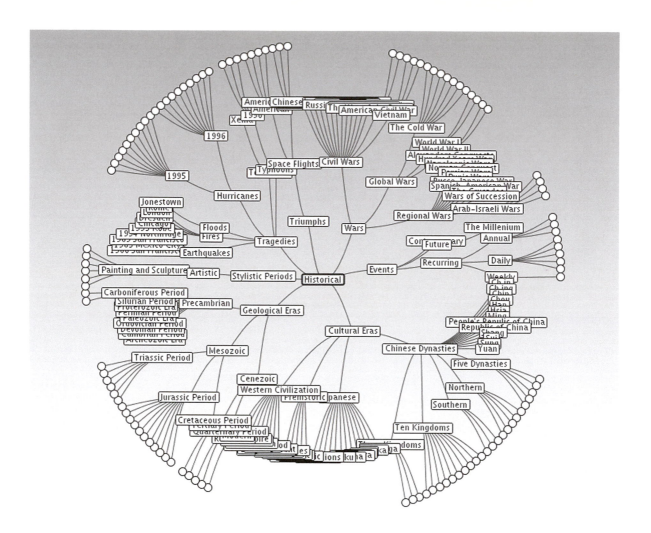

Roman Kennke
Xebece
2004

A hyperbolic tree mapping more than seven thousand nodes indicating historical events, periods, and relevant categories, using the multipurpose information visualization tool Xebece. One of the main strengths of Xebece is its ability to combine structured (tree) data with unstructured (text and graphics) data.

Werner Randelshofer
Treeviz
2007

Treeviz was created to identify usage patterns on an e-learning and file-sharing platform hosting about one million files. The tool shows files in a folder hierarchy using a number of visualization techniques, including circular treemap, rectangular treemap, sunburst tree, icicle tree, and hyperbolic tree. All visualizations can use a color gradient to reflect file properties (such as creation date and ownership). In these images Treeviz employs its hyperbolic technique to map a large musical database with a straightforward hierarchical structure composed of music, artist, album, and song.

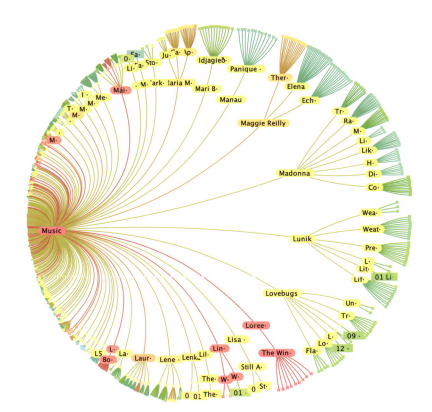

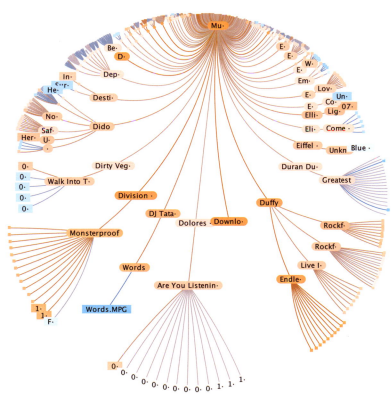

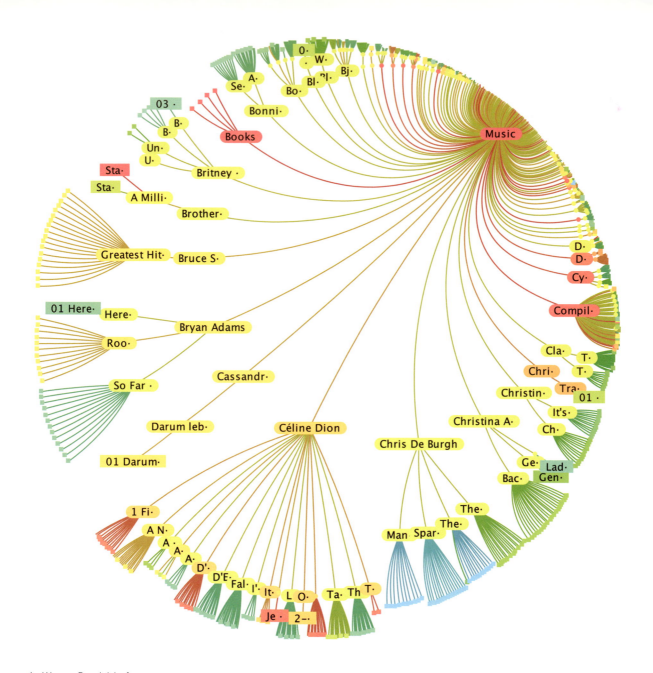

Werner Randelshofer
Treeviz
2007

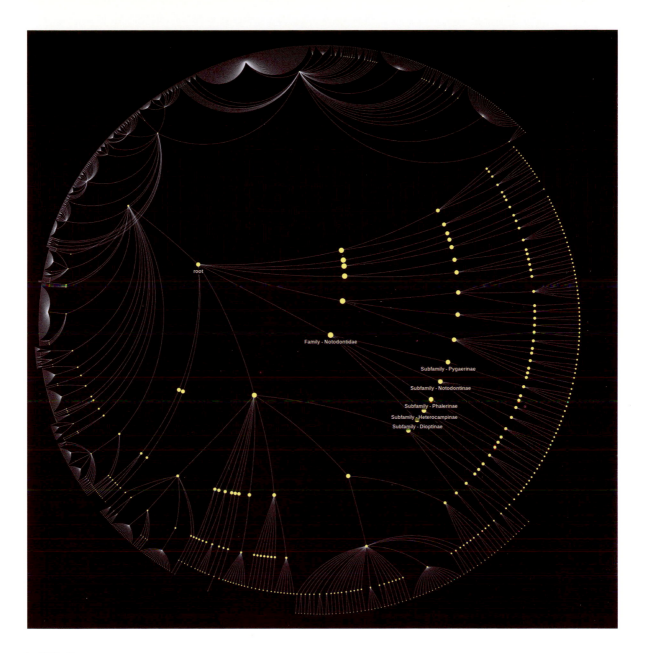

root

Family - Notodontidae

Subfamily - Pygaerinae

Subfamily - Notodontinae

Subfamily - Phalerinae

Subfamily - Heterocampinae

Subfamily - Dioptinae

Philip Bjorge
**Pacific Northwest moths
taxonomic hypertree**
2011

A large taxonomic tree of more
than one thousand species of moths
native to the Pacific Northwest region.
After some initial research on the
most appropriate visualization model,
Philip Bjorge chose a hyperbolic tree
technique, which provides an intuitive
user navigation readily displayable on
the web.

1

2

3

RECTANGULAR TREEMAPS

The rectangular treemap, sometimes called the mosaic graph, is a space-filling visualization model used for displaying hierarchical data by means of nested rectangles. Each major branch of the tree is depicted as a rectangle, which is then sequentially tiled with smaller rectangles representing its subbranches. The area of each individual cell generally corresponds to a given quantity or data attribute, for example size, length, price, time, or temperature. Color can indicate an additional quality, such as type, class, gender, or category. Even though area-based visualizations have been used for many decades, it was Ben Shneiderman who introduced the concept of recursive tiling in the early 1990s as a means of accommodating numerous hierarchical levels. Treemaps have recently become one of the most widespread methods for visualizing hierarchy, primarily due to their efficient and adaptable use of space, easily grasped structure, and ability to display thousands of entities simultaneously while still maintaining fairly good legibility. They have become a major object of study for modern computer science and epitomize the recent growth of information visualization.

Grand Divisions.

WESTERN CONTINENT, 14 millions square miles

UNITED STATES.

TERRITORY.

NORTH AMERICA.

MEXICO.

2,500,000.

7,200,000

1,200,000.

Square Miles.

PERU.

SOUTH AMERICA.

950,000.

BRAZIL.

6,800,000

Square Miles.

2,700,000.

EASTERN CONTINENT, 32 millions square miles.

EUROPE.

3,500,000

RUSSIA.
2,000,000
square miles.

square miles.

Siberia.

4,800,000

square miles.

ASIA

17,600,000

square miles.

CHINESE EMPIRE.
4,500,000
square miles.

CHINA PROPER
1,500,000
square miles.

HINDOOSTAN,
1,300,000
square miles.

AFRICA

11,000,000

square miles.

NEW HOLLAND

3,000,000

square miles.

William Channing Woodbridge
Comparative Chart of the Extent of Countries
1845

A comparative diagram showing the size and population of each continent and country of the world, part of a large physical, political, and statistical world atlas compiled by the American geographer and educational reformer William Woodbridge. The diagram comprises three major "continents": Western Continent, Eastern Continent, and New Holland (the historical name for Australia). The two first continents are divided into major regions, such as North America, South America, Europe, and Asia, then subdivided even further into subsets of selected countries, such as Mexico, Peru, Brazil, and Russia.

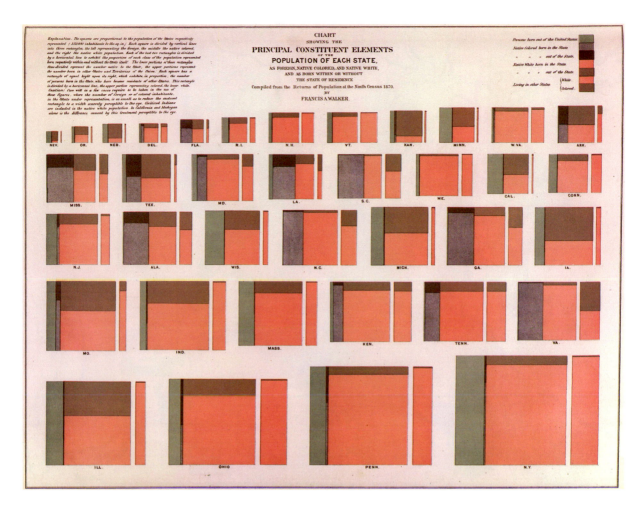

Francis A. Walker

Chart Showing the Principal Constituent Elements of the Population of Each State
1874

A remarkable chart compiled from the ninth census of the United States, taken in 1870. This not only is one of the earliest examples of a rectangular treemap, but also makes compelling use of the small multiples technique, a popular visualization strategy based on a grid of small similar graphics, allowing for easy comparison among them. The squares are proportional to the population of each state. Each square is divided by vertical lines into three rectangles: the left representing the foreign-born population; the middle, the native nonwhite population; and the right, the native white population. Each of the last two rectangles is divided by a horizontal line to show the proportion of each class of the population born within and outside the state itself. The lower of these two rectangles depicts the population native to the state, while the upper one exhibits, in proportion, the number of people born in other states and territories of the Union. Each state also has a rectangle of equal height to its right, representing the people born in the state who have become residents in other states; this is divided by a horizontal line into "colored" (top) and "white" (bottom).

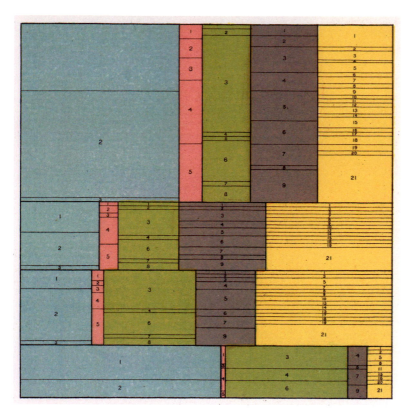

Henry Gannett
Classification of the Occupations by Race and Nativity
1900

A chart that was part of the twelfth census of the United States, prepared under the supervision of geographer Henry Gannett (1846–1914). Conducted in 1900, the twelfth census determined the resident population of the United States to be 76,212,168, a substantial increase of 21 percent over the 1890 census. This chart depicts the population's most common occupations, from left to right: agricultural pursuits (blue), professional services (pink), domestic and personal services (green), trade and transportation (gray), and manufacturing and mechanical pursuits (yellow). These occupations are divided into four horizontal bands among four main groups categorized by race and birth, from top to bottom: native white of native parents, native white of foreign parents, foreign white, nonwhite.

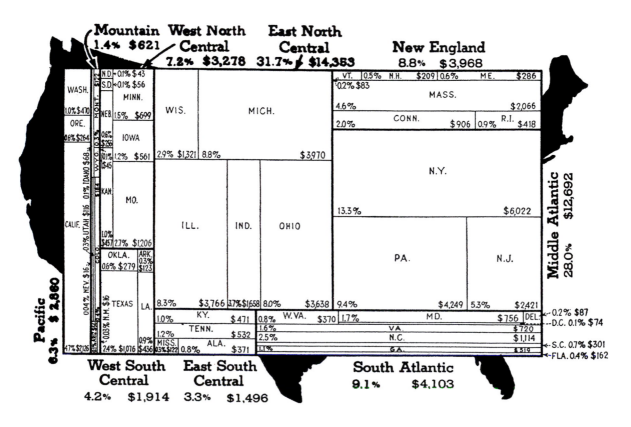

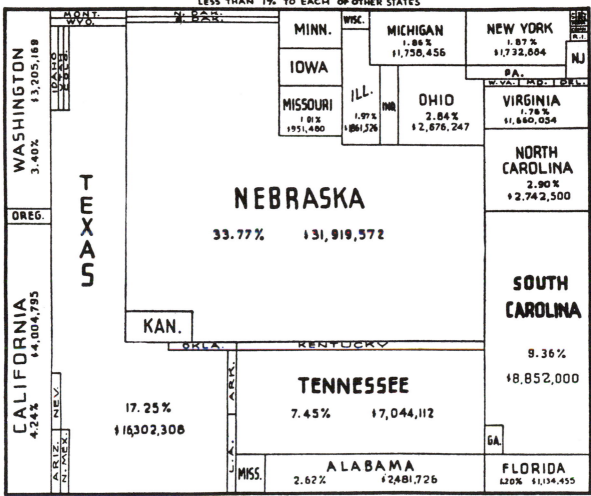

TOTAL OF LOANS AND GRANTS IN THE UNITED STATES, $94,526,263
93.50% TO 15 STATES AS SHOWN BELOW
LESS THAN 1% TO EACH OF OTHER STATES

MONT.
WYO.
N. DAK.
S. DAK.

MINN.
WISC.
MICHIGAN
1.86%
$1,758,456
NEW YORK
1.87%
$1,732,884
R.I.
NJ

WASHINGTON
$3,205,168
IDAHO
UTAH
COLO.

IOWA

PA.
W. VA. MD. DEL.

OREG.

MISSOURI
1.01%
$951,480
ILL.
1.97%
$1,861,526
IND.
OHIO
2.84%
$2,676,247
VIRGINIA
1.78%
$1,660,054

TEXAS

NEBRASKA
33.77% $31,919,572

NORTH
CAROLINA
2.90%
$2,742,500

CALIFORNIA
4.24%
$4,004,795
NEV.

KAN.

SOUTH
CAROLINA

9.36%
$8,852,000

ARIZ.
N. MEX.

OKLA.
KENTUCKY

17.25%
$16,302,308
ARK.

TENNESSEE

7.45% $7,044,112

GA.

L.A.
MISS.
ALABAMA
2.62% $2,481,726
FLORIDA
1.20% $1,134,455

Public Works Administration allotments for nonfederal power projects
From Willard C. Brinton,
Graphic Presentation
1939

Area-based chart of the United States first published in *Public Utilities Fortnightly* in 1938. The Public Works Administration (PWA) was a construction agency created in the United States in June 1933 as part of the New Deal program of recovery from the Great Depression. Dissolved in 1943, the PWA spent more than six billion dollars on numerous wide-ranging public works such as bridges, hospitals, and schools. Even though emptied of any geographical reference, this area-based map of the United States, with the size of each state representing the percentage and value in US dollars of PWA allotments for nonfederal power projects, still maintains the approximate geographical location of each state within its rectangular construct.

The United States manufacturing output
From Willard C. Brinton,
Graphic Presentation
1939 (opposite)

Chart showing an area-based map of the United States, originally published in *BusinessWeek* magazine in 1937. The areas of each state are proportional to their manufacturing output in 1935. It intentionally departs from an actual geographical map, using instead a rectangular tiling format to display the areas of the various states.

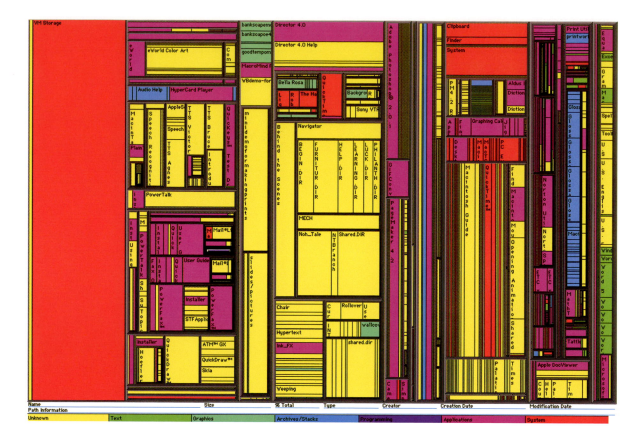

Ben Shneiderman
Rectangular treemap
1991

A treemap representation of the hierarchical, nested folder structure of a computer's hard drive. In 1990, while trying to solve the common problem of a filled hard drive, Shneiderman became obsessed with the idea of creating a compact visualization of directory tree structures. After trying a few node-link diagrams, he decided to explore ways of fitting a tree into a space-constrained layout. By rejecting solutions that generated blank spaces and overlaps, Shneiderman came up with a strategy of splitting the screen into rectangles in alternating horizontal and vertical directions while navigating down the various hierarchical levels of his hard drive. Even though area-based visualizations had been used for many decades, Shneiderman's process introduced a recursive tiling algorithm that has truly revolutionized the modern visualization of tree structures. Since then many variations of the original rectangular treemap have emerged, and many alternative types, such as circular and Voronoi treemaps, have also recently been developed.

Jarke J. van Wijk, Huub van de Wetering, Mark Bruls, Kees Huizing, and Frank van Ham
SequoiaView
1999 (opposite)

Visualization made with SequoiaView of the contents of a hard disk, using Shneiderman's treemap algorithm.

Each rectangle represents a file, with the area and color indicating file size and file type. To make the diagram's hierarchical structure obvious, the authors introduced two techniques: a "squarifying" algorithm (similar to the one used to create the *Map of the Market*, opposite top) designed to form rectangles that are closer to squares, and a cushion technique (shown here) that gives tiles an explicit shading. SequoiaView has been downloaded more than a million times and recently led to the spin-off company MagnaView, which employs a further generalization of these ideas to visualize business data.

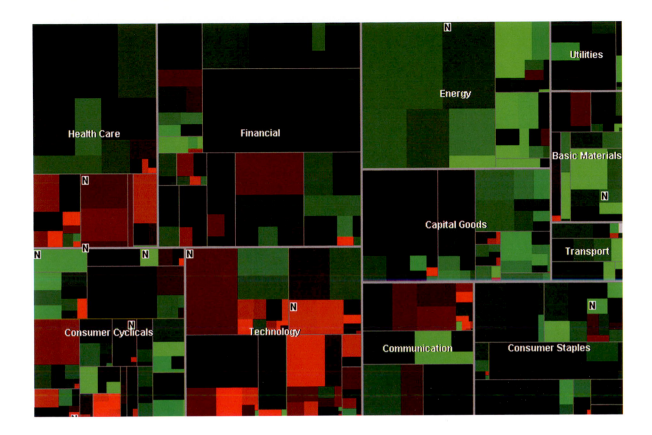

Martin Wattenberg
Map of the Market
1998

A remarkable, long-lasting treemap created by Martin Wattenberg for *SmartMoney* in 1998. This diagram not only popularized the rectangular treemap technique and made it a standard for visualizing financial data, but also was one of the earliest interactive visualizations online, inspiring many subsequent projects. The map uses a variant of Shneiderman's technique, but it introduced a new "squarifying" algorithm that creates tiles that are close to a square in shape, resulting in a uniform, legible layout that facilitates interaction. Each tile represents a publicly traded company, with area denoting market capitalization and color expressing change in stock price since previous market close (increases in green, decreases in red). Tiles are grouped by main categories, such as "Health Care," "Financial," and "Technology," which provide the user with a quick glance at the performance of a given industry. Still in existence and fully operational fifteen years after its launch, the *Map of the Market* is one of the longest-lived online visualizations.

Jean-Daniel Fekete
**Treemap visualization of the
Linux kernel 2.5.33**
2002

A rectangular treemap depicting
the entire Linux kernel—the basis of
the Linux family of UNIX-like operating
systems. Rectangles represent files,
and their size is proportional to the
file's size. They are colored according
to their file extension: yellow (source
file), pink (header file), dark blue (text
file), light blue (makefiles), red (shell
scripts), green (images), or gray (files
with nonregistered suffixes). Most red
and green files are not visible because
they are so small that each of their
rectangles occupies less than a pixel.

Marc Smith
Netscan Usenet treemap
2003

A dense treemap visualization
produced by the Netscan System, a
Microsoft Research tool that analyzes
the activity and conversation threads
within Usenet newsgroups. Created
in 1979, Usenet is one of the oldest
online discussion systems, still widely
in use today. The chart depicts a
year of messages among all Usenet
newsgroups. Each tile represents
a specific newsgroup, and its area
corresponds to the number of received
messages. Color signifies variation
in the number of messages from the
previous year: growth (green) and
decline (red).

Marcos Weskamp
Newsmap
2004

An online treemap visualization of daily articles compiled by the Google News aggregator. Each individual tile represents a cluster of news stories (or articles) that share similar content. Size indicates the number of related articles within a single news cluster, while color is used to aggregate these clusters into seven larger categories, including "World," "Business," "Technology," and "Sports." To complement the large, topical view of the global news landscape, users can filter the content of a given subset by either country or thematic category to examine it in more detail. Following Shneiderman's and Wattenberg's efforts, Weskamp's *Newsmap* generated a third wave of popularity for the rectangular treemap.

Martin Wattenberg
Color Code
2005

Interactive treemap of more than thirty-three thousand nouns selected from WordNet—a large lexical database of English. Each tiny rectangle corresponds to a word, which is assigned the average color of fifty images found by submitting that word to the Yahoo! image search engine. The words are clustered by meaning and together form a visual atlas of the English language.

Richard Wettel and Michele Lanza
CodeCity
2006

Image from *CodeCity: Software Systems as Cities*, a research project on software visualization revolving around a city metaphor. With this approach, industrial-size software systems are visualized in a 3-D treemap environment that resembles an urban layout. The districts of the city represent the system's packages, and the buildings represent its classes. The visible properties of the city's elements reflect a configurable set of software metrics: the building height is proportional to the number of methods of the class, the base size shows the number of attributes, and the color reflects the number of lines of code (the more lines of code, the more intense the shade of blue).

Julien Bayle
Visualization of Marseille youth hostel statistics
2008

A piece commissioned by the Marseille Youth Hostel to map its total number of visitors by nationality, using a "squarifying" area-based diagram. It was exhibited in 2008 on the hostel's website as well as on-site.

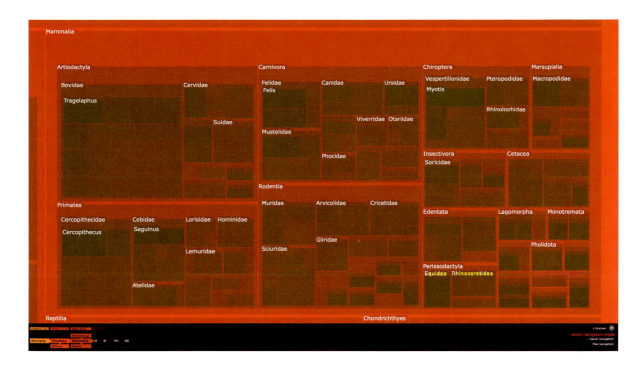

Bestiario
Biodiversity tree
2010 (above)

A treemap depicting the large and expanding database of the Natural Science Museum of Barcelona, which contains fifty thousand records collected throughout the last century. Most of the registered samples are mollusks, vertebrates, and arthropods. They are native to places all over the world, with higher densities of specimens from the Iberian Peninsula and the western Mediterranean Sea. This visualization maps all species in a nested mechanism, based on the modern hierarchical biological classification system of kingdom, phylum, class, order, family, genus, and species.

The Hive Group
Most Powerful and Deadliest Earthquakes since 1900
2011 (below)

A diagram built using Honeycomb Rich. This visualization provides an overview and analysis of the world's deadliest earthquakes since 1900, organized by country.

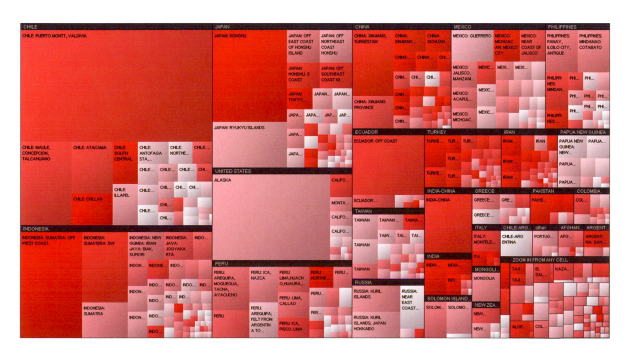

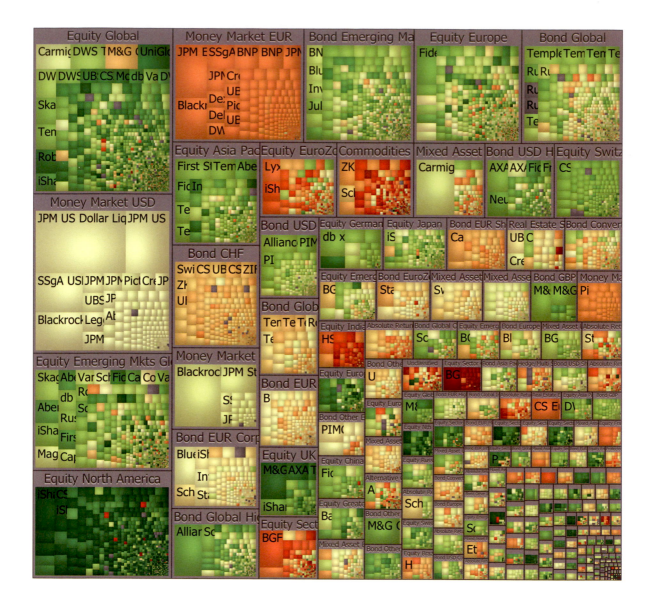

Macrofocus GmbH
Lipper Ch120501
2012

A rectangular treemap that illustrates all the investment funds registered in Switzerland, grouped by category. The size of each rectangle is proportional to total assets under each fund's management. Colors represent the funds' six-month performance in red (losses) or green (profits).

Theodor S. Klemming,
Panopticon Software AB
Telecom network traffic and QoS (quality of service) analysis dashboard
2012 (opposite)

Interactive treemap, part of an online dashboard that analyzes telecom network performance indicators, based on real-time feeds. Operators use this information to efficiently administer network capacity. The chart gives an overview of various statistics grouped by country, with the size of tiles indicating the volume of calls made.

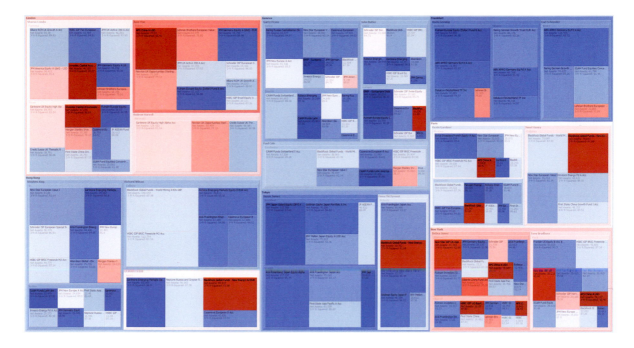

Peter Simpson,
Panopticon Software AB
Fund of funds analysis dashboard
2012 (above)

Interactive treemap, part of an
online dashboard that highlights the
risk and volatility of financial products.
The chart depicts a fund of funds
portfolio, with tile size representing net
assets and color conveying a selected
statistic from a set of available options.

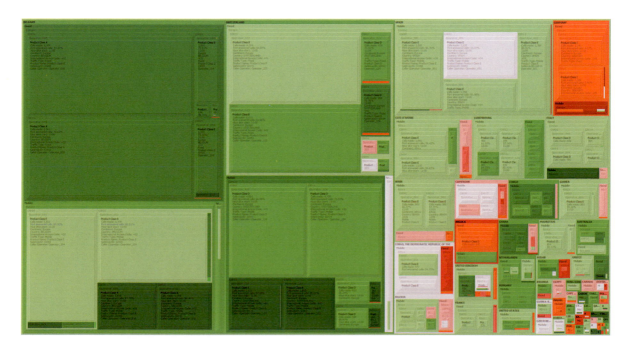

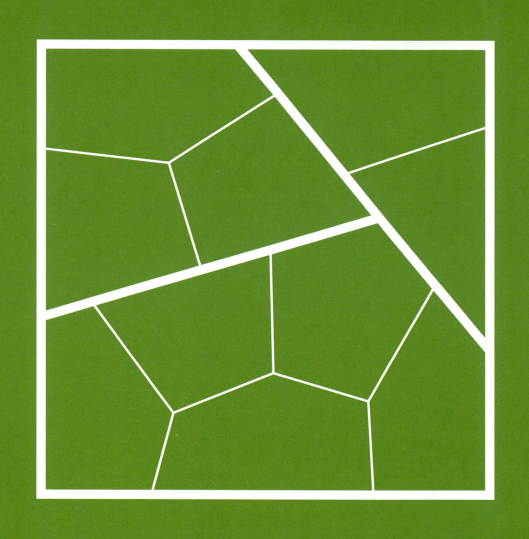

VORONOI TREEMAPS

Voronoi treemaps are a recent variation based on a mathematical segmentation of Euclidean space that dates back to Descartes. In its modern incarnation, this tiling mechanism is called Voronoi tessellation or Voronoi decomposition, named after the Ukrainian mathematician Georgy Voronoy, who in the early 1900s defined and studied the general proprieties of this adaptable lattice. Typically a polygonal cell is generated for each point in a given set of seeds. Each cell describes the region that is closer to its seed than to any other in the set. A further breakdown of subcells within these areas results in a perfect structure for continuous hierarchical clustering. Even though its recursive composition is similar to rectangular treemaps, the Voronoi treemap allows an improved subdivision of a given area that avoids similar shapes and aspect ratios, by making the location and contour of individual cells highly adaptive and configurable. Due to their flexible organizational principle, Voronoi treemaps are known for their organic layouts, featuring a rich, diverse assortment of shapes and configurations that can resemble stained glass or enthralling natural patterns. The model has wide applicability and it has proved popular in the visualization of file systems and genome data.

René Descartes
Vortices
From *Principia Philosophiae*
1644

An illustration of an explanation of the universe that was widely accepted in the seventeenth century, based on the Cartesian system of vortices: large whirlpools of tenuous or ethereal matter that were thought to move the planets and their satellites by contact. In *Principia Philosophiae* (*Principles of Philosophy*), Descartes expounds on the theory of celestial vortices in several illustrations similar to this one. In this diagram, vortices carry the planets around the sun. The sun (*S*) stands in the middle of the central vortex (*A, Y, B, M*), surrounded by contiguous vortex systems with centers *C, K, O,* and *L*.[1]

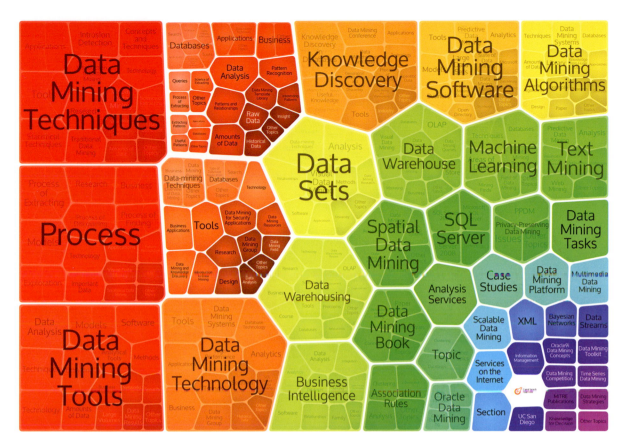

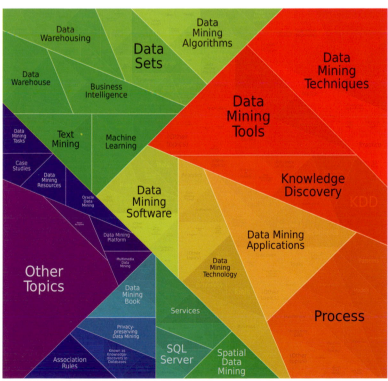

Stanislaw Osinski and Dawid Weiss
Carrot Search FoamTree
2010

JavaScript Voronoi treemap with a physics-inspired layout algorithm developed by Carrot Search. Carrot Search provides various text-mining tools and is best known for its Carrot2 project, an open-source search-results clustering engine that arranges collections of documents (mostly but not only search results) into thematic categories (above).

A layout variation of the original FoamTree Voronoi treemap that employs an alternative polygonal construct (left).

Oliver Deussen
Eclipse Voronoi treemap
2010

A Voronoi treemap of the hierarchical
file structure of the multilanguage
software development system Eclipse,
showing fifteen thousand classes.

Jörg Bernhardt, Juliane Siebourg, Julia Schüler, and Henry Mehlan
Vortices (Omics data visualization using treemaps)
2011

A Voronoi treemap where cells represent *Bacillus subtilis* genes. Following the human genome sequencing, "omics" is a recent neologism that refers to a variety of areas in systems biology that end in "-omics," such as genomics, proteomics, transcriptomics, metabolomics, and metallomics. Most omics studies focus on the functions, behaviors, and interactions of genes, molecules, and proteins. This diagram shows the difference in gene expression between a *Bacillus subtilis* culture grown under optimal conditions and one where cells suffered from glucose starvation. Jörg Bernhardt and his team have become strong advocates of the use of Voronoi treemaps in bioinformatics, specifically for mapping and analyzing proteomes (sets of proteins expressed by a genome, tissue, cell, or organism).

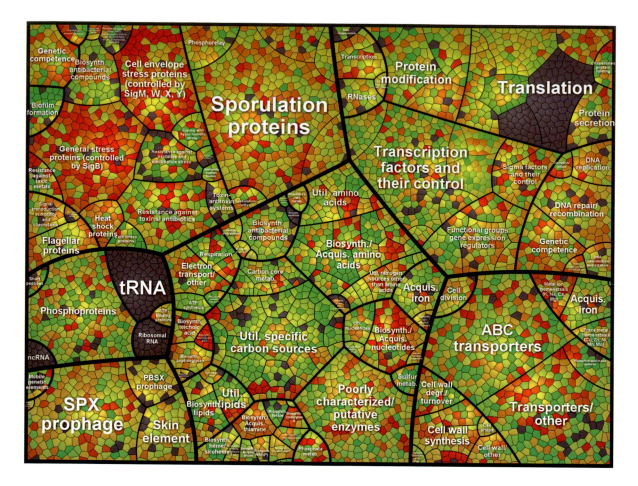

Jörg Bernhardt, Juliane Siebourg,
Julia Schüler, and Henry Mehlan
**Vortices (Omics data visualization
using treemaps)**
2011

A Voronoi treemap depicting an
experiment in arranging functional
categories of *Bacillus subtilis*, where
genes involved in the same cellular
function have been placed in close
proximity within treemap clusters.
The green-yellow-red color gradient
illustrates the differences in gene
response to an air plasma treatment
and an argon plasma treatment. The
red color highlights a stronger gene
activity in response to argon plasma,
while genes with green color show more
activity in air plasma–treated cells.

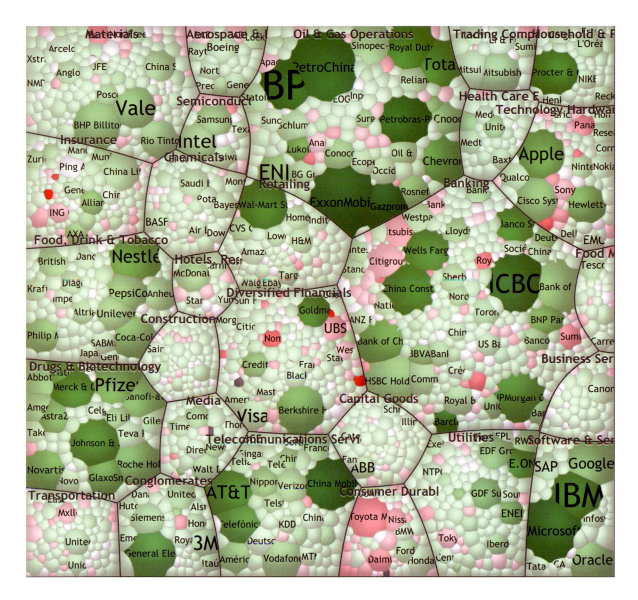

Macrofocus GmbH
Forbes Global 2000–10
2012

A Voronoi treemap generated by
Macrofocus of two thousand public
companies. The area of each polygon
is proportional to a company's market
value; color represents profits (green) or
losses (red).

CIRCULAR TREEMAPS

One of the most recent treemap variants uses circles instead of rectangles as part of its organizing mechanism. Each branch or section of the tree is represented by a circle, which is then filled with smaller circles representing subsections. As with other space-filling methods, the area of each individual circle may correlate with a given quantity or data attribute such as file size, while color may imply an additional quality or category such as file type. Even though the circular treemap's hierarchical structure is quite explicit and its patterns may be appealing, the wasted space between its cells make it a fairly ineffective visualization technique, particularly for incorporating a large number of levels or ranks. Because of this, the model has remained somewhat experimental and hasn't quite gained the same traction as its other treemap counterparts. Circular treemaps have been employed almost exclusively in the depiction of archives and directories of digital files.

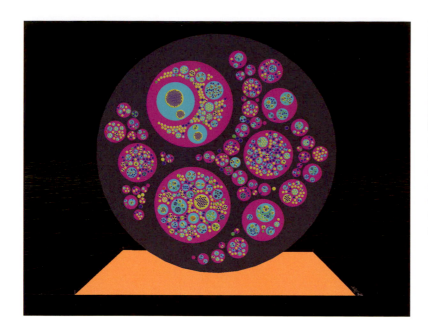

Thomas P. Caudell, Lisong Sun,
and Steve Smith
**Force-directed recursive layout
of tree hierarchies (FROTH) for
immersive network monitoring**
2003

Diagram generated by using the
FROTH method, an incremental layout
algorithm designed to be used for
real-time, immersive monitoring of
network traffic. It borrows a treemap
nesting construct but uses a system of
circles within circles instead of the more
standard tiled rectangles.

Kai Wetzel
Pebbles
2003

A map of a vast directory of
computer files, with color indicating
file type. Pebbles was one of the
first projects to use a nested-circle
treemap structure, and it inspired
a series of followers. According to
Wetzel, the idea came to him while
he was looking at a screen saver that
represented hyperbolic geometry
as an arrangement of circles. When
Wetzel first posted about the project,
he humbly considered the model
an evolutionary dead end, given its
inefficiency in space filling. But, despite
some challenges, this novel visual
method can allow for fast zooming in
on branches, since its layout doesn't
need to be recalculated with each
zoom.

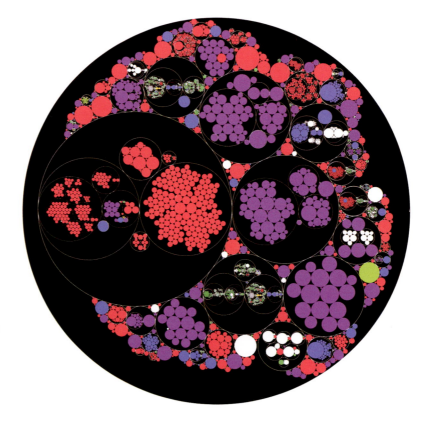

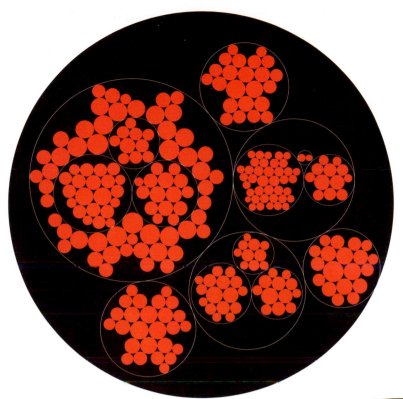

Kai Wetzel
Pebbles
2003

Detail of opposite.

Kai Wetzel
Pebbles
2003

A circular treemap of a directory of
digital images that features the images
themselves inside each circle.

Werner Randelshofer
Treeviz
2007

A circular treemap that charts a directory of computer files. Treeviz (see Chapter 06, page 141) was created to identify usage patterns on an e-learning and file-sharing platform hosting about one million files. The tool uses a variety of visualization techniques to describe the structure of files in their folder hierarchy: circular treemaps, rectangular treemaps, sunburst trees, icicle trees, and hyperbolic trees. All of these visualizations may use a color gradient to designate file properties such as creation date and ownership. The circular treemap and the rectangular treemap also use size to indicate how much storage space files occupy.

Werner Randelshofer
Treeviz
2007

An alternate view of a circular treemap generated with Treeviz.

Katayoon Etemad and
Sheelagh Carpendale
ShamsehTree
2009

An interactive circular treemap for
depicting large hierarchies, inspired by
natural floral motifs and symmetrical
phyllotactic patterns. The chart uses
a different circle-packing method,
ordering the various circles (and nested
clusters) in a series of concentric rings,
with the earliest ancestors (close to the
tree's root) encased in progressively
larger ones that are closer to the edge.
For each node's children, the authors
used a spiraling phyllotactic structure
(resembling the arrangement of plant
leaves on a stem) to draw the inner
circles.

Brent Schneeman
Tweetgeister
2010

A visualization that reveals clusters
of concepts within the social network
Twitter. Postings (tweets) contain 140
characters of information. Groups of
tweets that relate to a specific topic
(for example, a conference or a talk)
are often marked with hashtags (for
example, "#gopdebate" or "#sfriots").
The Tweetgeister project attempts to
diagram how these tweets relate to one
another, based on semantic similarities.
Larger clusters are then subclustered.
The clusters are represented using a
circle-packing layout provided by the
Protovis.js library, where each blue
outlined circle (representing one level
of hierarchy) is laid out in a spiral of
progressively larger ones. Individual
tweets are indicated by solid dots and
are color-coded by age (red being the
oldest, green the most recent).

Julia Dmitrieva and Fons J. Verbeek
Ontology visualization
2010

A representation of ranked structure based on an ontology hierarchy that takes an unconventional containment approach. In place of a traditional two-dimensional space-filling technique, the authors applied a sphere-packing method on a three-dimensional sphere. They augmented this visualization with semantic zoom functionality, which allows users to control the level of detail or hierarchical rank being analyzed.

Jeffrey Heer, Michael Bostock, and Vadim Ogievetsky
Flare package tree
2010

Visualization that looks deeply into the open-source software package Flare visualization toolkit (see Chapter 02, page 93) by showing its various hierarchical classes and subclasses in a series of enclosed circles, as typical of a circular treemap.

Fabian Fischer, Johannes Fuchs, and Florian Mansmann
Analysis of IP network traffic
From "ClockMap: Enhancing Circular Treemaps with Temporal Glyphs for Time-Series Data"
2012

An interactive circular treemap approach that allows for the exploration of hierarchical time-series data. The diagram shows the traffic of a large IP network. Each circle (with a donut glyph) illustrates the twenty-four-hour time sequence of a single IP address (grouped in small bands around the outer ring) or a subnetwork (represented by the larger symbols in the center). Users can further deconstruct each subnetwork into individual IP addresses by simply zooming in on them. Each one-hour slice is colored in a yellow-to-red scheme based on the amount of network traffic.

Macrofocus GmbH
Forbes Global 2000–10
2012

A circular treemap generated by Macrofocus (see Chapter 08, page 169). The size of the circles is proportional to the market values of two thousand public companies, with colors representing losses (red) or profits (green).

SUNBURSTS

Sunbursts, also known as radial treemaps, tree rings, fan charts, or nested pie charts, are a space-filling visualization technique that uses a radial layout, as opposed to the more widespread rectangular type. Similar to radial trees, sunbursts normally start with a central root, or top level of hierarchy, with the remaining ranks expanding outward from the middle. However, instead of a node-link construct sunbursts employ a sequence of segmented rings and juxtaposed cells. As with treemaps, the area of each individual cell usually corresponds to a given quantity or data attribute, with color indicating an additional quality. Ranking is emphasized in two ways: by concentric circles moving toward the diagram's periphery and by groups of subsections appearing within the angle swept out by parent sections. Due to their radial configuration, sunbursts fit well into symmetrical, square areas, but because of their radial distortion, distinctions between layers tend to be harder to perceive. Sunburst diagrams have been particularly popular in the depiction of file systems and genealogical relationships.

Annual net expenditure of the federal government

From Willard C. Brinton,
Graphic Presentation
1939

Two sunburst diagrams first published in *Mechanical Engineering* in 1921, showing the average annual net expenditure of the US federal government from 1910 to 1919. Both diagrams break down the different areas of expenditure in a radial sunburst configuration. The one on the right shows the overall federal spending, and the one below provides a greater level of detail on the budget elements not associated with the costs of war, such as public works, research, and education.

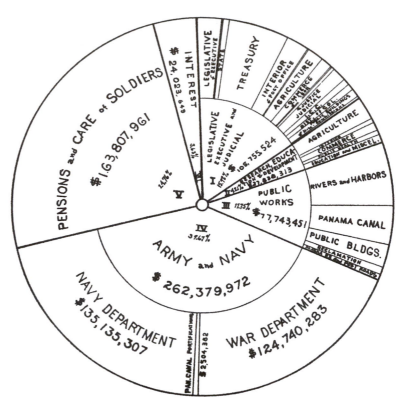

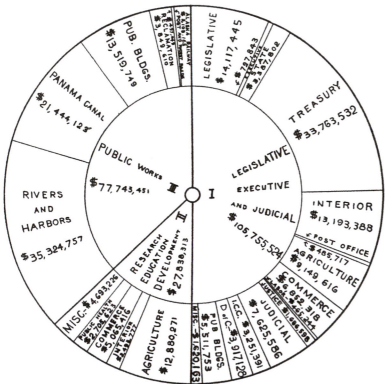

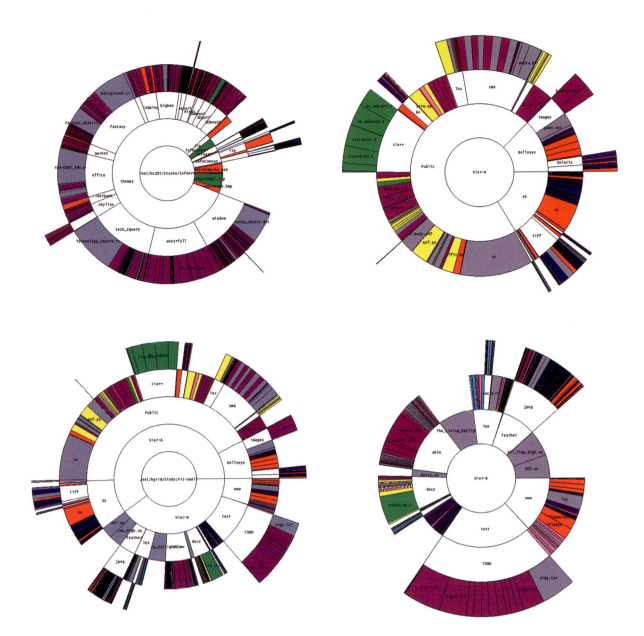

John Stasko
SunBurst
2000

One of the first modern, computer-generated sunburst diagrams. Inspired by Ben Shneiderman's rectangular treemap technique, Stasko introduced an alternative space-filling method for presenting hierarchical information, based on the idea of a nested pie chart, where the root of the tree is the epicenter and deeper ranks or branches move away from the center in a series of segmented rings. Here different iterations of a sunburst diagram map a typical digital file-directory structure, with color indicating file type and the angle swept out by a cell corresponding to file size.

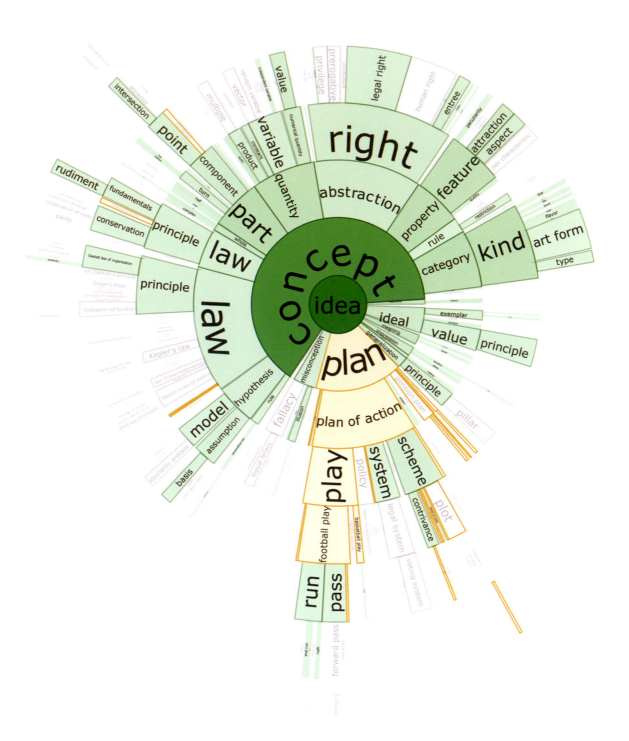

Christopher Collins, Sheelagh
Carpendale, and Gerald Penn
DocuBurst
2008

Sunburst visualization that
analyzes the semantic content of a
text document by comparing word
frequency with a lexical database.

DocuBurst displays the inherent
hierarchical structure of hyponyms—
specific words or phrases whose
semantic meaning is encompassed
by that of a common general class
(for example, "bed" is a hyponym
of "chair," since both are part of the
higher category "furniture"). The
resulting diagrams are overlaid with

occurrence counts of words in a given
document, providing visual summaries
at varying levels of detail. Interactive
document analysis is supported by
geometric and semantic zooming, the
ability to focus on individual words, and
links to the source text.

Marcin Ignac
Carrot2 clusters
2008

Part of an interactive sunburst visualization of search results from the Carrot2 clustering engine (see Chapter 08, page 165). The innermost ring represents root clusters or branches, while the succeeding radial ranks depict their various subclusters. The size of each cell on a ring indicates the number of documents in that cluster or category. Diagrams are interactive, and users can unfold minor categories and zoom into clusters to explore deeper levels.

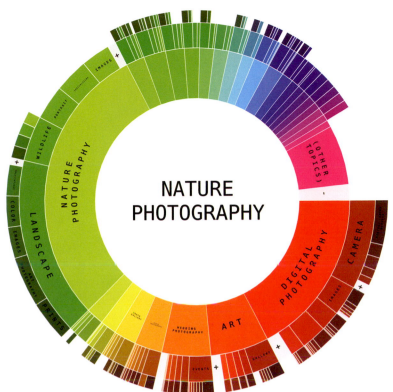

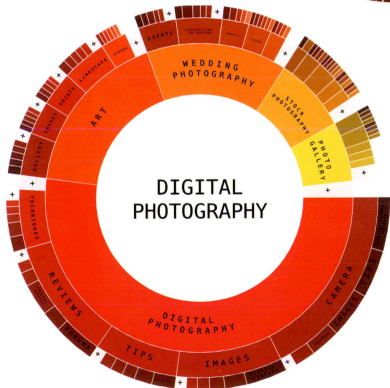

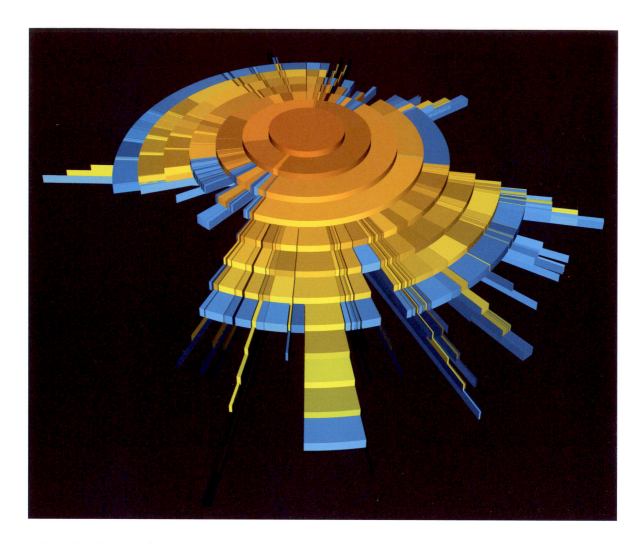

Mesut Kaya, Frank Schäffer,
and David Ikuye
3D Sunburst
2009

Diagram created by 3D Sunburst,
a visual approach to solving the
complexities of file-management
systems. The tool translates any
given folder into a two-color sunburst
diagram that can be viewed and used
as either a two- or three-dimensional
visualization of its content and
structure. Relationships between folders
(yellow) and files (blue) can easily be
understood by looking at the position
and angle of the segments that make
up the layers. A layer can be selected
as a whole to generate a list containing
all of its segments and corresponding
information.

Thomas Gonzalez
Wedge stack graph
2009 (opposite)

A sunburst diagram using the
Axiis open-source data visualization
framework to visualize the breakdown
of medals by country during the Beijing
2008 Olympic Games.

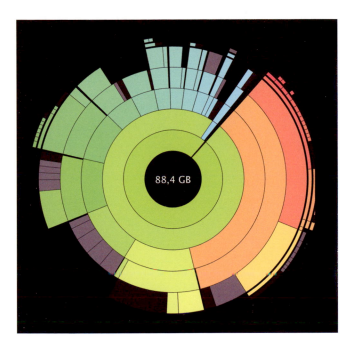

Taras Brizitsky and Oleg Krupnov
DaisyDisk
2009

An interactive sunburst diagram created using DaisyDisk, a simple Mac utility that scans a hard disk to analyze its space allocation. The resulting charts permit users to easily browse files and their names, descriptions, and content and remove unusually large files with a simple drag-and-drop action. As in other sunburst methods for disk-space mapping, color indicates file type, while the angle of each cell indicates a file's size.

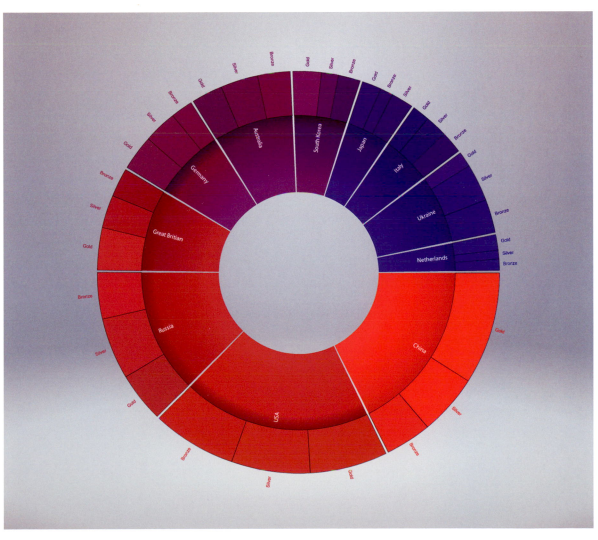

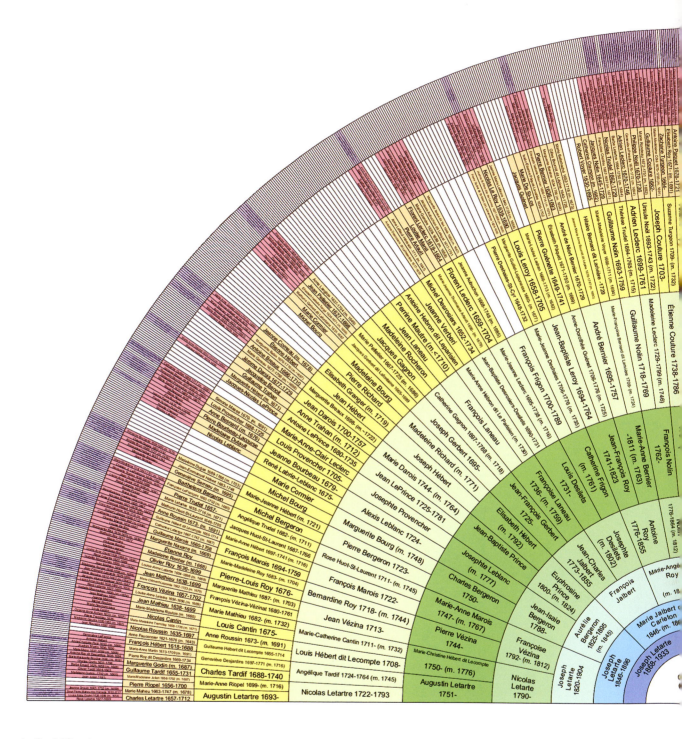

Daniel Seguin

GenoPresse genealogy printing software

2010

A genealogical sunburst diagram, or fan chart, rendered by the GenoPresse software. This diagram displays ten generations of ancestors of Ovila Letarte, born in 1909.

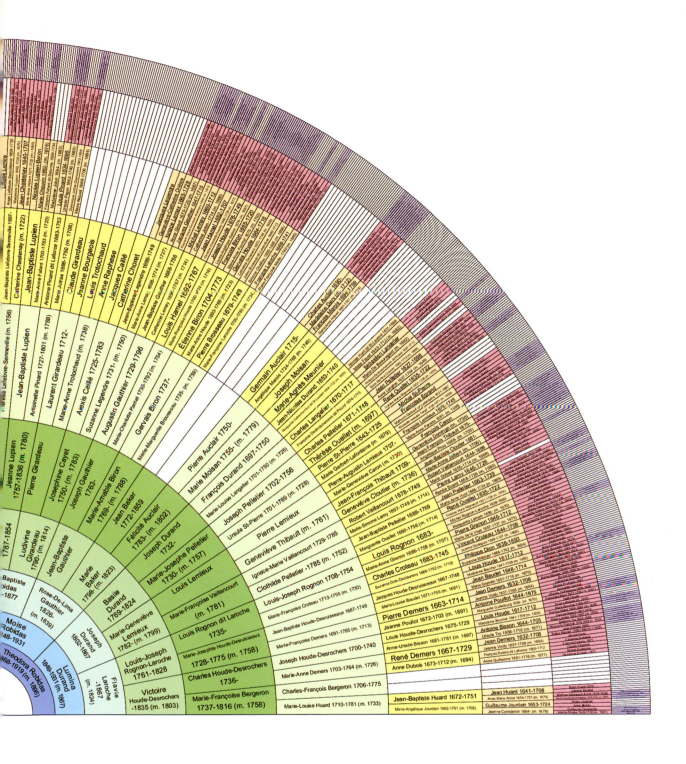

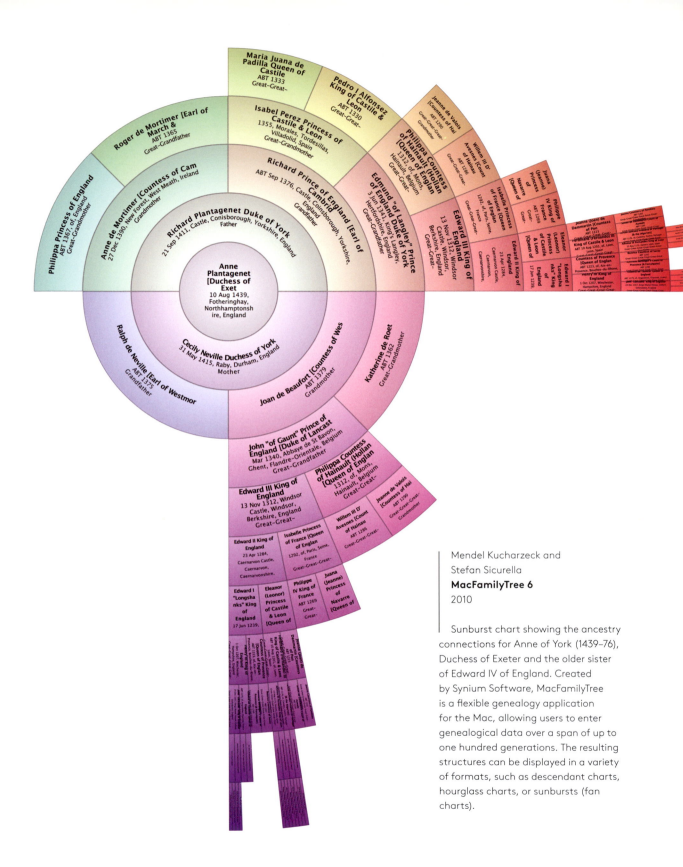

Mendel Kucharzeck and
Stefan Sicurella
MacFamilyTree 6
2010

Sunburst chart showing the ancestry
connections for Anne of York (1439–76),
Duchess of Exeter and the older sister
of Edward IV of England. Created
by Synium Software, MacFamilyTree
is a flexible genealogy application
for the Mac, allowing users to enter
genealogical data over a span of up to
one hundred generations. The resulting
structures can be displayed in a variety
of formats, such as descendant charts,
hourglass charts, or sunbursts (fan
charts).

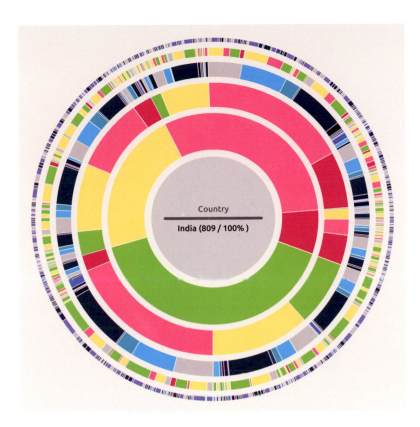

Dennis de Beurs, Simon Epskamp,
Werner Helmich, and Richard Jong
(FrontWise)
UN Global Pulse data flower
2011

Chart representing India's responses
to the 2010 United Nations Global Pulse
survey. This initiative questioned 3,794
inhabitants of five countries: Uganda,
Iraq, Ukraine, India, and Mexico.
Participants were asked two multiple-
choice questions and three open-ended
questions, focusing on their economic
perceptions. The resulting data set was
the starting point of a visualization
competition called "Giving Voice to the
Vulnerable through Data and Design."
The FrontWise information-design team
contributed a custom-built interactive
data explorer showing an overview of
the survey results organized by country.
Five rings represent the five questions;
each ring groups answers based on
the results of the previous question
and color-codes them according to
predefined responses. This methodology
reveals conditional connections among
the answers and may be used to gain
insight into how people cope with
economic uncertainty and perceive their
quality of life and future state of affairs.

Deroy Peraza (Hyperact)
The Champions Ring
2012

Chart depicting the 2009 NBA
Playoffs, from an outer ring that
includes the sixteen qualifying teams,
to the finals between the Los Angeles
Lakers and the Orlando Magic, to
the ultimate winner, the Los Angeles
Lakers, at the very center of the
diagram. Team performance patterns
are revealed over time through the
use of color.

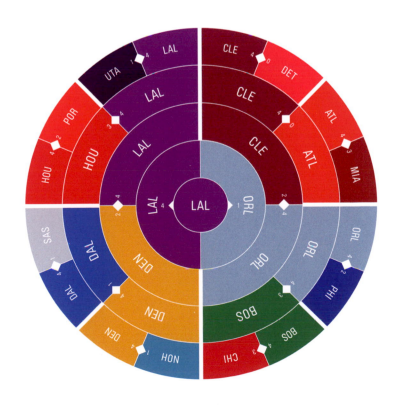

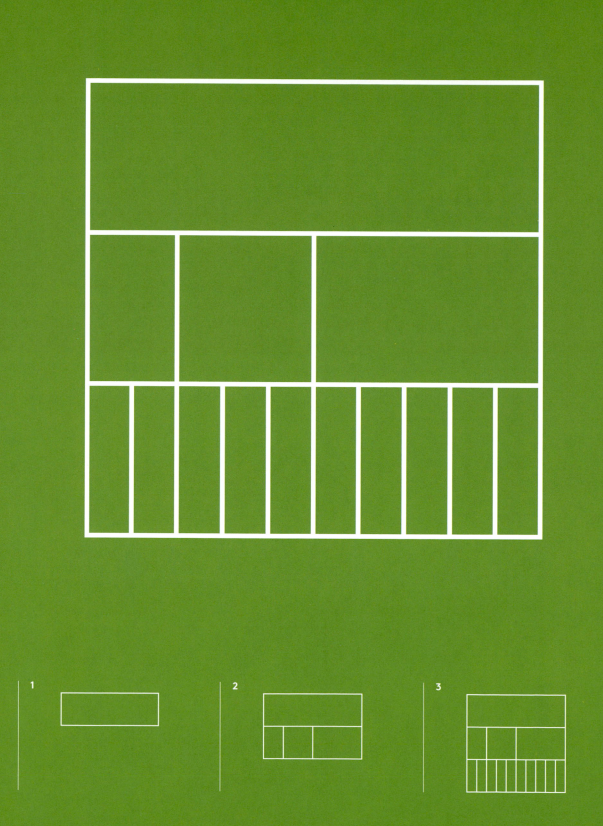

1

2

3

ICICLE TREES

Developed in the early 1980s by the statisticians Beat Kleiner, John Hartigan, Joseph Kruskal, and James Landwehr, icicle trees, also known as icicle plots, are largely similar to vertical and horizontal trees, but instead of a node-link construct, they employ an adjacency-area method, in which a series of juxtaposed rectangles indicate rank. Icicle trees are highly adaptive to space and layout constraints, able to adopt either a vertical, top-to-bottom flow or a horizontal, predominantly left-to-right structure. The area of each individual cell can represent a given quantity or data attribute—as in most space-filling visualization models—and cells typically are grouped into sections covering the width or height (depending on the orientation) of their parent sections. Because the icicle tree doesn't use a nesting mechanism for hierarchical levels, its use of space is not as efficient as that of the treemap or other types of space-filling techniques and can therefore become disproportionally wide or tall. Even though there's a wide applicability to the model, the icicle tree, like the circular treemap, is a lesser-used method for mapping hierarchical structures.

Jean-Daniel Fekete
The InfoVis Toolkit
2005

An icicle tree visualizing the directory of digital files for the InfoVis Toolkit. Among the many models offered by this early interactive graphics toolkit written in Java are several tree schemes, along with other, more conventional methods, such as scatter plots and time series.

Alexandru Telea, David Auber, and Fanny Chevalier

Visualization of source code structure

From "Code Flows—Visualizing Structural Evolution of Source Code" 2007

Detail of a visualization mapping the evolution of a computer program's source-code structure and its changes over time. To create this diagram, the authors extracted abstract syntax trees from consecutive revisions of the program's source code files (stored in a repository), found similar structures in consecutive trees using a tree-matching algorithm, and finally drew the trees using icicle plots that resemble shaded tubes. Colors indicate the types of syntactic constructs in the code, such as functions, classes, iterative statements, and declarations.

Music

A-ha
Céline Dion
Compilations
Depeche Mode
Enya
Kate Bush
Kim Wilde
Laura Pausini
Madonna
Mike Oldfield
Queen
R.E.M.
Roxette
Texas
The Corrs
Werner Randelshofer

Werner Randelshofer
Treeviz
2007

Icicle tree created with Treeviz (see Chapter 09, page 174) to map a large musical database organized by the common hierarchy of music, artist, album, and song.

Werner Randelshofer
Treeviz
2007

Alternate icicle tree model using Treeviz to map the same data set displayed in the previous figure. Here, the tool highlights a specific section of albums and songs by the artist Céline Dion and displays it on the right.

Rob Shell
Joint capability areas hierarchy
2010

An icicle tree that illustrates the hierarchical relationships among the joint capability areas (JCAs) of the US Department of Defense. JCAs are used to describe the range of Department of Defense activities, grouped by function, to support capability analysis, strategy development, investment decision making, capability portfolio management, and capabilities-based force development and operational planning. The goal of this project was to diagram the nine topmost JCAs (tier 1) and their subtiers (tiers 2 through 6). The root node, "Joint Capability Areas," appears on the left, with child nodes to the right. The size and color of each rectangle indicate the number of capabilities (descendants).

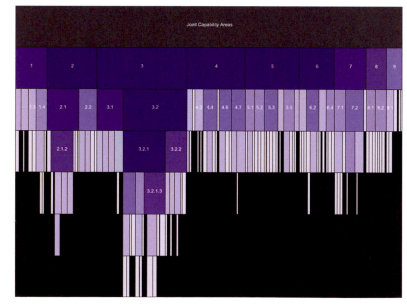

Rob Shell
Joint capability areas hierarchy
2010

An inverted view of the icicle tree shown in the previous figure. In this configuration, the root node, "Joint Capability Areas," appears at the top, with child nodes underneath. This demonstrates the flexibility of the icicle model to adapt to various layout constraints and requirements.

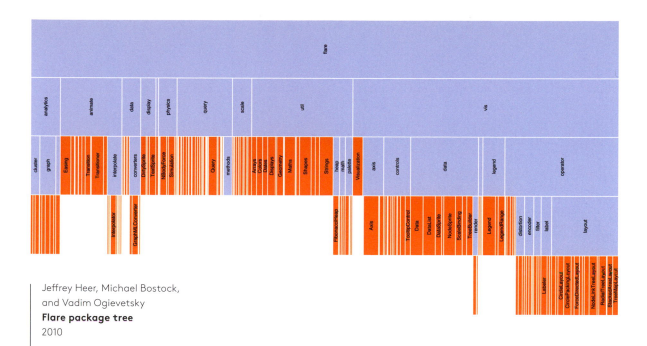

Jeffrey Heer, Michael Bostock,
and Vadim Ogievetsky
Flare package tree
2010

An icicle tree showing the various
hierarchical classes and subclasses
of the Flare visualization toolkit (see
Chapter 02, page 93) as a series of
juxtaposed rectangles.

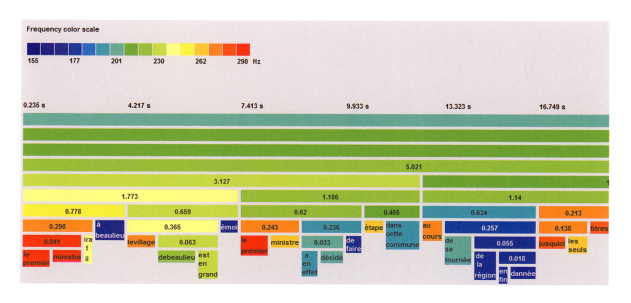

Céline De Looze
**ADoReVA (automatic detection
of register variations)**
2010

A layered icicle tree diagram depicting register changes in speech. In sociolinguistics, register (or pitch) and tempo variations can provide valuable insight into a speaker's identity and socioemotional state. The author developed a clustering algorithm called ADoReVA that detects these variations, groups consecutive speech units, and places them in a hierarchical nesting configuration based on their register level and span. The color of each unit indicates register level (hertz frequency): the warmer the color, the higher the frequency.

NOTES

FOREWORD

1 Ben Shneiderman, Cody Dunne, Puneet Sharma, and Ping Wang, "Innovation Trajectories for Information Visualizations: Comparing Treemaps, Cone Trees, and Hyperbolic Trees."

PREFACE

1 Manuel Lima, *Visual Complexity: Mapping Patterns of Information*.

2 Michael Friendly, "Milestones in the History of Thematic Cartography, Statistical Graphics, and Data Visualization: An Illustrated Chronology of Innovations."

INTRODUCTION

The epigraphs on page 14 are drawn from Francis Bacon, *Francis Bacon: The Major Works*, 189, and Merle Miller, *Plain Speaking: An Oral Biography of Harry S. Truman*, 293.

1 *The Holy Bible: King James Version*, Rev. 22:2; Gen. 3:22.

2 J. H. Philpot, *The Sacred Tree in Religion and Myth*, 11. (Citation refers to the Dover edition.)

3 Ibid., 88.

4 Ibid., 38.

5 Manuel Lima, *Visual Complexity: Mapping Patterns of Information*, 25.

6 Jean Paul Richter, *The Notebooks of Leonardo da Vinci*, vol. 1, 205.

7 Jeff Warren, Gabe Smedresman, et al., "On Visual Exegesis."

8 Mary Carruthers, *The Book of Memory: A Study of Memory in Medieval Culture*, 7.

9 P. L. Heyworth, ed., *Medieval Studies for J. A. W. Bennett: Aetatis Suae LXX*, 216.

10 Mary Franklin-Brown, *Reading the World: Encyclopedic Writing in the Scholastic Age*, 141.

11 Charles Darwin, "Letter no. 2465."

12 Theodore W. Pietsch, *Trees of Life: A Visual History of Evolution*, 87.

TIMELINE

1 Francis Bacon, *Francis Bacon: The Major Works*, 175.

2 Ibid., 189.

3 René Descartes, *Principles of Philosophy: Translation with Explanatory Notes*, trans. Valentine Rodger Miller and Reese P. Miller, xxiv.

4 Charles Darwin, *The Origin of Species*, 171.

FIGURATIVE TREES

1 Manuel Lima, *Visual Complexity: Mapping Patterns of Information*, 31.

2 Jeff Warren, Gabe Smedresman, et al.,"The Tree of Virtues & The Tree of Vices."

HORIZONTAL TREES

1 Mary Franklin-Brown, *Reading the World: Encyclopedic Writing in the Scholastic Age*, 137.

MULTIDIRECTIONAL TREES

1 Jean-Baptiste Piggin, "The Great Stemma: A Late Antique Diagrammatic Chronicle of Pre-Christian Time."

2 Mary Franklin-Brown, *Reading the World: Encyclopedic Writing in the Scholastic Age*, 151.

HYPERBOLIC TREES

1 John Lamping, Ramana Rao, and Peter Pirolli, "A Focus+Context Technique Based on Hyperbolic Geometry for Visualizing Large Hierarchies."

VORONOI TREEMAPS

1 I. Bernard Cohen, *From Leonardo to Lavoisier, 1450–1800*. Vol. 2 of *Album of Science*, 54.

BIBLIOGRAPHY

Alexander, Christopher. *Notes on the Synthesis of Form*. Cambridge, MA: Harvard University Press, 1964.

Bacon, Francis. *Francis Bacon: The Major Works*. Oxford World's Classics. Edited by Brian Vickers. New York: Oxford University Press, 2008. First published 2002.

Bates, Brian. *The Real Middle Earth: Exploring the Magic and Mystery of the Middle Ages, J.R.R. Tolkien, and* The Lord of the Rings. New York: Palgrave Macmillan, 2004. First published 2002 by Sidgwick & Jackson.

Bertin, Jacques. *Semiology of Graphics: Diagrams, Networks, and Maps*. Translated by William J. Berg. Madison, WI: University of Wisconsin Press, 1984.

Best, Steven, and Douglas Kellner. *Postmodern Theory: Critical Interrogations*. New York: Guilford, 1991.

Bohnacker, Hartmut, Benedikt Groß, Julia Laub, and Claudius Lazzeroni. *Generative Design: Visualize, Program, and Create with Processing*. New York: Princeton Architectural Press, 2012. Originally published 2009 as *Generative Gestaltung: Entwerfen Programmieren Visualisieren* by Verlag Hermann Schmidt Mainz.

Borges, Jorge Luis. *Collected Fictions*. Translated by Andrew Hurley. New York: Penguin, 1999. First published 1998 by Viking.

Brinton, Willard C. *Graphic Methods for Presenting Facts*. New York: Engineering Magazine Company, 1914.

——. *Graphic Presentation*. New York: Brinton Associates, 1939.

Brown, Lloyd A. *The Story of Maps*. New York: Dover, 1980. First published 1949 by Little, Brown.

Burkert, Walter. *Creation of the Sacred: Tracks of Biology in Early Religions*. Cambridge, MA: Harvard University Press, 1996.

Butler, Jill, Kritina Holden, and William Lidwell. *Universal Principles of Design: 100 Ways to Enhance Usability, Influence Perception, Increase Appeal, Make Better Design Decisions, and Teach Through Design*. Beverly, MA: Rockport, 2007. First published 2003.

Card, Stuart K., Jock D. Mackinlay, and Ben Shneiderman. *Readings in Information Visualization: Using Vision to Think*. San Francisco: Morgan Kaufmann, 1999.

Carruthers, Mary. *The Book of Memory: A Study of Memory in Medieval Culture*. Cambridge, MA: Cambridge University Press, 1990.

Carruthers, Mary, and Jan M. Ziolkowski. *The Medieval Craft of Memory: An Anthology of Texts and Pictures*. Philadelphia: University of Pennsylvania Press, 2004.

Chambers, Ephraim. *Cyclopædia, or, An universal dictionary of arts and sciences: containing the definitions of the terms, and accounts of the things signify'd thereby, in the several arts, both liberal and mechanical, and the several sciences, human and divine: the figures, kinds, properties, productions, preparations, and uses, of things natural and artificial: the rise, progress, and state of things ecclesiastical, civil, military, and commercial: with the several systems, sects, opinions, etc: among philosophers, divines, mathematicians, physicians, antiquaries, criticks, etc: the whole intended as a course of antient and modern learning*. London: J. and J. Knapton, 1728. Accessed January 8, 2013. http://digital.library.wisc.edu/1711.dl /HistSciTech.Cyclopaedia01.

Chi, Ed H. *A Framework for Visualizing Information*. Dordrecht, Netherlands: Kluwer Academic Publishers, 2002.

Christ, Karl. *The Handbook of Medieval Library History*. Edited and translated by Theophil M. Otto. Rev. ed. Metuchen, NJ: Scarecrow Press, 1984.

Cohen, I. Bernard. *From Leonardo to Lavoisier, 1450–1800*. Vol. 2 of *Album of Science*. New York: Scribner, 1980.

Cooper, J. C. *An Illustrated Encyclopedia of Traditional Symbols*. London: Thames & Hudson, 1987.

Crosby, Alfred W. *The Measure of Reality: Quantification in Western Europe, 1250–1600*. Cambridge, UK: Cambridge University Press, 1997.

Crump, Thomas. *A Brief History of Science*. New York: Carroll & Graf, 2002. First published 2001 by Constable.

Dackerman, Susan, Claudia Swan, Suzanne Karr Schmidt, and Katharine Park. *Prints and the Pursuit of Knowledge in Early Modern Europe*. Cambridge, MA: Harvard Art Museums, 2011.

Darwin, Charles. *The Origin of Species*. New York: Gramercy, 1995. First published 1859 by John Murray.

——. "Letter no. 2465." Darwin Correspondence Project Database. Accessed January 9, 2013. http://www.darwinproject .ac.uk/entry-2465/.

Descartes, René. *Principles of Philosophy: Translation with Explanatory Notes*. Translated by Reese P. Miller and Valentine Rodger Miller. Dordrecht, Netherlands: Kluwer Academic, 1991.

DeVarco, Bonnie and Eileen Clegg. "ReVisioning Trees." *Shape of Thought* (blog). Accessed November 16, 2012. http://shapeofthought.typepad.com /shape_of_thought/revisioning-trees/.

Dickinson, Gordon Cawood. *Statistical Mapping and the Presentation of Statistics*, 2nd ed. London: Hodder Arnold, 1973.

Diderot, Denis. "Encyclopedia." In *The Encyclopedia of Diderot & d'Alembert Collaborative Translation Project*. Translated by Philip Stewart. Ann Arbor, MI: Scholarly Publishing Office at the University of Michigan Library, 2002. Originally published as "Encyclopédie." In *Encyclopédie ou Dictionnaire raisonné des sciences, des arts et des métiers*. Paris: Briasson, 1751. Accessed December 7, 2013. http://hdl .handle.net/2027/spo.did2222.0000.004.

Edson, Evelyn. *Mapping Time and Space: How Medieval Mapmakers Viewed Their World*. Vol. 1 of *The British Library Studies in Map History*. London: British Library Board, 1998.

Eloy, Christophe. "Leonardo's Rule, Self-Similarity, and Wind-Induced Stresses in Trees." *Physical Review Letters* 107, 258101 (2011).

FAMSI—Foundation for the Advancement of Mesoamerican Studies. Accessed November 5, 2012. http://www.famsi.org/.

Fergusson, James. *Tree and Serpent Worship*. London: W. H. Allen and Co., 1868.

Foskett, Douglas John. *Classification and Indexing in the Social Sciences*. Washington, DC: Butterworths, 1963.

Franklin-Brown, Mary. *Reading the World: Encyclopedic Writing in the Scholastic Age*. Chicago: University Of Chicago Press, 2012.

Friendly, Michael. "Milestones in the history of thematic cartography, statistical graphics, and data visualization: An Illustrated History of Innovations." Department of Mathematics and Statistics, York University, Toronto, Canada, August 24, 2009. Accessed October 1, 2012. http://www.math.yorku.ca/SCS/Gallery/milestone/milestone.pdf.

Gayford, Martin and Karen Wright, eds. *The Grove Book of Art Writing: Brilliant Words on Art from Pliny the Elder to Damien Hirst*. New York: Grove Press, 2000.

Gerli, E. Michael, ed. *Medieval Iberia: An Encyclopedia*. New York: Routledge, 2002.

Ghent University Library, *Liber Floridus*. Accessed October 28, 2012. http://www .liberfloridus.be/index_eng.html.

Gombrich, E. H. *The Image and the Eye: Further Studies in the Psychology of Pictorial Representation*. London: Phaidon, 1994.

Gontier, Nathalie. "Depicting the Tree of Life: the Philosophical and Historical Roots of Evolutionary Tree Diagrams." *Evolution, Education and Outreach* 4, no. 3 (September 2011): 515–38.

Hageneder, Fred. *The Living Wisdom of Trees: Natural History, Folklore, Symbolism, Healing*. London: Duncan Baird, 2005.

Harris, Michael H. *History of Libraries of the Western World*. Lanham, MD: Scarecrow Press, 1999.

Harvey, P. D. A. *The History of Topographical Maps: Symbols, Pictures and Surveys*. London: Thames & Hudson, 1980.

Heer, Jeffrey, Michael Bostock, and Vadim Ogievetsky. "A Tour Through the Visualization Zoo." *Communications of the ACM* 53, no. 6 (June 2010): 59–67. Accessed December 9, 2013. http://hci .stanford.edu/jheer/files/zoo/.

Heyworth, P. L., ed. *Medieval Studies for J. A. W. Bennett: Aetatis Suae LXX*. New York: Oxford University Press, 1981.

Hobbins, Daniel. *Authorship and Publicity Before Print: Jean Gerson and the Transformation of Late Medieval Learning*. Philadelphia: University of Pennsylvania Press, 2009.

The Holy Bible: King James Version. Dallas, TX: Brown Books, 2004.

Hort, W. Jillard. *The New Pantheon; or an Introduction to the Mythology of the Ancients*. London: Longman, Hurst, Rees, Orme, Brown & Green, 1825.

J. Paul Getty Museum. "Loyset Liédet." Accessed November 2, 2012. http://www .getty.edu/art/gettyguide/artMakerDetails ?maker=1055.

James, E. O. *The Tree of Life: An Archaeological Study*. Leiden, Netherlands: E. J. Brill, 1966.

Jung, Carl Gustav. *Man and His Symbols*. New York: Dell, 1968.

Kemp, Martin. *Visualizations: The Nature Book of Art and Science*. Berkeley: University of California Press, 2001.

Kerren, Andreas, John Stasko, Jean-Daniel Fekete, and Chris North, eds. *Information Visualization: Human-Centered Issues and Perspectives*. New York: Springer, 2008.

Klapisch-Zuber, Christiane. *L'ombre des ancêtres*. Paris: Fayard, 2000.

Korzybski, Alfred. "A Non-Aristotelian System and its Necessity for Rigour in Mathematics and Physics." Paper presented before the American Mathematical Society at a meeting of the American Association for the Advancement of Science, New Orleans, Louisiana, December 28, 1931.

Kramer, Samuel Noah. *History Begins at Sumer: Thirty-Nine Firsts in Recorded History*, 3rd ed. Philadelphia: University of Pennsylvania Press, 1988.

Lamping, John, Ramana Rao, and Peter Pirolli. "A Focus+Context Technique Based on Hyperbolic Geometry for Visualizing Large Hierarchies," CHI Proceedings. Accessed December 19, 2012. http: //www.sigchi.org/chi95/Electronic /documnts/papers/jl_bdy.htm.

Lecointre, Guillaume, and Hervé Le Guyader. *The Tree of Life: A Phylogenetic Classification*. Translated by Karen McCoy. Cambridge, MA: Belknap, 2007.

Lewis, Peter. *Maps and Statistics*. London: Methuen, 1977.

Lima, Manuel. *Visual Complexity: Mapping Patterns of Information*. New York: Princeton Architectural Press, 2011.

Mazza, Riccardo. *Introduction to Information Visualization*. London: Springer, 2009.

Miller, Merle. *Plain Speaking: An Oral Biography of Harry S. Truman*. New York: Berkley, 1974.

Moles, Abraham A. *Information Theory and Esthetic Perception*. Champaign: University of Illinois Press, 1969.

Mullen, Chris. "The Family Tree and Other Metaphors." *The Visual Telling of Stories*. Accessed December 9, 2013. http://www.fulltable.com/vts/s/si/ft.htm.

Murdoch, John E. *Antiquity and the Middle Ages*. Vol. 5 of *Album of Science*. New York: Scribner, 1984.

Padovan, Richard. *Proportion: Science, Philosophy, Architecture*. London: Taylor & Francis, 1999.

Philpot, J. H. *The Sacred Tree in Religion and Myth*. New York: Dover, 2004. Originally published as *The Sacred Tree*. London and New York: Macmillan, 1897.

Pietsch, Theodore W. *Trees of Life: A Visual History of Evolution*. Baltimore, MD: The Johns Hopkins University Press, 2012.

Piggin, Jean-Baptiste. "The Great Stemma: A Late Antique Diagrammatic Chronicle of Pre-Christian Time." *Studia Patristica 62* (2013): 259-78.

Playfair, William. *The Commercial and Political Atlas and Statistical Breviary*. Cambridge, UK: Cambridge University Press, 2005.

Pollack, Rachel. *The Kabbalah Tree: A Journey of Balance & Growth*. Woodbury, MN: Llewellyn Worldwide, 2004.

Pombo, Olga. University of Lisbon. "Combinatória e Enciclopédia em Rámon Lull." Accessed October 16, 2009. http://www.educ.fc.ul.pt/hyper/enciclopedia/cap3p2/combinatoria.htm.

——. *Unidade da Ciência: Programas, Figuras e Metáforas* (Unity of science: programs, figures, and metaphors). Lisbon, Portugal: Edições Duarte Reis, 2006.

Porteous, Alexander. *The Forest in Folklore and Mythology*. New York: Dover, 2002. Originally published 1928 as *Forest Folklore, Mythology, and Romance* by Macmillan.

Preus, Anthony and John P. Anton, eds. *Essays in Ancient Greek Philosophy V: Aristotle's Ontology*. Albany: State University of New York Press, 1992.

Randelshofer, Werner. "Tree Visualization." Accessed December 9, 2013. http://www.randelshofer.ch/treeviz/index.html.

Rendgen, Sandra. *Information Graphics*. Cologne, Germany: Taschen, 2012.

Rhie, Marilyn M., and Robert Thurman. *Worlds of Transformation: Tibetan Art of Wisdom and Compassion*. New York: Tibet House, 1999.

Richter, Jean Paul. *The Notebooks of Leonardo da Vinci, Vol. 1*. New York: Dover, 1970.

Robinson, Arthur H. *Early Thematic Mapping in the History of Cartography*. Chicago: University of Chicago Press, 1982.

Rosenberg, Daniel, and Anthony Grafton. *Cartographies of Time: A History of the Timeline*. New York: Princeton Architectural Press, 2010.

Rossi, Paolo. *Logic and the Art of Memory: The Quest for a Universal Language*. Translated by Stephen Clucas. London: Continuum, 2006. Originally published 1983 as *Clavis Universalis: Arti Della Memoria E Logica Combinatoria Da Lullo A Leibniz* by Societa editrice il Mulino.

Schulz, Hans-Jörg. "treevis.net—A Visual Bibliography of Tree Visualization 2.0." *Computer Graphics and Applications, IEEE* 31, no. 6. Accessed December 9, 2013. http://www.informatik.uni-rostock.de/~hs162/treeposter/poster.html.

Shaw, Artie. *The Trouble with Cinderella: An Outline of Identity*. New York: Farrar, Straus and Young, 1952.

Shneiderman, Ben. "Treemaps for space-constrained visualization of hierarchies." University of Maryland Department of Computer Science. Accessed October 25, 2012. http://www.cs.umd.edu/hcil/treemap-history/.

Shneiderman, Ben, Cody Dunne, Puneet Sharma, and Ping Wang, "Innovation Trajectories for Information Visualizations: Comparing Treemaps, Cone Trees, and Hyperbolic Trees." *Information Visualization* 11, no. 2 (2011): 87–105.

Smith, W. H. *Graphic Statistics in Management*. New York: McGraw-Hill, 1924.

Sowa, John F. "Building, Sharing, and Merging Ontologies." Accessed October 12, 2009. http://www.jfsowa.com/ontology/ontoshar.htm.

The Speculum Theologiae. Yale University Beinecke Rare Book and Manuscript Library Archive. 2006. Accessed October 4, 2012. http://brbl-archive.library.yale.edu/exhibitions/speculum/index.html.

Staley, David J. *Computers, Visualization, and History: How New Technology Will Transform Our Understanding of the Past*. Armonk, NY: M. E. Sharpe, 2002.

Stasko, John. School of Interactive Computing at Georgia Tech Information Interfaces Group website. "SunBurst." Accessed November 19, 2012. http://www.cc.gatech.edu/gvu/ii/sunburst/.

Studtmann, Paul. "Aristotle's Categories." In *Stanford Encyclopedia of Philosophy*, Stanford University. Article published September 7, 2007. Accessed November 30, 2009. http://plato.stanford.edu/archives/fall2008/entries/aristotle-categories/.

Thomas, James J., and Kristin A. Cook. *Illuminating the Path: The Research and Development Agenda for Visual Analytics*. Richland, WA: National Visualization and Analytics Center, 2005.

Thomas, Peter. *Trees: Their Natural History*. Cambridge, UK: Cambridge University Press, 2000.

Thrupp, Sylvia Lettice, ed. *Change in Medieval Society: Europe North of the Alps, 1050–1500*. London: Owen, 1965.

Tidwell, Jenifer. *Designing Interfaces: Patterns for Effective Interaction Design*. Sebastopol, CA: O'Reilly, 2005.

Tufte, Edward R. *The Visual Display of Quantitative Information*, 2nd ed. Cheshire, CT: Graphics Press, 2001.

Van de Mieroop, Marc. *A History of the Ancient Near East ca. 3000–323 BC*. Malden, MA: Blackwell, 2006.

Van Doren, Charles. *A History of Knowledge: Past, Present, and Future*. New York: Ballantine, 1992. First published 1991 by Carol Publishing Group.

Ware, Colin. *Information Visualization: Perception for Design*, 2nd ed. San Francisco: Morgan Kaufmann, 2004.

Warren, Jeff, Gabe Smedresman, et al. "On Visual Exegesis." *The Speculum Theologie in Beinecke MS 416*. Accessed May 21, 2013, http://brbl-archive.library.yale.edu/exhibitions/speculum/v-exegesis.html.

——. "The Tree of Virtues & The Tree of Vices." *The Speculum Theologie in Beinecke MS 416*. Accessed June 25, 2013. http://brbl-archive.library.yale.edu/exhibitions/speculum/3v-4r-virtues-and-vices.html.

Weigel, Sigrid. "Genealogy: On the Iconography and Rhetorics of An Epistemological Topos." Accessed October 1, 2012. http://www.educ.fc.ul.pt/hyper/resources/sweigel/.

Woodward, David, ed. *Art and Cartography: Six Historical Essays*. Chicago: University of Chicago Press, 1987.

Wurman, Richard Saul, David Sume, and Loring Leifer. *Information Anxiety 2*. Indianapolis: Que, 2001.

IMAGE CREDITS

INDEX

Page references to illustrations appear in italics.

A Fellow of the Royal Society of Arts and nominated by *Creativity* magazine as "one of the 50 most creative and influential minds of 2009," **Manuel Lima** is the Design Lead of Codecademy.com, the founder of VisualComplexity.com, and professor of data visualization at Parsons The New School for Design.

With more than ten years of experience designing digital products, Lima has worked for Microsoft, Nokia, R/GA, and Kontrapunkt. He holds a BFA in Industrial Design and an MFA in Design & Technology from Parsons The New School for Design in New York.

Lima is a leading voice on information visualization and has spoken at numerous conferences, schools, and festivals around the world, including TED, Lift, OFFF, Eyeo, Ars Electronica, IxDA Interaction, MIT, Harvard University, the Royal College of Art, Tisch School of the Arts at NYU, EnsAD Paris, the University of Amsterdam, and Medialab-Prado Madrid. He has been featured in various magazines and newspapers, including *Wired*, the *New York Times*, *Science*, *Businessweek*, *Creative Review*, *Fast Company*, *Forbes*, *Grafik* magazine, *SEED*, *étapes*, and *El País*. His latest book, *Visual Complexity: Mapping Patterns of Information* (Princeton Architectural Press, 2011), has been translated into French, Chinese, and Japanese.

Published by
Princeton Architectural Press
37 East Seventh Street
New York, New York 10003

Visit our website at www.papress.com.

Editor: Sara E. Stemen
Designer: Jan Haux

Special thanks to: Meredith Baber, Sara Bader, Nicola Bednarek Brower, Janet Behning, Megan Carey, Carina Cha, Andrea Chlad, Barbara Darko, Benjamin English, Russell Fernandez, Will Foster, Jan Hartman, Diane Levinson, Jennifer Lippert, Katharine Myers, Lauren Palmer, Jay Sacher, Rob Shaeffer, Andrew Stepanian, Marielle Suba, Paul Wagner, and Joseph Weston of Princeton Architectural Press —Kevin C. Lippert, publisher

Library of Congress Cataloging-in-Publication Data
Lima, Manuel, 1978–
The book of trees : visualizing branches of knowledge / Manuel Lima. — First edition.
pages cm
Includes bibliographical references and index.
ISBN 978-1-61689-218-0 (alkaline paper)
1. Learning and scholarship—History.
2. Knowledge, Theory of—History.
3. Trees—Symbolic aspects—History.
4. Graphic methods—History. 5. Visual communication—History. 6. Communication in learning and scholarship—History.
I. Title.
AZ108.L56 2014
001.2—dc23

2013026128